OF SHADOWS

OF SHADOWS

One Hundred Objects from
The Museum of Witchcraft and Magic

Of Shadows:
One Hundred Objects From The Museum of Witchcraft and Magic

Colour photographs of museum objects Copyright © Sara Hannant 2016
Black and white photographs property of The Museum of Witchcraft and Magic
Texts Copyright © 2016 The Authors

Design and layout by Eric Wright
Printed by Kerschoffset Zagreb d.o.o., Croatia

ISBN: 978-1907222368

A CIP catalogue record for this book is available from the British Library.

Strange Attractor Press
BM SAP, London, WC1N 3XX, UK
www.strangeattractor.co.uk

Dedicated to the Founders and Friends

PSYCHOMANCY

ALPHITOMANCY

CHIROMANCY

CRYSTALLOMANCY

Preface
Ronald Hutton

Until recently, historians generally neglected material objects as evidence for what we could know about the past, leaving them to archaeologists, while archaeologists preferred to concentrate on more remote periods, and above all the ancient world and prehistory, where they were either dominant or wholly in charge. Neither had a lot of time for writing about magic, which was viewed as both an obscure and a trivial branch of human activity, and especially so if continued into modern times, when most scholars thought that people should really have got over it. All this consigned the material remains of modern magic to the ultimate periphery of interest for serious scholars. This situation has, however, altered almost beyond recognition in recent years, so that in 2015 alone no fewer than four different collections of scholarly essays were in press, all intended to impress academic as well as general readers and all dedicated to the material evidence for magical activity. Some had a global scope, and some covered the period from ancient times to the present, but all included modern European evidence and all made the point that to study the materiality of magic is now considered to be a thoroughly good thing.

So why the change, and why has it happened now? In part it can be put down to professional developments, the creation of an unprecedentedly large number of academic scholars in the Western world, with an unprecedented pressure upon them to carry out research and publication as rapidly and amply as possible. This has naturally pushed historians and archaeologists into a scramble for new source material and new subjects, in order to survive. It may also, however, be attributed to two much wider cultural phenomena. One is a new sense of material objects as personalities, with life cycles and biographies, and also one of them as texts, which can be read, and can deliver arguments, claims and stories even as the written word can do. Another is a diminishing fear of the supernatural, whether embodied in established religions or in the presumed actions of spells, charms and curses. The greatest threats to human existence are now perceived neither to be the anger of deities nor the caprices of an all-powerful natural world, but the consequence of ill-judged human action. This shift produces a willingness to probe the cosmos more deeply and understand it better, in order to find a place for ourselves within it which is both as comfortable and as sustainable as possible. At the same time, it diminishes traditional fears of transgression in considering ways of knowing the universe, and of working with it, to bring all past forms of knowledge and operation under fresh scrutiny. The great mysteries of existence – the fate of the individual personality on death, the extent and nature of the universe, and the possibility of a supreme intelligence or intelligences operating in its affairs – remain unsolved. We confront them, however, with a new globalisation of knowledge and sense of human freedom and potential; and with those, the figure of the magician increasingly takes its place alongside those of the spiritual leader, poet, storyteller, artist, scientist and politician as an expression of that sense.

This is the context, and the time, which is so appropriate for the appearance (or emergence) of the book to which these words are prefaced. It is in part a tribute to a remarkable collection, that of the Museum of Witchcraft at Boscastle; which has in turn been the creation of two remarkable men, Cecil Williamson and Graham King, now succeeded by a third, Simon Costin. Their private labours, supported by Graham's devoted team of volunteers, have built up the most coherent and comprehensive collection of objects related to the (mostly modern) practice of magic in the nation. The contents of the book consist of a large selection of exhibits from that collection, and the very different voices of Cecil and Simon, at times forensically objective and at others profoundly personal, are heard throughout it. It is therefore at once a vivid introduction to the materiality of magic, both for the newcomer and for those aware of the subject but not of the richness of evidence for it; and a series of reveries in which two individuals express their relationships with the objects, as personalities with their own experiences contained within them. Those reveries represent a spell-casting in their own right; but there is another kind of magic woven into the book, without which it would lack at least half of its character: that of the photographer Sara Hannant. Her decision to make images against a black background instead of the accustomed white automatically changed the priorities of representation in the recording and publication of a collection. Hitherto the general purpose of such an exercise has literally been to illuminate: to expose the objects concerned with the utmost clarity and so enable a recognition, and an understanding, of them to best effect. Sara's pictures are rites of evocation, which recognise the essentially enigmatic and secretive nature of most of what is displayed and call forth the character of each thing represented in the manner of an artist- or a ceremonial magician. Our ultimate lack of solid evidence for the provenance and purpose of so many of them only enhances their intrinsic power as characters in their own right, with their potential to reach out to the observer as an individual, and to inspire, repel, intrigue and provoke. As a result, this book is not merely a record of a unique collection and institution, a treble labour of love, but embodies a radically new and exciting approach to the work of representing the past to the present.

Left: Sara Hannant photographing a fishing float used as a scrying glass.

Articles of Faith
Simon Costin

Come... Drink from the Cup of
Forbidden Knowledge

The compulsion to collect is complex and fundamentally human. Objects resonate for people. They tell stories and sometimes they tell lies. The desire to collect and to then structure that collection into some form of order has been going on since human beings stopped being nomadic. This can be driven by numerous desires: the hunger for knowledge, the competitive challenge, the need to impress, or by the sheer unadulterated joy of ownership.

Quite often, personal collections exist purely for the enjoyment of the collector and his or her friends. At other times, collections start out that way and then the need to share takes over and a public display is created. So many museums started off as private collections which outgrew their original homes. Cecil Hugh Williamson's private collection grew into the Museum of Witchcraft and Magic, but I suspect his reasoning was not purely altruistic. Museums generally exist to impart knowledge, but Cecil once described his own as acting like a spider's web, attracting sources of occult information. His museum has been drawing people and objects into its web since 1951, when he first opened its doors on the Isle of Man and now, 64 years later, I find myself one of Cecil's more than willing flies.

Williamson was born on 18 September 1909 in Paignton, South Devon. His parents lived in Carrington House on Curzon Street, Mayfair, his father an authoritarian career officer in the Fleet Air Arm of the Royal Navy, his mother distant, vain

and somewhat embarrassed at having had a child. She sometimes tried to pass him off as a visiting cousin from Ireland. All pretty loveless and not untypical of the times and class he was born into. Inevitably, Cecil was shipped off to boarding school, firstly Norfolk House in Buckinghamshire and later Malvern College in Worcester, or to relatives in France for the holidays.

It seems though that the occult was never far away, even at a young age. The family home was said to contain a sad female ghost and a rather lively poltergeist. When Cecil was six years old, he was packed off to stay in the Devon village of North Bovey with his uncle, the Reverend William Russell-Fox. Whilst playing in his uncle's garden, he heard shouts coming from behind the garden wall. A mob was attacking an elderly woman and, without thinking, Cecil ran to protect her. His uncle came to the rescue and dispersed the crowd. It transpired that the elderly woman was in fact the local wise woman, branded a witch by the mob and dragged out to be 'scratched', a process whereby blood had to be drawn from the accused's skin in order to reverse a curse. Cecil became friends with the woman, who later said to him, 'Look up, look up young man, there are other places and other things.'

Some years later, when at Norfolk House, Cecil was mercilessly bullied. After a beating by the bully, Bulstrode, the school's cook took pity on him and outlined how he might tackle the problem.

'One day I wandered up the road to her rather nice cottage and she introduced me to the witch's swing. To make this, you find a tree with a suitable bough and get some rope and make a swing. But there's one extra thing, and that is to make yourself a little bonfire and put lots of grass on it so that it reduces the flame and produces a column of smoke. So you sit on the swing and as you swing backward and forward through this column of smoke you use a mantra for whatever your wish is. In my particular case I said:

'Take Bulstrode away Take Bulstrode away Take Bulstrode away Bulstrode away Bulstrode away.

'You go on doing that for not less than twenty minutes. Bulstrode did not return from the school holiday, he had a skiing accident and was crippled for life.'

Cecil was amazed and his interest in the powers of the occult began to blossom.

Cecil's grandmother shared a house on Thurloe Square in London with her friend, Mona Mackenzie, a well-known medium. Mona was also an astrologer who Cecil claimed taught him clairvoyant skills. He was also introduced to a medium known as Madam De La Haye who was immediately very taken with Cecil and announced that she could see a bright light shining around him. She promptly offered him the job of being the 'Boy in White' during her séances. He was to stand by De La Haye's side, dressed head to toe in luminous white, while she attempted to reach the spirits of the departed. Williamson later described this experience as his introduction to the 'High society bogey bogey business'.

Several years later, while still young, his grandmother took him to Dinard in France where, at the once grand Hotel Crystal (which has now slipped to 3-star), he was again roped-in to help, only this time as a collector of semen from the devotees involved in pseudo-gnostic, sado-masochistic rituals. All of this must have been quite an eye-opener for one so young, and Williamson stated that it was his introduction to the 'crazy world of occult cults, cocaine and the Charleston'.

After the First World War, Williamson passed his entrance exam to become a Naval Officer but, due to radical cuts in defense expenditure at the time, this dream was not to be, which must have vexed his parents. It's strange to think, given what Williamson would later go on to establish, that he then toyed with joining the clergy, much to his father's extreme displeasure. Instead he was packed off to Southern Rhodesia to learn about tobacco cultivation. This turned out to be something of a blessing in disguise, due to the fact that the seventy-year-old 'house boy', a native named Zandonda, was well-versed in the magical arts, healing and shamanism, and taught Cecil the secrets of juju charm-making and how to step 'beyond the veil'. So here we have a young man who has already had more contact with the occult world than most people experience in a lifetime.

Williamson was sent packing from Rhodesia when a German scientist, whom he was assisting, discovered a link between tobacco and cancer, which was not the outcome that the Imperial Tobacco Company was hoping for. Paid off handsomely, Cecil returned to London looking for fresh opportunities. He became interested in the film industry during the transition from the silent era into sound, and worked for Radio Luxembourg before assisting in several of the film studios that existed at the time.

In the early 1930s he met Gwen Wilcox, one of the star make-up artists for Max Factor and the daughter

of film producer Herbert Wilcox. They married in 1933, when Williamson was 24. His growing interest in film led him to visit Germany, known for its avant-garde film production. While staying at a B&B in Cologne, he got to know his host, a man by the name of Rudolf Hans. There was a lot of interest in the paranormal and the occult in Germany at this time and Hans just happened to have an interest in the occult and ran a newsletter for other interested parties. Williamson's fate was about to take another rum turn.

Chance Meetings

In 1937, Williamson's father happened to be in Surrey shooting game with friends, one of whom was a Colonel Maltby from the foreign office. While chatting, Maltby mentioned that he was heading up a section of the Secret Service to study the occult scene in Germany. Maltby was brother in-law to the British occultist Dion Fortune, so he may well have had a personal interest in the subject. Cecil's father mentioned that his son was also rather interested in the occult, so a meeting was arranged and Williamson was enrolled as a spy for MI6. On his next trip to Cologne he innocently asked Hans if he might see the mailing list for his occult newsletter, a copy of which was duly handed over. Maltby was delighted and when the war broke out a few years later, Williamson was called in once again. He was based at Haddon Hall, adjacent to Bletchley, and worked for Sefton Delmer's Political Warfare Executive (PWE), whose main aim was to spread disinformation and 'discomfiture to the enemy'. It was arranged that Williamson would travel back to Germany under the guise of a folklorist gathering material for 'The Witchcraft Research Centre'. What exactly he

managed to find out about the Nazis' involvement with the occult is unknown, but several books have examined their interests since. Williamson used this time to amass quite a lot of material, much of which he was able to keep after the war, and so began the start of his collection.

One of my favourite stories, told in Cecil's last recorded interview in 1998, involves his version (one of several), of the infamous 'Operation Mistletoe' ritual. He states that it was performed in Ashdown Forest by a group of Canadian soldiers, assorted occultists and Aleister Crowley's alleged son, to repel the advances of the Nazis. A team of seamstresses set to, making robes from army blankets for the soldiers, and a life size dummy of Hitler. A device was strung from the trees in the forest to launch the dummy into the air, which then exploded. Cecil describes it as 'an absolute pantomime'.

When the war ended, Williamson wrote, produced and directed a number of films but claims in his interviews that he saw television as likely to take over and so looked to take another path. Having spent so much time in London, he often visited the larger museums and got to know James Laver, curator and art historian at the Victoria & Albert Museum. Williamson must have mentioned his interest in the occult and Laver claimed that sadly, the major museums were not allowed to display anything related to witchcraft. And so Laver planted the seed that perhaps, with Cecil's collection, he might think of setting up a small museum of his own.

Beginning in Stratford-upon-Avon, he found an army-built fire station and in 1947 his museum opened. The local church folk, however, did not take kindly to the museum and he was later to say that: 'it did teach me one thing, that Christianity and

persecution go together like a horse and carriage. So the years roll on and the attacks continue and keep me company'. Not for the last time, Cecil and Gwen packed up and left.

In late 1950 an event took place that would weave Williamson's life together with a man who would later become the founding father of a new religion, Wicca. There are various reports as to how Williamson met Gerald Brosseau Gardner, but the place they met is agreed, the Atlantis Bookshop on Museum Street in Bloomsbury, London. The bookshop had been a magnet for the occult-minded since it opened in 1922, and Gardner was a frequent visitor, especially as the publication of his book, *High Magic's Aid* in 1949, was funded by the shop's proprietor, Michael Houghton. Houghton had a flat behind the shop where like-minded souls could meet in privacy and drink the copious amounts of coffee that he provided. Williamson told Gardner of his museum idea and no doubt what had happened in Stratford. Cecil gave Gardner his card and some weeks later Gerald invited Cecil to a meeting of the Folk-Lore Society on 13 December 1950.

The two began to correspond in January 1951, with Gardner initially referring to Cecil as 'Mr Wilkinson' and later as 'Cyril' before finally getting it right later in the year. Gardner was quite keen to have the museum sited at a nudist club he was involved with, but Williamson was less enthused. Remembering the Isle of Man, having filmed the TT racing there for the Manx Tourist Department, Williamson set off to see if they might be able to help. The Castletown Board of Commissioners and the Chief Executive Officer of the Publicity Board were indeed enthusiastic about the museum project and in Castletown he was shown a ruined early 17th

century windmill, along with two cottages, a huge barn and plenty of space for a car park. Gardner claimed the mill was already known as the 'Witches Mill' by the locals, due to a coven of witches who had lived in nearby Kirk Arbory. Whilst there are records of trials of witches from the 17th century in Kirk Arbory, there are no written records that witches ever used the mill, so this may have been invented to give the mill a more magical aura. Either way, this snippet of local history must have seemed an auspicious start for the project.

The Witches' Kitchen

Williamson moved to Castletown to oversee work on the buildings in early 1951, with Gwen joining him later in May. It was Gwen's suggestion to open a café to help generate income and 'The Witches' Kitchen' was sited on the ground floor of the old granary building. The museum's guide stated that the aim was to 'bring back and offer to the public many of the old country dishes associated with the numerous feast and festival days, which are found throughout the calendar'. They must have worked extremely hard to get things ready. Williamson had already alerted his media contacts about the project and, in April, the BBC arrived to film a ten-minute piece about the museum, which featured Gardner and was broadcast live on Saturday 14 April 1951.

The idea was to get as much of the museum ready as possible and then to expand at a later date. On the first floor of the building was a re-creation of the magic circle as used by the Elizabethan magician, Dr John Dee. A report from the *Isle of Man Examiner*, dated 20 April 1951 describes it thus:

'The main feature will be Dr Dee's magic circle, of which he produced carefully drawn plans. The circle

must be constructed to a complicated formula of dimensions and there are constituents involving an altar carved with innumerable cabalistic signs, each with a separate significance; inscriptions of the names of Hebrew gods, nine candlesticks each in the form of a different symbol, black earth (to be specially imported), the Eye of Horus, the magician's wand and a cup and four white swans wings.'

Cecil enlisted the help of the students from the Douglas School of Art to create the painted elements. Gerald was also busy helping to create objects for display and sending them over. He was not yet living on the island, but letters show he was asking Williamson to keep a look out for, 'any sort of small house or flat or cottage for rent or sale'. Then suddenly, around mid-May 1951, Gardner arrived with a music case, a toothbrush, his pyjamas and little else. Eventually he found a small, vacant, 400-year-old stone cottage, but the owner was unwilling to sell. In a newspaper article entitled, 'I Am a Witch', printed in the *Daily Dispatch* on 5 August, 1954, Gardner describes how he called upon his friends for help.

'Eight other witches helped me to cast a spell. We danced round a priestess of the Moon Goddess. Charcoal, herbs and incense burned in a cauldron. We chanted phrases and made signs handed down to witches for generations.'

Something must have worked, for no sooner had Gerald arrived back on the island than the house was offered to him for sale. He bought it and builders were brought in. By the spring of 1952, Gerald, together with his wife, Donna, had moved in and he was installed as the museum's 'resident witch'.

In July 1951, 'The Folklore Centre of Superstition and Witchcraft' opened to the public, featuring objects from both men's collections. Cecil hoped to attract like-minded others so that he might learn from them: a membership scheme was set up to encourage people to join and they would be sent a journal containing news and articles. No copies of this journal have been found, so it's uncertain whether it ever came to be set up. Gardner hoped to use the museum as a means of promoting his newly founded ideas for Wicca and would sell inquisitive visitors signed copies of his book, *High Magic's Aid*.

For a while things went well, but Williamson was sceptical of Wicca and, as is often the way, arguments over money started to drive them apart. The first year was difficult and, in January 1952, Cecil wrote

To Greet you with Kind Thoughts and Best Wishes for a Merry Christmas and a Bright and Prosperous New Year

from

The Witches' Kitchen, Arbory Rd., Castletown, Isle of Man.

to Gardner, who holidayed abroad during the winter months due to his asthma, asking for financial help. Gardner arranged for £200 to be sent and his bank suggested that he buy the mill buildings, which were currently leased, and mortgage them to Williamson. It seems that this is what happened because, on 29 February 1952, Gerald wrote to his solicitors asking them to prepare a mortgage for £2100 which was transferred to Williamson in June of that year.

Williamson must have been concerned as to how he would be able to repay the mortgage, and as the 1952 season drew to a close with very little to show in the bank he started to review his situation. In December, a severe storm hit the island and badly damaged some of the mill buildings so there were now also repair bills to be paid. During the 1953 season further strains on their relationship surfaced over the display of objects and, at the end of the season, Gerald's solicitors served formal notice on Cecil for unpaid interest on the mortgage. In March 1954 Williamson sent Gardner a telegram asking him to withhold legal action until they could talk, Gerald being abroad for the winter. Details of the discussion are unknown but in April 1954, Cecil and Gwen moved out, having sold the mill to Gardner.

Disagreements followed as to which items should remain and which were rightfully Williamson's. With Cecil's collection gone, it was difficult for Gardner to fill the spaces. This is probably why, after Gardner took over, the surviving images from the museum booklet show a huge number of swords and weapons gleaned from his personal collection adorning the walls and filling the cases. Cecil did agree to leave his collection

of amulets, which he allegedly cursed*. In the early summer of 1954, when the doors reopened, The Witches Mill had become 'The Museum of Magic and Witchcraft', with a new owner, Gerald Gardner.

The Wandering Witch

Back on the mainland, the Williamsons were looking to locate to a tourist destination for increased footfall. They found a drill hall, left empty after the war, next to a café in Windsor. The 'Witchcraft Research Centre' opened in 1956 and the museum was doing well, until a year or so later when Williamson was paid a visit by 'two gentlemen in grey suits' from the nearby Royal Household. Apparently the museum was deemed to be something of an embarrassment and would have to go. New premises had to be found and within a week the Williamsons had moved yet again, this time to Bourton-on-the-Water in the Cotswolds, to a building which today houses a model railway collection.

Their time in Bourton-on-the-Water proved to be one of the most challenging for Cecil and Gwen. In late 1956 the new incarnation of the museum opened. There was a degree of local hostility from the start. The Christian community was so concerned that they set up a picket outside with 'Satan's House' placards. Of course this only helped to pique people's curiosity even further and door takings were good. The intimidation continued however, and a dead cat was strung up outside the door. Next came an arson attack, which damaged part of the building.

Cecil's days were numbered, but not in the way the local vicar's were. He refused to give Cecil's

* Funnily enough, many of them have made their way back to the current museum in Boscastle and, in 2012, I was able to personally collect a number of the charms from a kindly donor in New York and return them to the museum.

housekeeper communion and even went so far as to spread further hatred by preaching against him at a Sunday service. Within 21 days the vicar was dead. I can only imagine the uproar this must have caused within the church community. Whilst Cecil never declared that he was responsible, he was quoted as saying that, under pressure, the only weapons at his disposal were, 'Time, silence, single combat or magic'.

It was time to move yet again. During their short time in Bourton-on-the-Water, the Williamsons had bought two small properties in Looe and Polperro in East Cornwall, so everything was packed up and taken down there, with them moving into the Polperro cottage. In quite rapid succession Cecil opened a Museum of Smuggling in Polperro, followed by a very short-lived attempt at another witchcraft museum called The House of Spells in Looe, which, once again, the local Christians vehemently objected to. This closed and was followed by The House of Shells, which Gwen managed in the grounds of Buckfast Abbey in Devon. Still longing to reopen his witchcraft museum, Cecil happened to visit Boscastle, possibly drawn by tales that witches once used to 'sell the wind' to sailors on the quayside by magically binding the wind into a length of knotted rope. Should they be at sea with a low wind they just had to untie one of the knots to increase the breeze.

Boscastle is uniquely situated. It nestles in a valley in North Cornwall, not too far from Tintagel, which has its own magical associations. The craggy rocks of Boscastle harbour look out to the Atlantic Ocean and high up on the right they seem to form the profile of Queen Victoria. An unusual rock formation has created a blowhole, which some call the Devil's Bellows, and if the conditions are right, waves hit one side of the rocks, forcing water through a hole, resulting in a plume of spray jetting across the harbour with a deep thudding sound. As well as the magical setting, for a good part of the year Boscastle enjoys a healthy tourist footfall, so it's easy to see why Cecil might have thought his museum could work there. He purchased a warehouse in the harbour and had it converted into a series of spaces which could once again house his collection. It opened in 1960 as The Witches House and later became The Museum of Witchcraft. And there it has remained ever since.

Safe Harbour

For the 36 years that Cecil ran the museum in Boscastle, he was able to meet many local people who would often point him in the direction of anyone who may have known the 'old ways'. These people he referred to as his 'Aunty Mays'. These traditional, or 'wayside witches' were a rich source of magical lore, and as the museum grew and developed it took on more of a West Country feel suited to the area.

Cecil felt that the museum displays also had to give the public what they expected to see, to a certain degree. This resulted in three somewhat lurid tableaux: 'The Horned God', 'The Temple', and 'The Witches Cradle'. These were more Hammer Horror than history, depicting foetuses dipped in tar being offered up to a goat-headed figure by a naked witch and in another, a scantily clad woman draped over an altar, 'Prepared for the Act of Spiritual Conception'. Perhaps by the 1960s though, people's attitudes had changed, as these sensational displays didn't lead to pickets or dead cats.

The bulk of the collection was displayed in brightly-lit cabinets with little sense or order, each captioned with Cecil's highly individual typed descriptions.

Seen together, these captions tell much of Cecil's magical thinking and his belief in the spirit world. One such caption, placed next to a human skull, reads:

'The human skull is the symbol of death. For the witch death holds a strange fascination. Each and every one of us is born to die, but is death a final end to life? The witch says no. For she knows that: "There are other places and other things". Her whole life and being is devoted to the ever present but unseen world of spirit.'

When the museum opened Cecil was 51 years old, and he ran the museum until he retired aged 87.

He employed staff to manage the place while he and Gwen moved to Witheridge in Devon. By the early 1990s Cecil's health was failing and he looked to sell the museum, very much hoping that it would remain in Boscastle. He alerted the press and several newspapers ran stories, reporting that the museum was for sale and in search of a new owner.

Meanwhile in Hampshire, Graham King, a young man with a talent for invention, had grown a successful business developing a unique rostrum camera device for photographing historic books. Whilst out walking on the Wiltshire Downs one day he met the

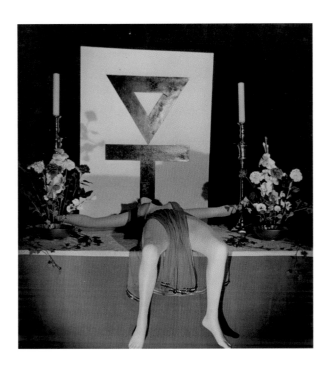

Dongas Tribe. The Dongas, responsible for the birth of the British Road Protestors movement, were to later squat Twyford Down in an attempt to save the site from the Ministry of Transport's road building programme which threatened this beautiful part of the English landscape. Sadly the road went ahead, but the protest attracted much interest from the national media and subsequently campaign groups like the Campaign for Better Transport, were born.

Graham experienced a kind of epiphany after his meeting with the Dongas, and decided to sell his comfortable house, car and company and look to totally change his lifestyle. While this was all proceeding a friend of Graham's happened upon one of Cecil's newspaper articles and showed it to him. Intrigued, Graham called Cecil to make an appointment and set off for Boscastle in his (soon to be sold) Jaguar. The two men got on very well and

Cecil was delighted that Graham didn't intend to break up the collection. This had been the fate of Gardner's museum in 1973 when Monique Wilson, who had inherited it, sold everything to Ripley's Believe It or Not! in America, thus destroying a unique Wiccan legacy.

With the sale agreed, Graham took it upon himself to walk the 230 miles from his home in Hampshire to Boscastle, arriving on 31 October 1996 to complete the purchase at midnight. Graham brought a fresh pair of eyes to the collection and was eager to refurbish the museum and to get the building properly rewired in the process. The first things to go were the tableaux. The Horned God became a figure of Baphomet and the Temple scene was replaced with a careful reproduction of a cunning woman's cottage, circa 1890, complete with some of Cecil's collection of taxidermy. The objects were all removed from their cabinets and grouped together to lend a sense of order and to make their purpose clearer to visitors. Headings such as 'Divination', 'Sea Witchcraft', 'Persecution', 'Herbs and Healing', 'Curses' and 'Modern Witchcraft' all helped to tell a story. In Cecil's day the library had

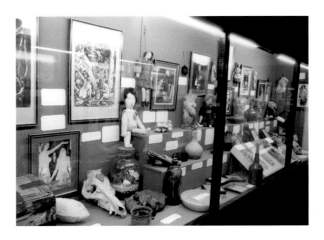

been relatively small but Graham worked hard to build it up to be one of the best occult libraries in the UK, now containing over 6000 books, manuscripts and some very important correspondence from key figures within the Neo-Pagan movement.

In 2000, a Dutchman, Bob Richel, contacted the museum. Bob had inherited a remarkable collection of occult items, put together by his father-in-law, Mr Eldermans. Eldermans had been a Magister of either the sex magic group Ars Amatoria, or Aleister Crowley's occult group, the Argentium Astrum (Silver Star) or A∴A∴; we do not know which. There are artefacts in the collection relating to both organisations. This truly unique collection was to be a real jewel in the museum's crown as, along with many hand-made objects, there were over 2000 paintings and drawings. Bob was quite elderly and was concerned about the future of the collection. Graham visited him in Amsterdam and couldn't quite believe the sheer scale of the collection, which had once been even larger. Much of the documentation regarding the collection had disappeared before Bob inherited it, along with an index for all the images. Sadly, shortly after Graham's visit, Bob died, and all the material came to the museum sooner than expected.

The Deluge

Graham had become an Auxiliary Coastguard during his time in Boscastle and eight years into his tenure as director of the museum, his well-trained eye was to play a vital role, when a devastating flash flood hit the village on the afternoon of 16 August 2004. Heavy rain had been falling for some time that afternoon and, together with a high tide, this caused the river to breach its banks. Graham was the first to call the Coastguard and later helped to direct the rescue as the water rose to a height of 3 metres, destroying around one hundred homes and businesses. Seven Westland Sea King helicopters helped to rescue 150 people clinging to trees and stranded on the tops of buildings. Remarkably nobody was badly hurt or killed.

The museum was badly damaged and although everyone working there that day was able to remove many objects to the first floor, the water rose so rapidly that it was impossible to save everything. When the water had subsided the building was filled with a metre and a half of sewage, mud and debris. Miraculously, partly due to where the museum was positioned, a relatively small percentage of items was lost from the collection, even though almost all of the ground floor glass display cases were shattered. The mud trapped many pieces and, over a period of months, an army of volunteers carefully washed, cleaned and disinfected everything. Walls which had been torn down were rebuilt, and floors re-laid. Cash donations and offers of help came in from all over the world. The National Maritime Museum stored the library books to protect them from the damp while the clean up operation went on.

On the day of the floods I was at home watching the ruination with horror. I had known of the museum for many years, but lacking a car and not being able to drive, it had always seemed too remote to reach. Trauma often prompts action: I sent a donation but knew there must be more I could do to help. A friend of mine, Jane Wildgoose, had recently introduced me to John Furlong, then the Head of Administration for the Public Engagement Group of the South Kensington museums. John mentioned to me that the Geology Museum in London was decommissioning some lovely old mahogany

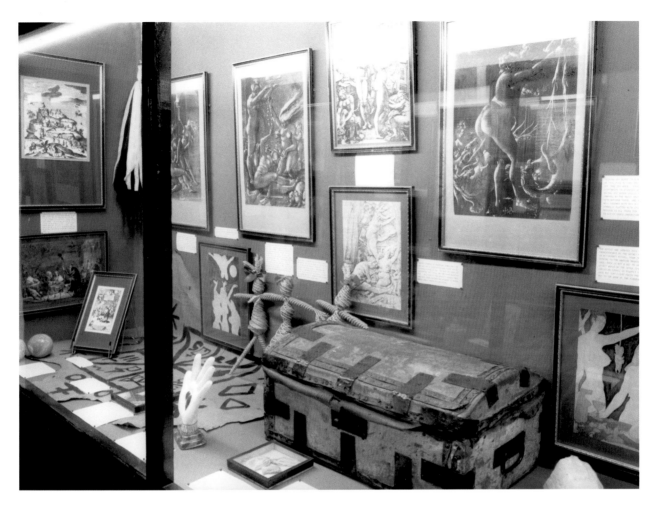

display cases. I put in a call, went to a warehouse in Wandsworth, measured and photographed the cases and sent everything to Graham in Cornwall. Within a few weeks Graham had sorted out a van and arrived in London to meet me and collect it all. With his usual sense of invention, he cleverly dismantled the cases with an electric saw and put everything back together in Boscastle to fit the spaces inside the museum. The whole ground floor was given a complete makeover and, at the end of March 2005, the museum opened once again.

Seeds Are Sown

I first visited Boscastle on a grey stormy day in April of 2005. Graham was able to collect me from Bodmin Parkway station. As you leave Camelford and pass Slaughter Bridge, the first dramatic view you get of the village, spread out beneath you, never fails to make the heart leap. Then, as you descend into the valley, mobile signals fade and you enter the liminal space between land and sea. It truly is a magical landscape.

I was totally smitten by the museum. As someone who has been involved in various forms of magical practice for most of my life, and as a person who collects and responds deeply to objects and museums, that first visit was totally overwhelming.

So many encounters with so many wondrous objects. One of the many things I like about museums is the way they can make rare things available to many. And here were so many rare things. By rare I don't mean objects made from precious materials, I mean objects that we rarely get to see: scrying crystals, a magical practitioner's working tools, human skulls bound in iron, mandrakes, a bird trapped in wax and used as a curse, blasting rods, ceremonial gowns, pinned poppets and moles' feet charms. Here were the untold stories of Britain's rich magical heritage, showing that it is as alive now as it has always been. As a repository of occult knowledge, I suspect that the museum is unsurpassed.

Over the next nine years I journeyed back and forth from London to the museum as often as I could, and one year Graham invited me to spend a month working there. In a way my previous visits felt a little like a courtship, and over the month I stayed at the museum, my appreciation of and relationship with the collection deepened. Spending time quietly alone in the galleries and in the library, when everyone had gone home, gave me the chance to come to a much deeper understanding of the spirit of the collection. There is a very strong genius loci attached to the museum and its location and it felt important to connect with it somehow. When looking through a box of Cecil's writings and display captions, I came across something that outlined what witches in the area once did:

'Yes witches did and still do dance with the wind in high places above the Sea. You should try it sometime; it is an experience never to be forgotten. I guarantee that you will be carried away with the wind. You will experience a greater emotional release and revelation than is available by the use of the most lethal and potent drugs. For you have cast yourself in to the arms of the universal creator. In those fleeting moments you will experience the full power and awesome majesty of our creator and benefactor.'

A week or so later there was a fantastic storm; the wind came hurtling in from the sea to the point where it was difficult to walk without being bent over. Later that night, remembering Cecil's words, I struggled up in the wind and rain to the Coastguard's lookout

post, built originally as a folly in the early 1800s. I had barely reached the top when my hat was whisked out to sea. Taking that as a sign, I hurriedly whipped off my clothes and stuffed them in my rucksack. What I must have looked liked, standing naked with my arms outstretched to the sea, being pushed against the wall of the folly, I can only imagine. But Cecil was right; the emotional release was more intense than anything I had felt before.

Later, tucked up in bed, I felt as if I had offered a part of myself up.

Fast forward several years to 31 October 2013 and I'm sitting at the table in the Library, with Graham and his solicitors, as the deeds and legal documents are spread out and signed and I become the museum's new custodian.

At the November 2013 AGM of the Friends of the museum, Steve Patterson, writer, folklorist, cunning man and a long-time Friend of the museum, gave a talk on the history of the museum and its creator. He reminded everyone of something Cecil said in an interview.

'In one of his rare television appearances (*Well Worth a Visit* BBC, 1996) when asked what was going to happen to the museum when he passed over, he replied that "he would have to pass the question over to his Familiar spirit". It was the spirits that passed the museum over into Graham King's capable hands, and it is the spirits that have passed it over once again.

'Make no mistake about it, the spirits are still very much in control!'

The world of Witchcraft & The Magic Makers

AWAITS YOU

AT

THE MUSEUM

OF

WITCHCRAFT

IN

BOSCASTLE

NORTH CORNWALL

4775 Parade Printing Works, Ltd., Southside St., Plymouth. Tel. 64882

Before your very eyes.

Of Shadows
Sara Hannant

*'If you really must understand this world,
first you must stand upon your head.'*

CECIL WILLIAMSON, FOUNDER OF THE
MUSEUM OF WITCHCRAFT AND MAGIC.

While working on *Mummers, Maypoles and Milkmaids: A Journey through the English Ritual Year* I became fascinated by the practices of modern witches. I have also been exploring, through a long-term project, the personal connections we have to objects and the significance and memories we attach to them. I was, therefore, delighted to be invited by the Museum of Witchcraft and Magic to undertake an artist residency to photograph some of their magical objects.

My initial visit to the museum in January 2013 provided an opportunity to immerse myself in the collection. The museum presents many approaches and applications of witchcraft and explores the nature of magic through a wide range of artefacts: from cures to curses, from spirit houses to spells for sailors, from the tools of wayside witches to the ceremonial robes worn by Western ritual magicians. The collection includes a variety of handmade and mass produced items. Historical implements used in the persecution of witches are also represented. I started a process of research and reflection exploring a selection of the magical artefacts I found the most resonant. I set up a photographic studio in the library and began experimenting with different lighting techniques, approaches and styles in response.

Of Shadows is informed by the practices of witchcraft and magic, where the symbolic properties of the objects and their materials are paramount, serving as mediatory devices to harness natural forces or the spirit world. Furthermore, the objects seem to retain magical potency despite separation from the owner or the passing of time. It is, therefore, a great privilege to encounter and sense the inherent magical presence of each of these artefacts.

It soon became apparent that it was best to photograph at night, enabling the objects to emerge from the darkness, where it is said magic begins. Reflecting on this process, I found parallels with photographic practice. Superstition and magic have encircled photography from the beginning. In many cultures, the word for photography/photographer translates as 'soul taker', 'shadow catcher', or 'face stealer'. The camera itself was perceived as a magical object, and photographs were thought to possess supernatural powers, or be amenable to witchcraft.

In witchcraft, magic is practiced to bring about transformation and sometimes objects are made or charged with magical intent for this purpose. Similarly, the photographic process can transform objects, images and ideas that contribute to its meaning. I became fascinated to explore how light and darkness define and articulate our relationship to enchantment and if this mechanism can be employed to suggest narrative and significance.

The museum had previously followed the photographic convention of presenting objects in front of a white background with an even illumination rendering a seemingly faithful appearance of the entire piece, recording detail and information. For cataloguing a ruler is often included to provide scale. The images appear as objective documents of the objects' existence, functioning as a quotation for reference. In contrast, I wanted to create images that evoke an atmosphere conducive to magical potency and promote an understanding of the object's heritage, interpreted through the medium of photography.

The intensity of weight or conviction of an object in a photograph is conveyed by the power with which we are made aware of its absence or presence. As the writer John Berger has suggested in *Understanding a Photograph* (2013), 'what it shows invokes what is not shown.' This notion of what is revealed or concealed is of particular significance in relation to magical artefacts, inviting the viewer to engage with the immediacy of the on-going moment as presented while imagining a possible narrative regarding the object's original function.

The one hundred objects have been selected to indicate the breadth of the collection and its future displays. As the object biographies accompanying each photograph reveal, there are many enduring traditional practices and accepted beliefs pertaining to folklore and magic that continue today. It is evident how the understanding and use of some items have been adapted in relation to changing social and spiritual contexts. For example, the household broom or besom, recognised as an emblem of the witch, is also used in Romani and Pagan wedding ceremonies and in Wicca to symbolically cleanse a sacred space.

Although captions by their nature are intentionally brief, I felt it important to locate and expand upon Cecil Williamson's original object descriptions (some of which were written in the 1950s) in relation to contemporary magical thinking. This expansion also provided an opportunity to position his ideas together with comparative and supportive views from disciplines such as history, anthropology and folklore, opening up some potential areas for future research.

Spending time at the museum and doing research for the book has significantly enriched my practice and prompted me to investigate further the blurred boundary between performance and ritual, and the production of art and occult practices. I have become interested in the magical belief invested in offerings left at sacred wells in Cornwall. In folklore, a strip of cloth or 'cloutie' is torn from a person's garment, dipped into the well then hung on a nearby tree. It is believed that as it falls and rots, the person's illness will disappear. The cloths connect pilgrims' hopes and dreams to the opaque but powerful numinous - the divine power or spirit thought to inhabit the sacred place. Unfortunately, some people leave cloths made of fabrics that will not biodegrade, and the offerings are consequently removed by the Cornish Ancient Sites Protection Network.

While the custom of leaving votive offerings at sacred sites is common throughout the UK, *Of Shadows* also presents magical objects that represent esoteric rituals and once-silenced belief systems. In some cases, the selected artefacts expose tensions between the portrayal of witches in popular culture and their actual practices. It is possible to notice recurring shapes associated with magical potencies, such as the circle or the hand, which often

They feared and hated the Witch but
they did not hesitate to call upon
her knowledge in times of need.

articulate a physical relationship to the world and our bodies. It may even be possible to see how folk magic has influenced aspects of our culture today. A herbal medicine jar tells of how the wise women and cunning men understood the medicinal properties of the natural world. Ritual wands used by members of The Golden Dawn speak to us about the religious motifs of Ancient Egypt and the mystical rites of Freemasonry. A floral headdress worn at Beltane by a modern Pagan reflects an understanding of the Wheel of the Year and the power of ritual to connect with the changing seasons.

The subsequent editing and sequencing of the images necessitated a long process of scrutiny, critique and revisions. Artefacts are not organised by category or timeline, or according to aesthetic or formal affinities, with the exception of the ceremonial objects made by George Alexander, the herbs from the Monica Britton Collection and articles from the Richel-Eldermans Collection, which are grouped together. The book is designed so that each object might freshly insert its storyline and prompt a dialogue with neighbouring images. In this way, the spells of traditional witches appear alongside everyday charms and the working tools of ceremonial magicians.

However mysterious an object may be, it is also something that has a real and distinct existence; by definition, an object is an entity that can cast a shadow. The title *Of Shadows* relates to this definition while also referencing the heritage of magical thinking in the form of the grimoire – a spellbook or tome of magical knowledge referred to by many modern witches as a Book of Shadows. Indeed Cecil Williamson, the founder of the museum, when asked a question, would often answer that he must consult his shadow.

Of Shadows

Photographs by Sara Hannant

Captions by Sara Hannant and Simon Costin;
original labels by Cecil Williamson

1. Moon Talisman

40 x 65 x 2 mm

This moon talisman belonged to Gerald Gardner (1884-1964), founder of the religion Wicca. Gerald met Cecil Williamson in 1946 and they became friends and business partners, Cecil employing Gerald as 'resident witch' at the Witches' Mill when the Folklore Centre of Superstition and Witchcraft first opened on the Isle of Man in 1951.

Over the years, however, their friendship deteriorated. In 1954 Cecil moved his collection back to England and sold the Witches' Mill to Gerald who renamed it the Museum of Magic and Witchcraft and henceforth displayed his own artefacts.

When Gerald died, he left his collection to a High Priestess, Monique Wilson. Together with her husband, Campbell Wilson, they ran the museum for several years then sold the entire collection to Ripley's Believe It Or Not! in America, whereupon the items were divided between museums in Gatlinburg and San Francisco. When both museums closed in 1985, the artefacts were sold at auction. Many years later Mark Sosnowski, a witch living in New York, purchased thirty-nine of these items on eBay and donated them to the Museum of Witchcraft in 2012. Rumours circulated that Cecil had cursed Gerald's collection, so a suitable ritual was performed to release the artefacts and allow them to be displayed.

Documentation supplied by Ripley's Believe It or Not! describes this object as 'a silver moon talisman… used by a witch, circa 1740'. However, it is thought most probable that Gerald made it himself.

The moon is considered by some to be the ruler of all magical arts and spells are often timed to coincide with the phases of the moon. Coordination with the new moon is favourable for spells concerning new beginnings or for enhancement, whilst the waning moon is a time for spells intended to decrease, reverse or banish.

Most Wiccans hold gatherings at the full moon and the witches' goddess is often seen as a triple-faced moon goddess, representing the maiden, mother and crone/matriarch. In Wiccan rites the goddess is requested to enter the body of the priestess and speak through her, a process known as 'drawing down the moon'.

RED THREAD, A STONE WITH A HOLE IN IT,
AND A SILVER COIN WITH A LADIES HEAD,
ARE STRUNG TOGETHER AND WORN AROUND THE
NECK TO CURE AND KEEP AWAY FITS. THE
SILVER COIN MUST BY SOME MEANS BE
OBTAINED OR EXCHANGED FROM OUT OF A
CHURCH OFFERTRY BOX.

2. Hag Stone with Sixpence and Red Thread

270 x 25 x 20 mm

Hag stones, holey stones or witch stones with naturally occurring holes are thought to have regenerative power and protect physical vitality. Wearing one around the neck or hanging one above the bed is believed by some to promote fertility or to stop the night-mare visiting. Hag stones were also hung in domestic houses, barns or stables for protection from witches or the evil eye.

As per Cecil Williamson's caption, records detailing the healing powers ascribed to so-called 'sacrament money' and rings made with the coins were believed to cure fits. Usually, the sufferer had to beg for individual pennies from at least twelve different people, preferably from those who were unmarried and of the opposite gender (Simpson and Roud, 2000).

Red, the colour of blood and the living body, is generally associated with good luck and health. Many folklore collections refer to the use of red thread, wool, flannel, and ribbons in connection with a wide range of cures and for the prevention of witchcraft.

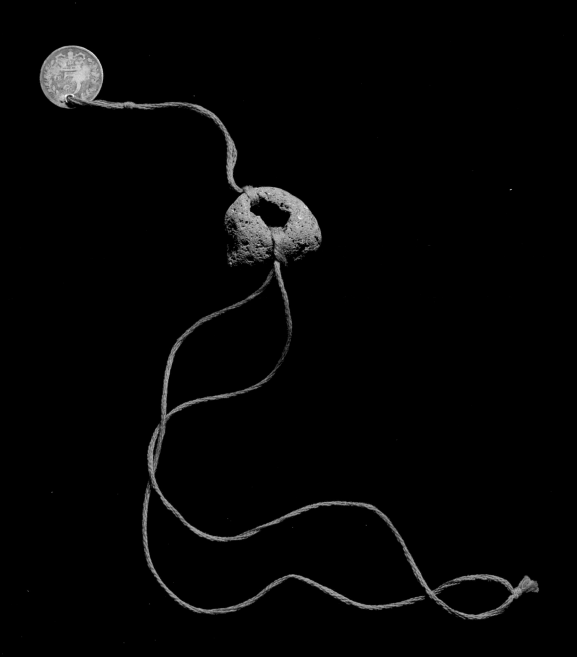

3. Fortune-Telling Machine

450 x 450 x 150 mm

This fortune-telling machine was originally made to raise funds for Queen Charlotte's Hospital in London. It was badly damaged in the Boscastle floods of 2004 so Graham King, the museum's owner and curator at the time, rebuilt it using tarot card images to replace the illegible facia. Placing a coin into the slot sets the needle spinning, and where it stops determines the prediction, according to the symbolic meaning of the individual tarot card.

Fortune-telling machines first appeared in the 1900s on end-of-pier attractions, in penny arcades and fairgrounds across Europe and the United States. Wheel of Fortune machines with spinning dials such as this were a popular development from the original glass-fronted booths that contained life-like models of fortune-tellers with colourful names such as Zoltar Speaks, Madame Zita, Princess Doraldina and the Geneco Gypsy Grandma Fortune Teller.

Round and round the ball will spin
Till it draws your good luck in
Ah, I can foretell for you
Good luck in a month or two

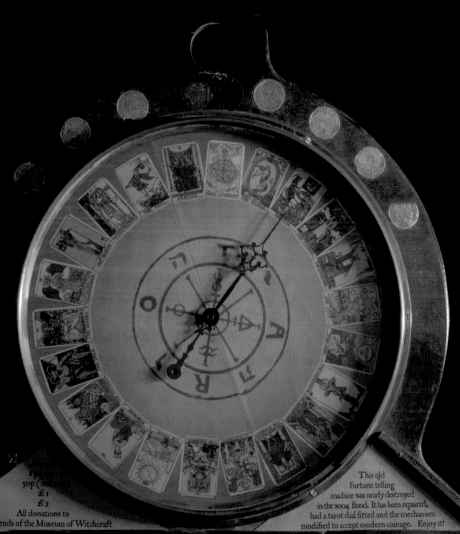

All donations to
The Friends of the Museum of Witchcraft

This old
fortune telling
machine was nearly destroyed
in the 2004 flood. It has been repaired,
had a tarot dial fitted and the mechanism
modified to accept modern coinage. Enjoy it!

50p
£1
£2

Tarot Readings

4. Wax Hand Votive Offering

150 x 95 x 10 mm

An object crafted to resemble an anatomical part of the human body, such as this miniature wax hand made in Fatima, Portugal, can often be purchased near Roman Catholic and Greek Orthodox churches. These objects are ceremoniously offered with prayers for healing the body part represented. Although ritual use of symbolic words, actions or objects to produce desired results can be defined as magic, the person performing it might not recognise it as such. Saints and angels are often called upon to assist with this type of folk Christianity.

Votive offerings have been used since ancient times to petition higher forces such as supernatural beings, deities and divinities. Offerings left for deities at sacred sites or places of worship are called 'votive' after the Latin *vōtīvus*, 'promised by a vow'. Similar votive offerings are often left as tokens of gratitude when relief or healing has been granted – these are known as ex-votos.

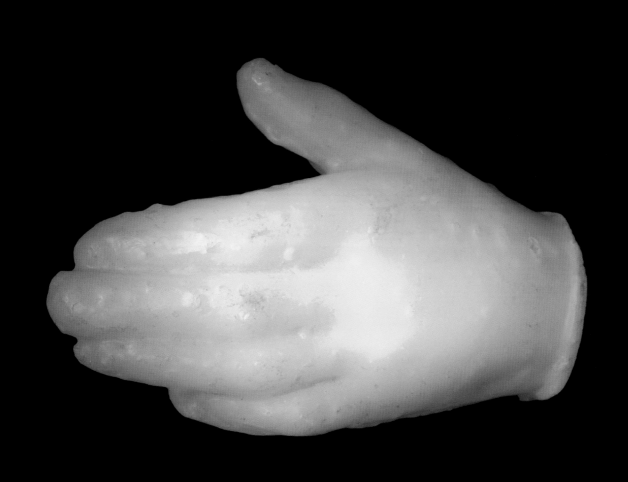

5. Brownie Pate's Athame

290 x 60 x 20 mm

Cecil Williamson gave this athame to a witch friend, Brownie Pate, who kept it with her skull 'Henry'. The Athame has an embellished hilt made of black paper-mache, layered with gold-painted sigils – magical symbols – similar to the magical symbols on 'the Knife of the black hilt for making the circle' in S. L. Mathers' transcription of the medieval grimoire *The Key of Solomon* (1888).

An athame is a black-handled blade used by many modern witches as a working tool. The athame is not used for cutting but for casting the circle and directing energy during a ritual. In Wicca the athame most commonly represents the element of fire, and is one of the four elemental tools, the others being the wand (**see item 48**), pentacle (**see item 24**) and chalice (**see item 52**).

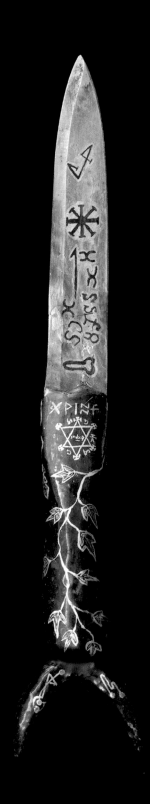

6. Runes

37 x 23 x 6 mm

These modern ceramic runes were made in China and produced by Carlton Books Ltd, sold in a velvet pouch accompanied by *The Runes Book* by Horik Svensson (1995). Carlton Books claim you can 'Predict your destiny with this ancient Viking divinatory system'. However, rune magicians Nigel Pennick and Bob Oswald advocate using the runes to gain self-knowledge and ascertain life direction. They suggest deriving interpretations by using an approach that appreciates the runes in their historical context.

Runic alphabets evolved in pre-Christian times in Scandinavia and Germany. The arrival of Anglo-Saxons in England led to the development of the Futhorc system used (circa 400-1100 AD) for writing and magical purposes.

The original meaning of the word 'rune' is secret, mystery or hidden. Each rune has a name, a phonetic value, symbolic image and esoteric meaning in divination. Many people choose to make their own runes for divination or 'rune casting'. One of the traditional methods involves cutting a branch from a tree into disks and carving a specific rune on each disc. The runes are then most commonly stored in a pouch for safekeeping.

To consult the oracle, the enquirer sits in a quiet place. Many rune-casters choose to face North, the direction of the gods of Norse mythology. With their question in mind, the enquirer can gently swirl the runes around, scatter them across a cloth or, as each rune falls into the enquirer's fingers, lay it down. Runic symbols are thought to represent the entire universe and unique meanings of individual runes are interpreted in accordance with the specific casting layout or spread used.

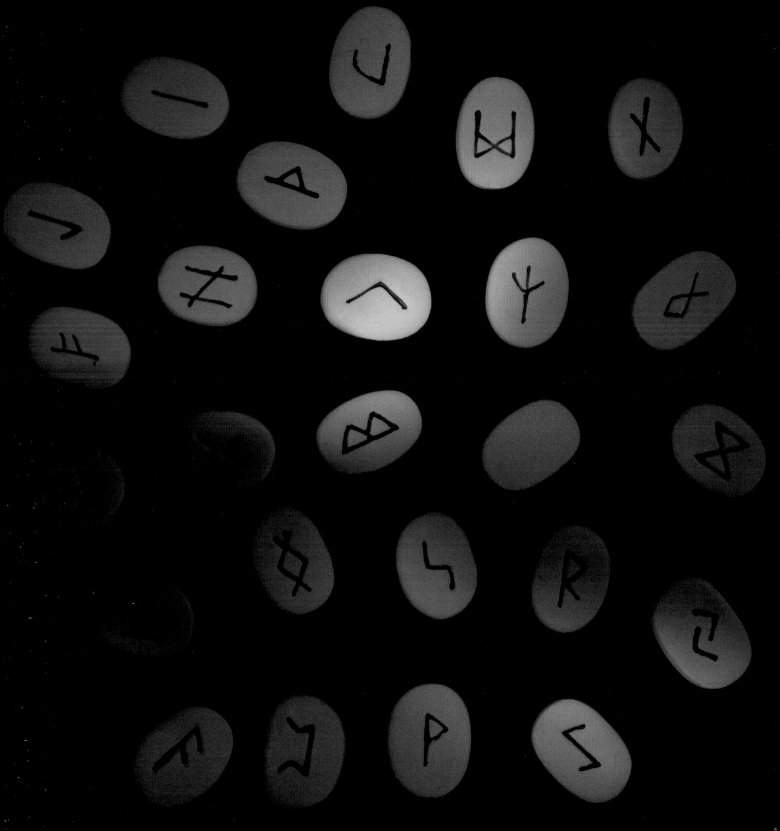

7. Witch Bottle

200 x 165 mm

Bellarmine bottles, also known as Bartmann jugs, from the German Bartmann, 'bearded man', were manufactured throughout the 16th and 17th centuries, predominantly in Cologne, Germany. Witches adapted the bottles for a variety of uses, including making spirit houses (shelters for spirits that could cause problems for people if not appeased), or vessels to contain hexing (cursing) spells.

A common usage of such witch bottles was in defence against magical attack:

'Another way [to treat someone bewitched] is to stop the urine of the patient, close up in a bottle, and put into it three nails, pins or needles, with a little white salt, keeping the urine always warm: if you let it remain long in the bottle, it will endanger the witch's life, for I have found that they will be grievously tormented making their water with great difficulty, if any at all.' *Astrological Practice of Physick* (1671).

This Witch Bottle was found after the war, bricked into a wall of a bomb-damaged house in Plymouth, Devon. Inside the bottle are pins, hair, nail clippings, bird bones and a small piece of red coral. Cecil Williamson speculated that the filling and concealment of the bottle took place sometime between 1895 and 1912.

Brian Hoggard, an independent researcher studying the archaeology of folk beliefs, has recorded 213 English examples of these bottles via a survey he conducted from 1999-2001 and later accounts reported to his website www.apotropaios.co.uk. Of the 213 bottles on record, 97 bottles positively identified as 'bellarmines'.

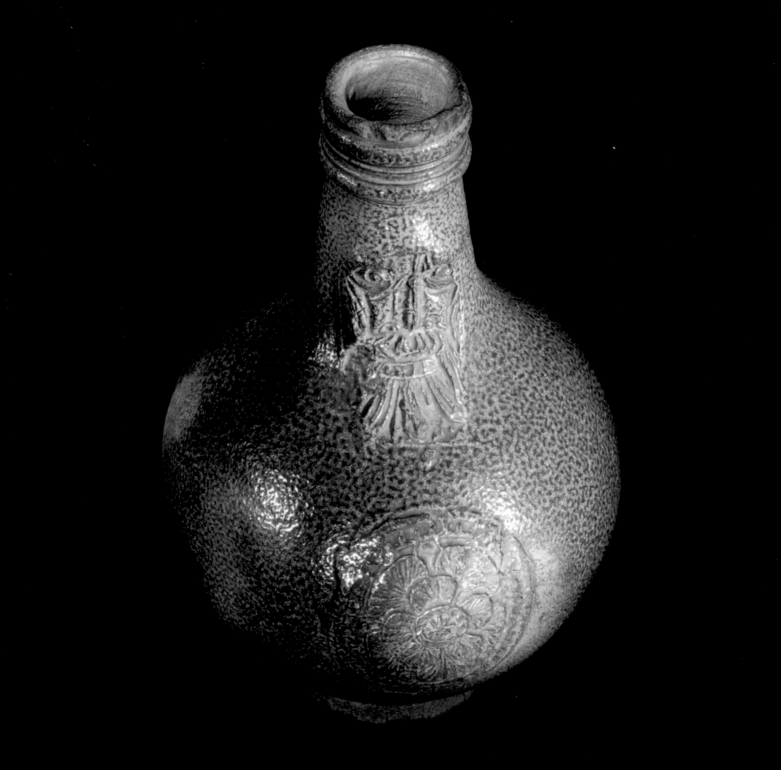

8. The Witch Family by Eleanor Estes

210 x 130 mm

Eleanor Estes (1906-1988) was an American author and children's librarian in Connecticut. She wrote *The Witch Family* in 1960. It tells the tale of two young girls called Amy and Clarissa who create a series of stories and drawings about an imaginary Old Witch. As the book develops, the boundaries between the girls' reality and those of their stories become blurred. At one point the girls are not able to return home, having been invited to the birthday party of one of their own characters. The book is testament to the power of a child's imagination to transform the everyday into the magical.

like to draw pictures," she said...
she said.

"Ah-h-h," said Old Witch in a...
voice as possible. "Ah-h-h, to gl...
flash she got Little Witch Girl som...
Also some paper.

So, the little witch girl came cra...
bed and sat down on the porch in...
pictures. She could rock and draw...
day wore on, she became accustom...
Witch and was not scared of her hch-...

Watching the little witch girl grad...
ease, the old witch slyly put forth...
"Betwixt now and Halloween," she...
that, well, that old biting bumblebee...

"What be the matter with you any...
Girl. "Always talking about bees...
bee in your bonnet?"

Old Witch grabbed off her h...
thought to shake this out. But...
it, and she went into the witch...

Tired of drawing, the little...
and picked up Old Witch's...
had left in the porch ye...
should fall out of it and...
rune concerning M...

Little Witch G...
this rune aloud...

that Old Witch was Head Witch of all witches? Little Witch
Girl still felt lonely. "Thank you," she repeated coolly. "And
I am a very sweet little witch," she said as if...
"and I never go outside the line coloring"...

A CIRCULAR HORSESHOE PLACED AMONG BUTTER
MAKING IMPLEMENTS WILL KEEP AWAY EVIL
INFLUENCES AND INSURE A GOOD WEIGHT OF
BUTTER. A HORSESHOE NAIL TIED TO THE CHURN
OR TUB IS USED FOR THE SAME PURPOSE.

9. Horseshoe

190 x 180 x 25 mm

Horseshoes currently appear on wedding cakes, key rings and greetings cards, and are generally regarded as a symbol of good luck. However in the past, horseshoes were set on the door or nailed to the main mast of a ship to repel witches. Indeed, Admiral Lord Nelson had a horseshoe nailed to the mast of his flagship 'Victory'.

Bad dreams, storms, disasters and diseases were often blamed on witches. The custom of hanging horseshoes over a doorway to prevent witches from entering the house is mentioned in *Miscellanies* (1696) by the English antiquary and natural philosopher John Aubrey (1626-1697). Aubrey uses astrological correspondences to assert that iron gives horseshoes their counteractive power. He explains that 'Mars/iron is hostile to Saturn/lead, and therefore to witches'. Iron was first found as a meteorite and was known by the ancient Egyptians as the 'Metal of Heaven', perceived as a gift from sacred powers.

The English folklorist Edward Lovett (1852-1933) in his book *Magic in Modern London* (1925) describes how a horseshoe was sometimes wrapped in red flannel and hung over the bed to protect against nightmares. He adds that a shopkeeper in Camberwell, south London, told him that 'practically all his friends did the same thing and that it was as the best cure for nightmares in the world'.

Since the 16th century, most accounts agree that a horseshoe fixed vertically should have the heel of the shoe point upwards to catch the good luck.

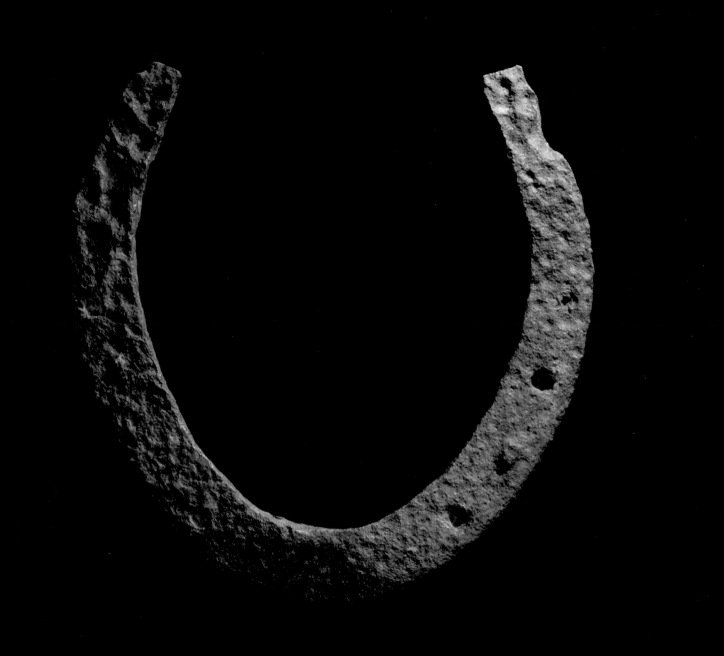

10. Nail Man Poppet

190 x 180 x 25 mm

The making of effigies for positive or negative effect is ancient and international. The word poppet is an older spelling of puppet from the middle English popet, meaning a small child or doll. In folk magic and witchcraft a poppet, also known as moppets, pippies and mommets, is a doll or puppet made to represent an individual, and used for casting spells on that person or assisting them through magic. Sir James Frazer in his book *The Golden Bough: A Study in Magic and Religion* (1890) defined this form of magic as sympathetic or imitative magic – 'like causes like' – whereby the action performed on the object represents the intended action on the person.

Potency is thought to be enhanced if the poppet is given the person's name or incorporates his or her blood, nail clippings, hair or clothing; Frazer defined this as contagious magic: the embodiment of the person provides a link through which he or she can be helped or harmed.

The violent insertion of iron nails into this figure implies the maker's intention to inflict pain and suffering on the person. Cecil Williamson describes the object thus: 'Male figure heavily stuck with pins from a French source made by a woman to be revenged upon a restaurant proprietor who had caused her daughter's pregnancy.'

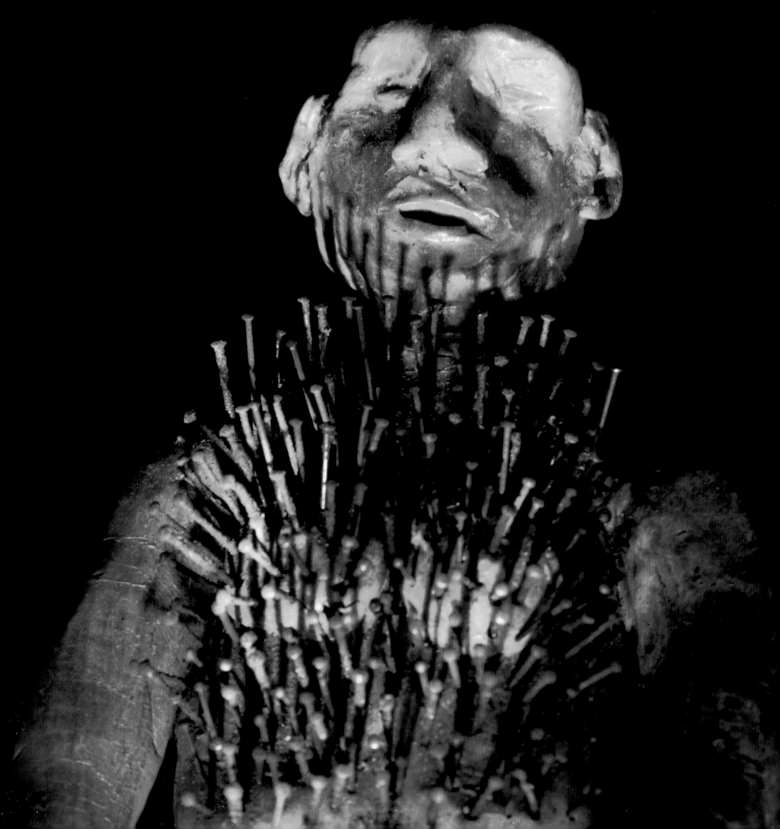

11. Love Charm

460 x 90 x 20 mm

According to Cecil Williamson this object is a:

'Sea witch love charm consisting of a wife's stocking, a red wax-covered shell resting on a scallop shell saucer and a certain substance, from Combe Martin, 1937'.

The inclusion of personal items such as clothing is common in both charms and curses. Unwashed garments are thought to be more potent, retaining a greater essence of the individual. Love charms usually involve binding items from the individuals concerned such as hair, nail clippings or bodily fluids.

Shells are considered an emblem of good luck because of their association with water, the source of survival and fertility. The anthropologist Mircea Eliade in his book *Rites and Symbols of Initiation: The Mystery of Birth and Rebirth* (1996) suggests shells are related to the moon and woman, and this notion is supported within Romani folklore.

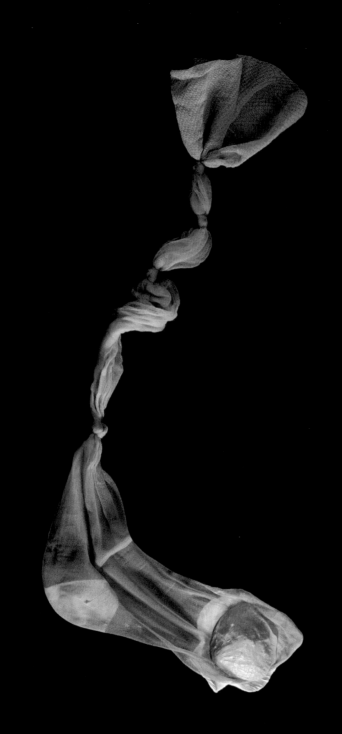

12. Mechanical Witch

170 x 260 mm

A 1980s replica of a Victorian mechanical automaton. When wound up, the witch's head nods gently back and forth, causing the rod attached to her hat to swing a small metal ball. The witch was found in the window of a pharmacy in London, the metal ball repeatedly rapping against the windowpane to attract passers-by.

The wise-woman or witch was once the provider of health remedies to the poor. Cultivating and recognising the properties of healing herbs, she could supply painkillers, digestive aids and anti inflammatory agents. Many of the herbal cures developed by wise-women still have a place in modern pharmacology. As quoted in *Witches, Midwives and Nurses* (1976):

'So great was the witches' knowledge that in 1527, Paracelsus, considered the "father of modern medicine", burned his text on pharmaceuticals, confessing that he "had learned from the Sorceress all he knew".'

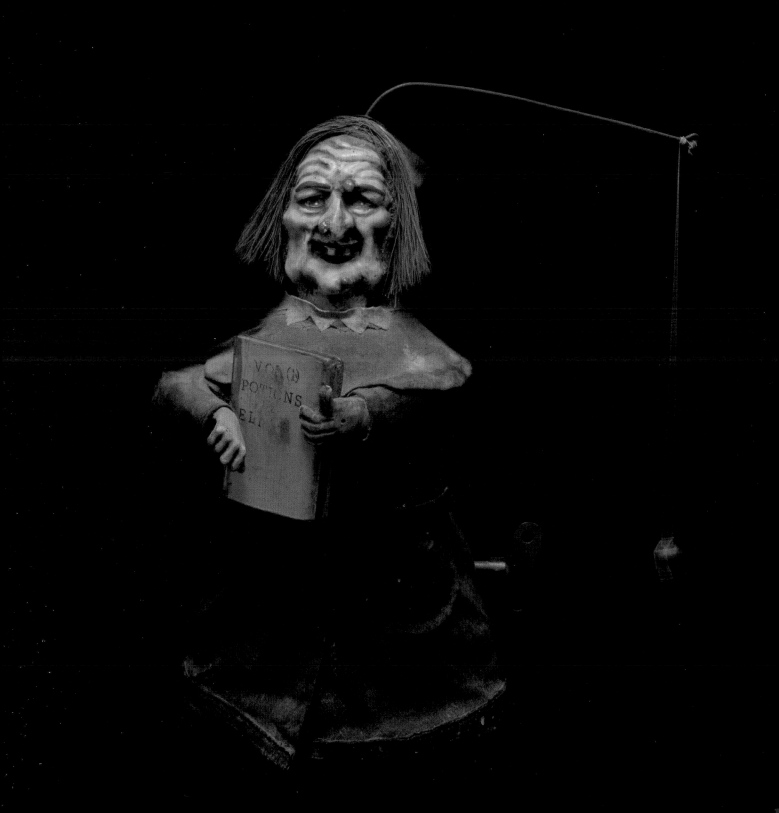

13. Three Keys on a Chain

125 x 30 x 70 mm

Keys, especially old ones, are thought to be powerful magical objects. It is said that three keys on a chain will bring health, wealth and love. The function of a key is to lock or unlock and so symbolically keys are thought to release or hide knowledge, opportunity or desire. Romani Gypsy lore states that if you carry a charm in the form of a key it will bring forth positive situations, help you learn secrets and have a good life. The use of keys as a protection charm is widespread throughout the UK. It is believed that to banish nightmares, a key must be placed under the bed, and – according to Robert Herrick's *Hesperides or The Works Both Humane & Divine* (1648) – to protect a child a key is placed in the cradle.

Keys are often given on Saint Valentine's Day as symbols of romantic love, with an invitation to unlock the giver's heart. The Roman priest Saint Valentine, commonly associated with love and marriage, is also recognised as the patron saint of epilepsy, which was once thought to be primarily a heart-related disease. In Italy on 14 February a special ceremony is held at the Oratorio di San Giorgio chapel in Monselice, where children are given a charm in the form of a golden key to protect them from epilepsy.

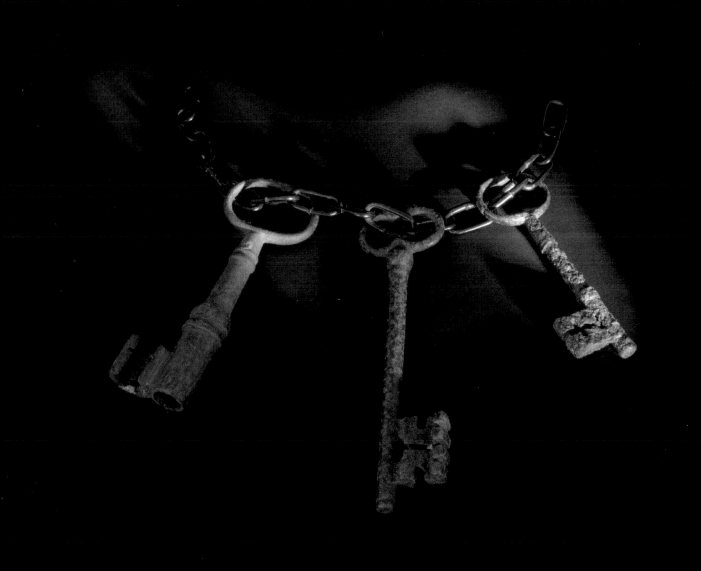

14. Shadwell Sham

100 x 125 x 10 mm

Cecil Williamson explains:

'This strange medallion came to the Witchcraft Research Centre with a long story. In brief, a winter storm, shipwreck and strange men speaking a foreign tongue rescued from the sea while others were lost and drowned. One of the rescued, as a token of thanks to his rescuer, presented him with this odd object. In no time at all it was reputed to have magical powers, and so many people sought its aid. This is understandable for the figure depicted upon it is every inch that of a traditional magician. Anyway, the local witch woman was quick to get her hands upon this bauble of money spinning potential. Eventually like most curios it came on the market. But it is not dormant – strange incidents continue to happen around it... In fact this is probably one of the ingenious forgeries made by Billy Smith and Charley Easton in the mid 19th century. They were Thames 'mudlarks' who realised they could get a high price for medieval artefacts such as pilgrim badges, and so started making their own, generally from lead or lead alloy and later brass. They produced thousands of objects before they were finally unmasked, and although they were taken to court the case against them could not be proved.'

Between 1856 and 1870 Billy and Charley cut into plaster of Paris with nails and knives to create moulds, finishing their 'cock metal' (a lead/copper alloy) counterfeit antiquities with acid to simulate the effects of age, then passing them off to auction houses.

Many scholars, including the Rev Thomas Hugo, Vicar of St Botolph's, Bishopsgate, believed them to be authentic. Initially the archaeologist Charles Roach Smith, unable to locate an original form from which the objects were copied, suggested that the 'finds' could not be forgeries. Later, in 1861, Smith Roach suggested the artefacts were devotional items dated from the reign of Queen Mary, imported to replace similar artefacts destroyed during the Reformation.

More recently it has transpired that Billy copied one design from a butter mould.

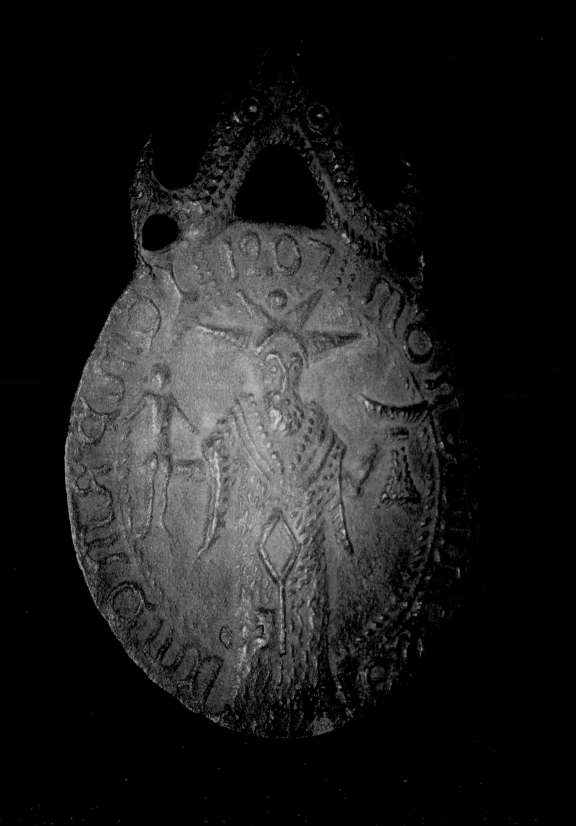

15. Hair with Yellow Ribbons

460 x 130 x 60 mm

The provenance of this object is unknown, though it is thought most likely to be a charm for a parted loved one. Hair is used in numerous traditional beliefs, cures, tales and divination practices. In many traditions, it is customary to keep a lock of a loved one's hair as a keepsake or memento. Charms that include hair are often used in binding spells to engender love. In contrast, as is told in the ballad 'Willie's Lady' (1912), a witch might prevent a woman in labour from giving birth by secretly knotting the ribbons in her hair.

The contemporary use of yellow ribbons is partly inspired by the 1973 hit by the American group Dawn, 'Tie a Yellow Ribbon Round the Ole Oak Tree'. In the song, the yellow ribbon signifies a 'welcome home' for the prisoner returning from jail. In recent years, the yellow ribbon has become a personal and political symbol of tribute, protest and loss, used in song, stories and ritual enactment.

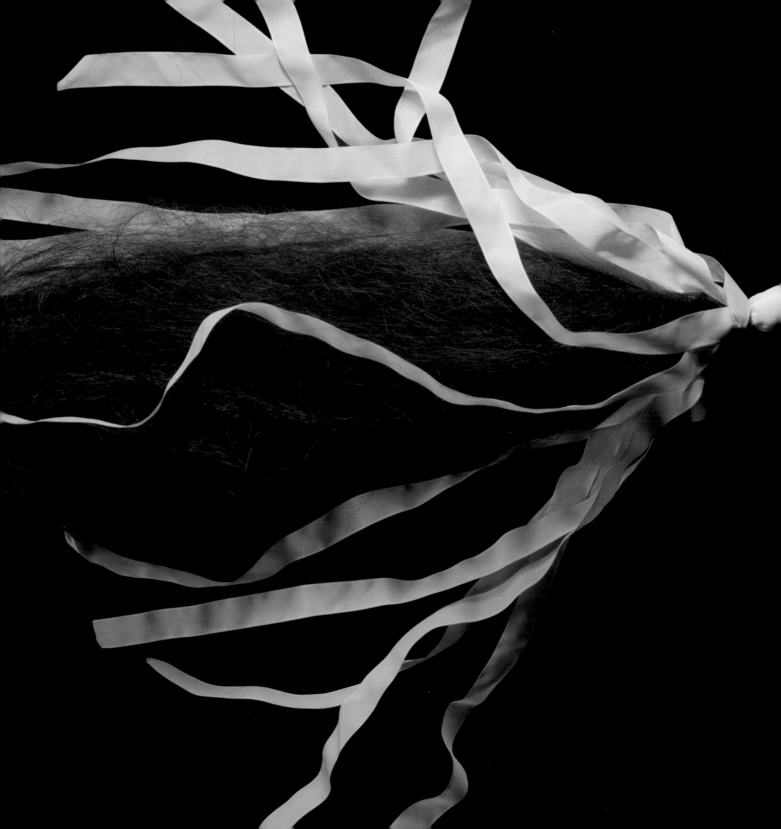

16. Healing Bottle

255 x 70 mm

A witch living in St. Lawrence, Bodmin in Cornwall, made this healing bottle. The original text by Cecil Williamson explains, 'Here we have a green bottle part-filled with curative herbs, some hair from the sick person and pins to prick and drive away the evil spirits of fever and sickness. All rather nice, at least the "green witch" is doing her best to help someone in distress.'

Bottles such as this were often concealed within the house of the person seeking protection. Most commonly secreted at thresholds or liminal places such as above or beneath doorways, within chimneys or buried under hearths. A surprising number have survived, predominantly from the 17th and 18th centuries, and their production by magical practitioners continues to this day.

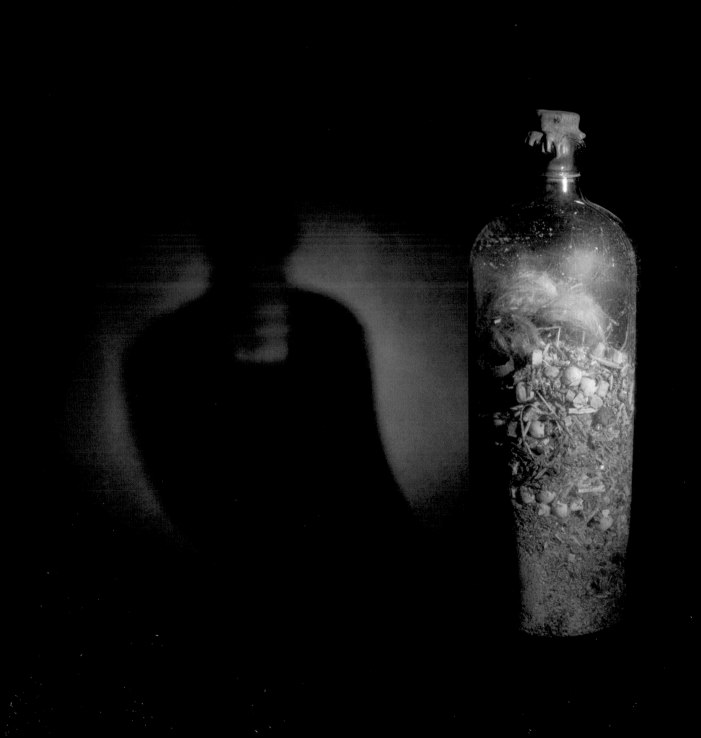

17. Glass Knitting Needles with Knitting

260 x 9 mm

According to Cecil Williamson:

'West Country witches retain a strong Celtic tradition in much of their spell making incantations, such as repeating a thing over and over and over again. So using witches' knitting needles, which must be blunt, thick and made of glass, they repeat the spell stitch by stitch. Black wool for cursing or revenge magic and other colours in keeping and related to the work in hand for beneficent magic making. When the spell is regarded as being really strong the knitting is taken off the needles and burnt.'

Museum documents indicated that in the 1800s bluntly pointed needles were sold at country fairs as 'the Devil's knitting needles'. The needles were regarded as charms to divine the presence of the devil and his assumed servants, the witches. Thirteen rows of thirteen stitches are knitted, leaving the thirteenth stitch of the last row incomplete. If anyone picks up the knitting and completes the thirteenth row, then it was believed that they were party to the devil.

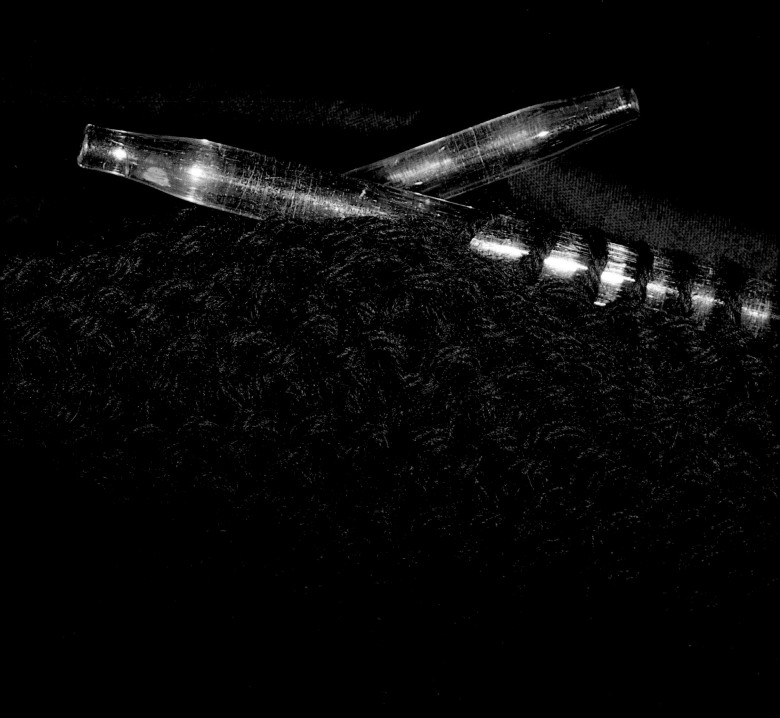

18. Antler Prickers

125 x 15 x 15 mm

These three antler tines belonged to a witch living in Devon and were used to make holes in the earth to plant seedlings and harvest herbs. Naturally-formed tools have been used in this way for centuries. Some contemporary Pagans use antler tines as a wand.

Antlers are a symbol of spiritual authority because they grow above the physical head, reaching towards the realm of spirit. They signify regeneration, because they die and grow back. In many traditions this characteristic has been revered and antlers are regarded as a symbol of the magical ability to renew.

The museum has five tines strung together, which collectively resemble human fingers, known as a Hand of Fate.

According to Cecil Williamson it is:

'The dreaded witches hand of fate. Five fingers formed of horn − spoken to and then cast with violence upon the bare ground. From the position of the horn fingers as they lie upon the ground a reading is made and a verdict given.'

The folkorist Steve Patterson has identified the most probable maker as a mid-20th-century resident of Parracombe known locally as a witch − one Ms Boxer, or 'Old Boxey'.

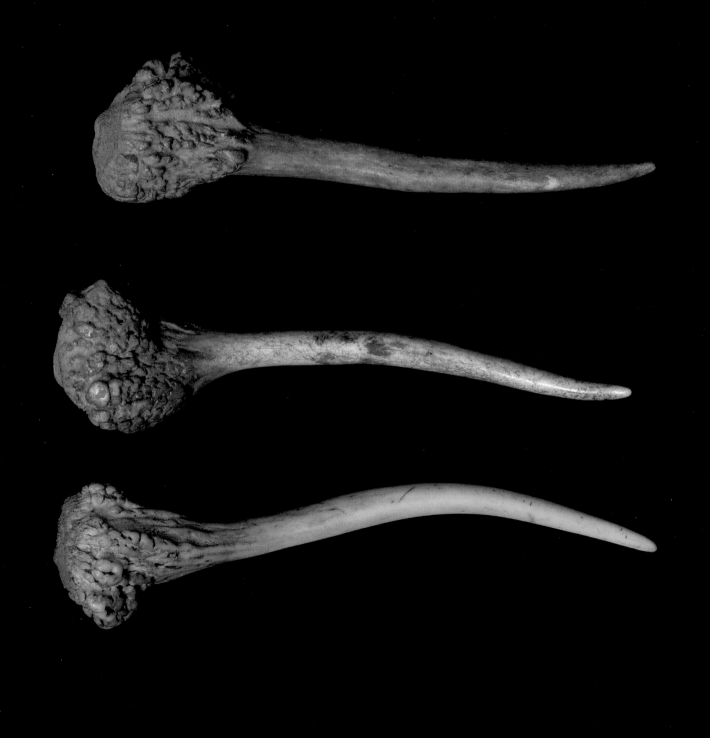

19. Hitler Pincushion

120 x 90 x 45 mm

The Hotzi Notzi pincushion was sold for sixty-nine cents by Johnson & Co, and originally came with a label, which reads, 'It is good luck to find a pin, Here's an 'Axis' to stick it in.' The pin cushion was copied from a similar popular image of 'Kaiser Bill' (the German emperor Wilhelm) sold in the First World War. Several variations of the Hitler pincushion were sold in the United States during the Second World War. They became increasingly popular after President Roosevelt acquired one for his desk. In Chicago, there even existed a 'Stick-a-pin-in-Hitler Club': a curious 20th century use of an old magical practice.

In March 1941 the popular magazine *Reader's Digest* ran an article entitled 'Hexing Hitler!' encouraging the British public to make Hitler dolls and to stick pins into them. It was suggested that the following chant (provided by the occultist William Seabrook)

be repeated during the ritual. Islan was a pagan god worshipped in Central Europe in the Middle Ages.

Islan, come and help us,
We are driving nails and needles,
We are driving pins and needles,
In to Adolf Hitler's heart.
We are driving nails and needles,
We are driving pins and needles,
Cats will claw his heart in darkness,
Dogs will bite it in the night.

A reader of the magazine, Fred W. Schultz, responded to the article by suggesting that the International Ladies Garment Workers Union could design and mass-produce such a doll accompanied by hexing instructions.

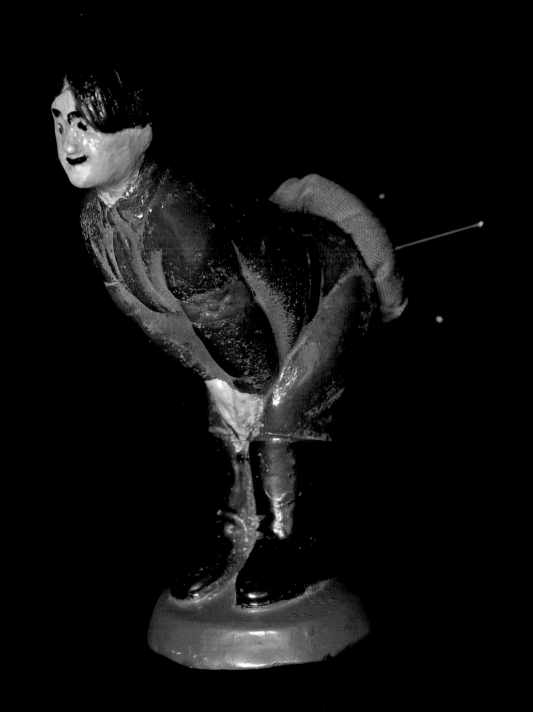

THIS IS A NASTY ONE, BEING PURE BLACK
MAGIC TO ILL WISH. THE PRINCIPAL ITEMS
ARE IN THREE PARTS, THE STRANGE MADE-UP
ITEM OF THREE HOOKS AND THE DOUBLE WIRE
RING SUPPORTING TWO ROWS OF FACE MASKS.
WHEN BEING USED THE SORCERER ROTATES
THE WHOLE THING SLOWLY AS HE INTONES
HIS RITUAL CURSINGS. IMPALED ON THE
HOOKS ARE LIVING ANIMALS, SUCH AS THE
FROG SHOWN (AND THE LAST VICTIM TO SUFFER)
BELOW IS THE HUMAN SKULL SET ON A WHITE
DISH IN A DRESSING OF DRIED HERBS. THE
FROGS DIE AND THE FLUIDS OF DECAY DRIP
DOWN ON TO THE SKULL TO RUN DOWN AND
SATURATE THE HERBS. THESE ARE THEN USED
IN A CERTAIN WAY AGAINST THE INTENDED
VICTIM.

20. Dried Toad Charm

370 mm high

In 1938, this mysterious contraption was discovered concealed in a chimney during a house renovation in Axminster.

It was suspended about nineteen feet above hearth level and some five feet down from the top of the stack, presumably fixed in position from outside on the roof ridge.

The purported curative powers of toads include remedies to treat cancer, plague, rheumatism, sprains and whooping cough among others. In medieval Britain the natterjack toad was thought to possess a jewel buried in its head that could counteract poisonous bites and help women in childbirth. In Scarborough Museum there are two toads, each hung in a fabric bag, found in 20th century Devon cottages, allegedly to keep out witches.

Of the many small animals mentioned in witchcraft records, mice and toads are commonly used as the witch's familiar. Supposedly nurtured by the witch's blood, these creatures were thought to embody diabolic spirits, which acted on behalf of the witch. In Somerset there are tales of witches threatening, 'I'll toad 'ee!' It was believed that a witch must pass these animals on to someone before she dies.

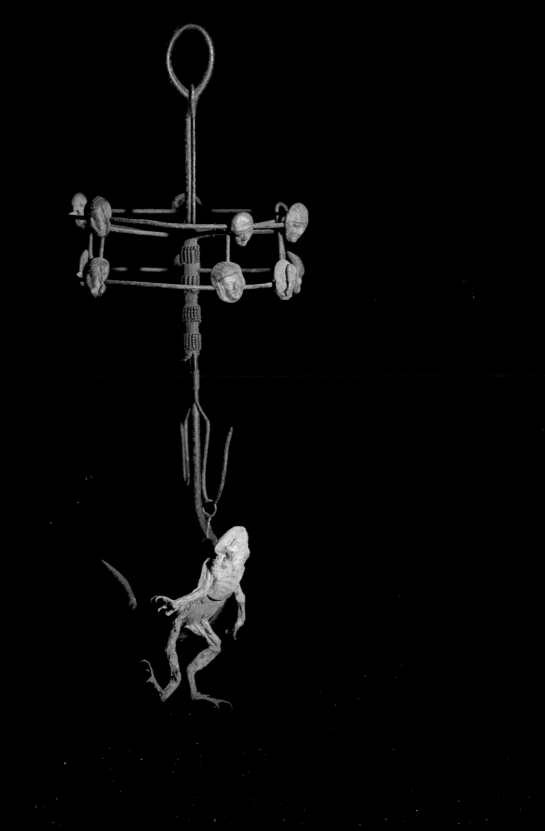

21. Horn Cup

125 x 50 mm

Horn is most commonly associated with strength and power. The psychiatrist Carl Jung suggests that horn is a dual symbol of both male and female; while the penetrating shape is considered active and masculine it is also shaped like a receptacle, which is feminine in attribute. Unlike antlers that shed and regrow, horns start to grow at birth and become larger throughout the life of the animal. Drinking horns are bovid horns removed from the bone core, cleaned and polished and used as drinking vessels. The cornucopia or horn of plenty originates from classical antiquity as a symbol of abundance and nourishment, commonly represented as a large horn-shaped container overflowing with produce, flowers or nuts. It has been suggested that the shape of a natural horn was also the model for the rhyton, a horn-shaped drinking vessel (**see item 86**).

This horn beaker belonged to Magelee of Northam. The incised decoration includes the year 1870.

Cecil Williamson explains:

'Horn is a product of a living animal, so it has spirit force. A bowl or cup fashioned out of horn has a certain power within it. The witch makes use of this power when mixing and blending her powders and potions.'

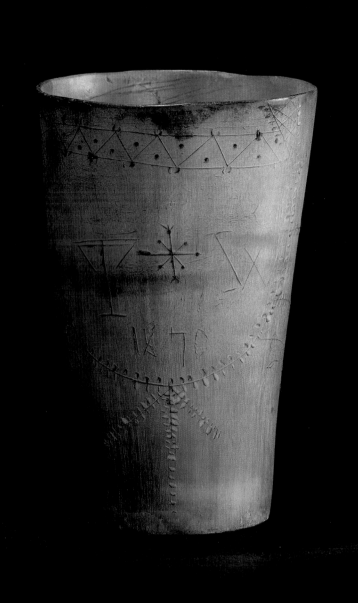

SNAIL SHELLS HAVE BEEN USED AS LOVE
CHARMS SINCE THE DAWN OF TIME. THE SNAIL
IS WELL KNOWN FOR ITS "PASSIONATE NATURE"
AND ENJOYMENT OF THE ACT OF LOVEMAKING.
HENCE, AMONG COUNTRY FOLK AWARE OF THESE
FACTS, IT HAS BEEN THE CUSTOM FOR A MAN
TO MAKE UP ONE OF THESE LOVE CHARMS AND
HANG IT AT NIGHT OUTSIDE THE DESIRED
ONE'S WINDOW. WHEN DISCOVERED, THE LADY
KNOWS FULL WELL THE MEANING OF THE CHARM.
WHAT DOES SHE DO? - BEING A WOMAN AND
FULL OF CURIOSITY, USUALLY SHE TRIES TO
DISCOVER HER "SECRET ADMIRER".

22. Dough People

100 mm high

In Britain, dolls, effigies or poppets are occasionally found hidden in buildings. While many of the objects concealed in liminal places are believed to prevent evil forces from entering, other reasons might have motivated the concealers. Scholars of folklore and archaeology agree that the location of deposition is not always indicative of purpose. Cecil Williamson suggests that:

'This is real Cornish witchcraft. The figure of a countrywoman flanked by a fisherman and a miner, in front a gold painted snail shell. As they say around here "trouble at her crossroads".

'This little lot were found secreted on the top side of a big old roof beam in a cottage at Portreath.'

23. Devil Head Incense Burner

370 mm high

During the Victorian era, devilish motifs and hybrid creatures featured on a variety of objects including trays, mirrors, candlesticks and furniture. This 'Devil Head Incense Burner', possibly influenced by the Roman satyr-head oil lamps to which it bears a resemblance, also reflects the Victorian love of Gothic imagination. Although the design was originally playful, due to the presence of a horned figure, contemporary occultists often incorporate these objects in their rites.

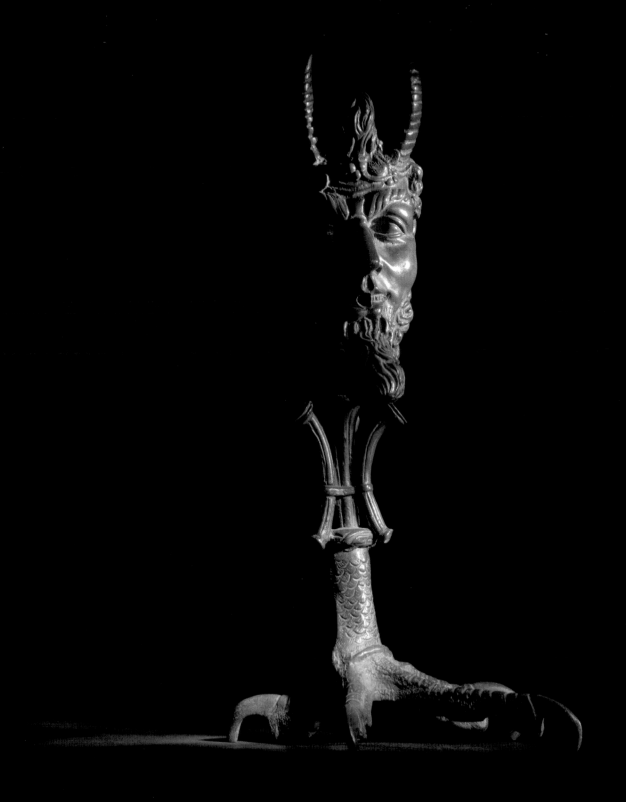

24. Stewart Farrar's Pentacle

150 mm diameter

This brass pentacle belonged to the occultist and author Stewart Farrar (1916-2000), who was instrumental in the development of Wicca. The pentacle is engraved with Wiccan symbols: the waxing and waning moon crescents and the circle topped with a crescent represent the Moon Goddess and Horned God respectively. 'S' symbolises a kiss, and 'S' with a line symbolises the scourge, reflecting mercy and severity. Triangles and a small pentagram represent the three degrees of initiation with each motif signifying different attributions to different groups.

In Wicca, the pentacle represents the element of earth. It is often the centrepiece of the altar on which objects are placed for consecration or blessings. The five-pointed star pentagram is regarded as the mark of the magician and the primary symbol of the Craft, often used as a protective symbol when summoning or banishing spirits. To Gnostics and Neoplatonists, it symbolises the perfect universe, the four elements plus spirit.

25. Kern Baby in a White Dress

420 x 220 x 100 mm

Kern Babies or Corn Maidens were once a common sight at the end of the harvest period. Traditionally they were made from the last sheaf of corn gathered from the harvest and were occasionally dressed in a child's christening gown or with decorations cut from paper. In some villages, they were paraded through the streets and subsequently placed in the last pew of the local church, sometimes with an apple in their pocket. Alternatively the dolls were kept until the next sowing time when they would be burnt and the ashes scattered over the fields to ensure a good harvest for the coming year.

In *The Statistical Account of Scotland* (1797) a report from Perthshire gives a colourful account of harvest celebrations:

'It was, till very lately, the custom to give what was called a Maiden Feast, upon the finishing of the Harvest; and to prepare for which, the last handful of Corn reaped in the field was called the Maiden. This was generally contrived to fall into the hands of one of the finest girls in the field, was dressed up with ribands, and brought home in triumph with the music of fiddles or bagpipes. A good dinner was given to the whole band, and the evening spent in joviality and dancing, while the fortunate lass who took the Maiden was the Queen of the Feast; after which this handful of Corn was dressed out generally in the form of a Cross, and hung up with the date of the year, in some conspicuous part of the house. This custom is now entirely done away, and in its room each shearer is given 6d and a loaf of bread. However, some farmers, when all their Corns are brought in, give their servants a dinner and a jovial evening, by way of Harvest Home.'

26. Eye of Horus Amulet

13 x 17 x 4 mm

Known as the wedjat eye, this faience protective amulet is associated with Horus, the Egyptian god of the sky. The drop and spiral below the eye imitate the markings on a lanner falcon, the bird sacred to Horus. The name wedjat means 'the sound one' and refers to the left eye of Horus, which was plucked out by his rival Set, the god of chaos and confusion, during their battle over the throne. Hathor, the goddess of love and motherhood, healed the wounded eye. Subsequently the wedjat came to symbolise the healing process and that of 'making whole'. The waxing and waning cycle of the moon is thought to reflect Horus losing and regaining his sight. Wadj also means 'green', which symbolised regeneration to the ancient Egyptians. Horus first used the wedjat as an amulet when he restored life to his father Osiris, the god of the underworld. Widespread belief in the regenerative and protective powers of the amulet meant that it was placed among the wrappings of numerous mummies and worn as jewellery by the living.

27. Pendulum

50 x 40 mm (widest), chain: 170 mm x 1 mm

A handcrafted pendulum made with a cabochon amethyst on a polished pewter chain. A pendulum is one of the most commonly used tools for divination and dowsing. Amethyst is thought particularly conducive to developing clairvoyance. The device is said to work by tapping into the practitioner's intuition and sixth sense. It can act as a form of receiver and transmitter, from higher guidance, guardian angels and spiritual teachers.

Held lightly between thumb and forefinger the pendulum can swing freely in any direction, back and forth, side to side, with circling or elliptical oscillations. This swing or gyration indicates the answers to 'yes' or 'no' questions.

A pendulum can also be used for healing purposes, to cleanse and dispel negativity in a room, to retrieve lost objects or to find water. Like a dowsing rod, the pendulum is regarded as an amplifier for the user's involuntary physical movements reacting to the sensory perception of 'rays' or 'radiation' – this is known as radiaesthesia.

THROUGHOUT THE SOUTH WEST THESE OLD TIME
IRON CAULDRONS OR SIMMERING POTS ARE
STILL USED IN THE "BREWING UP" OF A
WIDE RANGE OF MAGICAL PREPARATIONS. THE
REASON FOR THIS BEING THAT IT IS STILL,
THE BEST TOOL FOR THE JOB.

28. Cauldron

350 x 460 x 400 mm

The cauldron is a tool for magic, a receptacle for the forces of transmutation and germination, and its role in spellcasting is ancient. The Roman poet Ovid describes the witch Medea heating a potent mixture in a bronze cauldron. Her carefully chosen ingredients include herbs, precious stones, flower heads, dark juices, ocean sands, hoar frost collected by moonlight, the wings and flesh of an owl, the skin of a water snake, an old stag's liver, and the eggs and head of a crow that has lived for nine human lifetimes. With these and 'a thousand other nameless things', she restores youth to Jason.

In her book *Practical Magic: A Book of Transformations, Spells and Mind Magic* (2003) Marian Green explains that the cauldron is a meeting point of the four elements. The iron pot represents the element of earth, the fluid it contains is for water, the burning wood below is for fire and the rising steam represents air. Modern witches sometimes light a candle in a small cauldron to represent the hearth fire. In Wicca, the cauldron is a feminine symbol; according to Gerald Gardner's Book of Shadows, the cauldron of Cerridwen is the 'Holy Grail of immortality'.

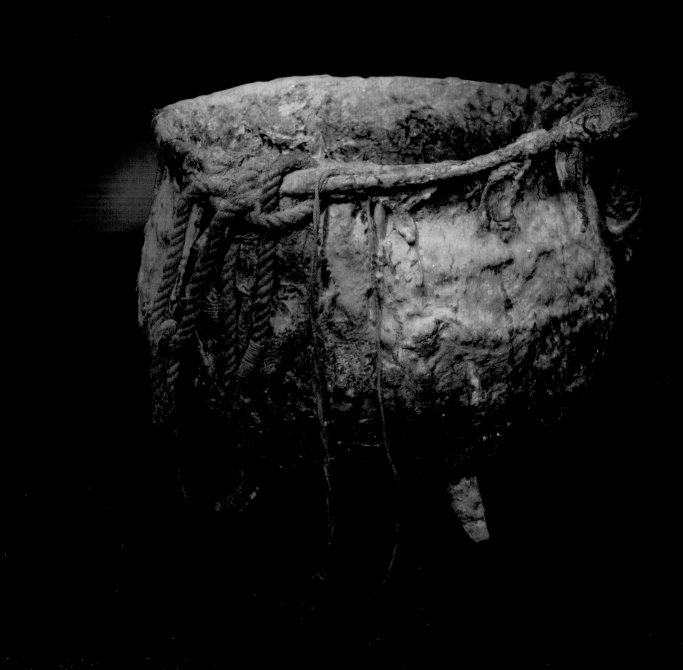

FOSSILISED SHARK'S TEETH.
COUNTRY FOLK HAVE ALWAYS HELD THESE IN
HIGH ESTEEM FOR THEIR MAGICAL POWER.
OFTEN THEY ARE MISTAKENLY CALLED ELF
SHOT,WHICH IN FACT ARE PRE-HISTORIC
FLINT ARROW HEADS.THREE EXAMPLES OF
WHICH ARE SEEN HERE,AND CLEARLY SHOW
THEIR SIMILARITY IN SIZE,SHAPE AND
FORM TO THE FOSSILISED SHARK'S TEETH.
WITCHES HAVE ALWAYS USED ELF SHOT AS
A MEANS OF ILL WISHING CATTLE.WITH
FINGER AND THUMB THEY SPRANG THE FLINT
ARROW HEADS AGAINST THE FLANKS OF THE
BEAST.SOON AFTER THE ANIMAL WILL BEGIN
TO AIL.

29. Sharks' Teeth

100 x 75 x 25 mm

These fossilised sharks' teeth belonged to Granny Rowe, who lived in Bridport from 1902-17. She used the teeth for a range of castings and charmings, from fortune telling to curing chilblains. Sharks teeth were also worn to repel the evil eye. Seeing a shark following a ship was an unlucky omen for sailors who believed the fish could 'smell' sickness on board and was thus waiting for a death. Originally there were forty teeth in a sacking bag. Unfortunately, some of the teeth and the bag were lost during the flood in 2004.

YOU CAN KEEP YOUR CLOCKS, WATCHES AND DIGITAL
LIGHT AFFAIRS. FOR THE WITCHES WORKING IN THE
SOUTH WEST INSIST ON SEEING THEIR TIME PASS.
FOR SEEING TIME FLOW BY, THERE NEVER HAS BEEN A
BETTER INSTRUMENT DEVISED BY MAN THAN THE SAND
GLASS. WHEN A WITCH IS BUILDING A SPELL,
CREATING A POTION OR IS ENGAGED IN SOME MAGICAL
OPERATION, THE TIME FACTOR PLAYS AN IMPORTANT
PART IN EVERY STAGE OF THE OPERATION. EXAMPLE,
TO STIR THE CAULDRON ANTI-CLOCKWISE FOR TWO
FALLS OF THE SAND. YOU SEE, WE ARE AGAIN MAKING
USE OF SPIRIT FORCE.UNLIKE THE MECHANICAL
MECHANISM OF A CLOCK WITH ITS TICK-TOCK-TICK,
THE SILENT KNIFE-LIKE MOVEMENT OF THE SAND AS
IT STREAKS DOWNWARD IMPARTS A SENSE OF LIFE AND
OF A LIVING THING MOVING WITHIN. SIMPLY PUT,
THE WITCH IS WORKING WITH A VISUAL SPIRIT FORCE.

30. Hour Glass

150 mm high

This hour glass is made from mahogany with four turned supports. The connecting glass bulbs contain sand that takes an hour to pass from the upper to the lower bulb.

The timing of spells is of great importance to many witches, particularly to practitioners of high magic, for whom the days of the week have astrological and mythological meanings. For instance it is thought advantageous to carry out spells aiming at obtaining prosperity or power on a Thursday, which corresponds with Jupiter, and to carry out love spells on a Friday, which is associated with Venus.

31. Horse's Skull

530 mm long

This particular skull came from a farm in the Drewsteignton area in Devon where it had hung high up on the cross beam of the main barn. In the UK horses' skulls have occasionally been found in chimney breasts, and beneath doorways or floors in houses. It was thought that in a house, points of entry such as doors, windows and chimneys were the most prone to witchcraft and must be guarded. It is also believed by some that a horse's skull has acoustic properties and can improve resonance for music making. Ellsdon church in Northumberland has three skulls in its bell tower, suggesting the skulls may function in the same way as the bells, to scare away malevolent spirits, or perhaps there is support for a belief in the skulls' acoustic properties.

Horses were thought particularly vulnerable to supernatural attack; their night sweats were interpreted as hag riding by witches or fairies. The animal's resistance to moving at certain times was interpreted as sensitivity to the presence of evil, or an awareness of sites where hauntings or violence had occurred. Secret ways of controlling horses were developed by farmhands, apparently using magical ritual and substances to attract or repel. It was said that cunning folk could immobilise a horse with a word.

32. Witch Ball

400 mm high, 760 mm circumference

Glassmakers in Nailsea, Bristol manufactured these reflective glass balls from 1788 until 1873. Suspended in a window or dark corner, the witch ball is said to protect the household from the evil eye by reflecting away or absorbing any ill fortune. The ball is said to grow dull if there is ill wishing 'in the air' and so must be watched for warnings and regularly wiped clean. Hence, the witch ball was also known as a 'watch ball' or 'wish ball'.

Pliny and other classical authorities wrote about the accepted belief that disease or death can be inflicted by the evil eye. Human sight was thought to be an active process, with the eye emitting actual rays. Emotions such as anger or envy transformed these rays into a magical force that could inflict disease on a person or animal. Throughout medieval and Elizabethan times the evil eye, also termed 'eye biting', 'fascination' or 'overlooking', was regarded as witchcraft.

Witch balls are currently sold commercially in the UK as 'friendship balls' or 'sun catchers', silvered in various colours or decorated internally with elaborate swirling patterns.

33. Blackthorn Blasting Rod or Wand

890 x 80 x 70 mm

This is an example of old magic. The Blackthorn is often depicted in European fairytales as a tree of ill omen and its thorns are used as pins to stick into a poppet (**see item 10**). Blackthorn often grows near sacred wells and is associated with access to the Otherworld, and its protective powers.

A blasting rod, as its name implies, is most commonly used to direct negative energy or to cause harm to others. Blasting is sometimes considered the best form of defence. This blasting rod was among the magical objects donated to the museum by the occultist Iain Steele. It is made from a single branch of blackthorn, which has divided into three stems, twisted together into a helix, and joined together at the end. Once dried out the rod was painted black, then varnished and tied with dark red ribbon. According to Michael Howard, an authority on witchcraft and magical practices, this rod 'is old and may have come from Norman Gills or some other Old Craft source.'

A wand is a tool with which to direct the user's will or intention; certain wands suit different purposes, practitioners and traditions. The occultist Major Thomas Weir had a blackthorn walking stick, topped with a carved satyr's head. When he fell ill in 1670 and confessed to a life of sorcery, he was burned at the stake along with his stick, which was said to make 'rare turnings' in the flames.

Since 1642, the Gentleman Usher of the Black Rod has struck his blackthorn rod three times against the doors of the House of Lords to gain admittance to the annual State Opening of Parliament in the UK.

34. Cornish Piskie

40 x 25 x 10 mm

Britain has a rich history of fairies, piskies, elves, gnomes and goblins. This brass Cornish piskie (or pisky) was originally sold as a lucky charm. In the Southwest, piskie or pixie refers to a supernatural being with magical powers, somewhat akin to a fairy. In Devon and Cornwall piskies are sometimes thought to be the ghosts of unchristened children or the souls of pagans or druids.

In Ottery St Mary in Devon, Pixie Day is celebrated to commemorate the midsummer's day in 1454 when the town managed to 'rid itself' of its Pixie menace. Legend has it that the local pixie clan did not take kindly to the early monks who came to build a church in what was then called Otteri. On hearing that the monks would be escorting church bells from Wales, the pixies cast a spell over the entourage and instead of taking the road to Otteri they were led to the cliff edge at Sidmouth. In a trance, the priests were about to plunge to their deaths when one of them stubbed their toe on a rock and uttered, 'God bless my soul' and the spell was broken. The pixies later imprisoned the bell ringers in the Pixies Parlour, a local cave, but the Vicar of Ottery St Mary rescued them. Each year the local Cub and Brownie groups re-enact the story.

The folklorist Katharine Briggs presented a body of evidence for the belief in fairies using the term to cover a wide range of forms, characteristics and attributes. In her book *A Dictionary of Fairies* (1976) she explains that piskies can appear in a flickering light, and can cause people to be 'pixie-led' – losing their way even in a familiar neighbourhood. Piskies can be solitary or social; the latter can be seen circle dancing. Like poltergeists they can play tricks, cause strange noises, tangle horses' manes and make them sweat. They can also steal children. A single piskie, however, can be helpful like a brownie, but will cease working if spied on, given clothes, mocked or thanked.

Pixie fine, Pixie gay!
Pixie now will run away.

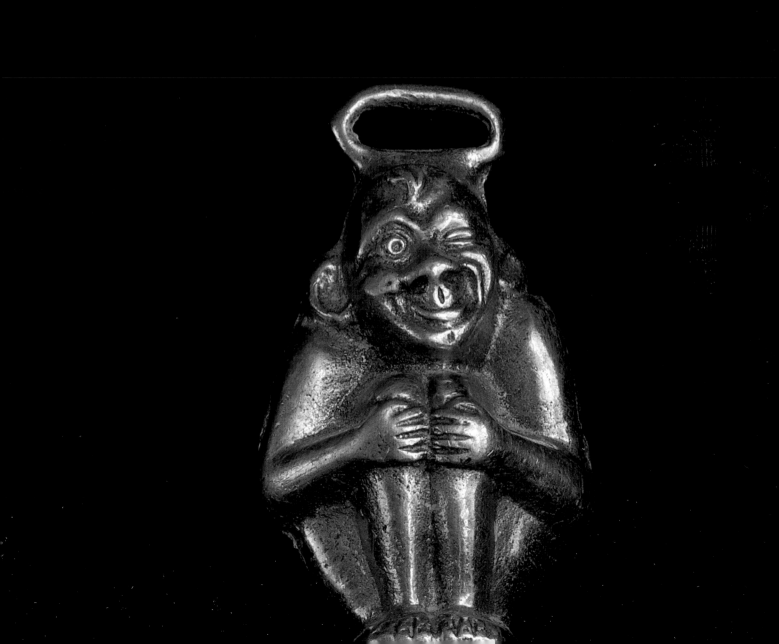

35. Invocation

240 x 95 x 10 mm

Occultists have written and consulted magical texts for centuries, the earliest examples coming from ancient Mesopotamia and Egypt. With the advent of the printing press came the publication of books of spells sometimes known as grimoires from the French word grammaire (grammar). Just as grammar contains the rules and uses of language, a grimoire contains the rules to magic. These ancient magical tomes contain detailed instructions on the use of spells, the conjuring of spirits, angels and demons, and the making of charms and talismans.

Many grimoires, such as alchemists' texts, were encoded to protect authors and publishers from persecution and were thus comprehensible only to initiated adepts. Existing grimoires are translations, copies, compilations or adaptations of lost works, and only a few, such as Samuel Liddell MacGregor Mathers' transcription of *The Key of Solomon and The Lesser Key of Solomon* (1888), are considered standard authorities.

The modern witch's equivalent of the grimoire is the Book of Shadows, a record of an individual witch's personal spells, rituals and knowledge, usually handwritten, sometimes with the intention of passing it on from one person to another. Modern Wicca and various Pagan groups actively preserve this tradition.

This Book of Shadows belonged to the witch Brownie Pate (1922-2006). It contains information about voodoo and the featured page shows a musical invocation consisting of a collection of notes arranged alphabetically.

Brownie met Cecil Williamson in Cornwall where she was working as a ballet teacher. When the press identified her as a witch she was accused by the local Christian community of being a 'corruptor of the young'. Forced to move, Brownie relocated to Lancashire where she became well known for her tarot readings at local fairs. On hearing that Cecil had retired and was not in good health, Brownie moved to be near him. When Cecil died, he left Brownie several magical objects. Subsequently Brownie became friends with Graham King, who was the museum owner and curator from 1996-2013. In 2006, Brownie bequeathed to the museum all of the items she inherited from Cecil and many of her magical tools.

The Legba invocation

Invocation to Ybo.

Y-bo lé-lé Y-bo lé-lé, Sang Y-bo

ça oupo té pou-moin Y-bo, cé môin ou ové...

It means "Ybo, the hour has come! This is the hour of blood, Ybo! What can you bring me, Ybo? It is I whom you are...

Drum 4/4 ♩= p 3

36. Garland Headdress

50 x 650 x 30 mm

Adorning the head with flowers is part of many traditional festivals, rituals and ceremonies, seen as a mark of honour, a tribute or as a union with the forces of nature.

In the past, gathering flowers and greenery to make garlands and decorating public buildings and homes to welcome in the season was common practice. 'Going a-Maying' was banned in the Cromwellian period due to the amorous activities of young people unchaperoned in the woods. The term 'green gown' was a well-known metaphor for what young women received for lying on the floor with their lovers.

The custom of Bringing in the May was re-instated after the Restoration and is practiced today during Mayday garlanding customs in Bampton, Helston and Castleton among others, and the elaborate costumes of Jack-in-Green celebrations throughout the UK.

Many communities participate in the various folk traditions that mark the changing seasons, solstices and equinoxes. A veneration of nature and a desire to embody the seasonal spirit is often reflected in the costumes worn. Some modern Pagans also perform sacred rituals and ceremonies at the annual cycle of eight seasonal festivals commonly referred to as The Wheel of the Year. Each period is associated with certain events, although celebrations by different sects can vary in date and name. Yule (20-23 December) is a midwinter festival observing the rebirth of the sun, marking the last month of the old year and the first month of the New Year. Imbolc (1-2 February) marks the beginning of Spring. Ostara (19-22 March) is a time of fertility. Beltane (1 May) is associated with the beginning of Summer. Midsummer (19-23 June) is the turning point when the day is longest. Lughnasadh or Lammas (1 August) is the first of the three Wiccan harvest thanksgiving festivals. Mabon (21-24 September), the Autumn Equinox, is the second harvest festival. Samhain (1 November) is the last of the harvest festivals and a liminal time when it is believed to be easier to communicate with the dead.

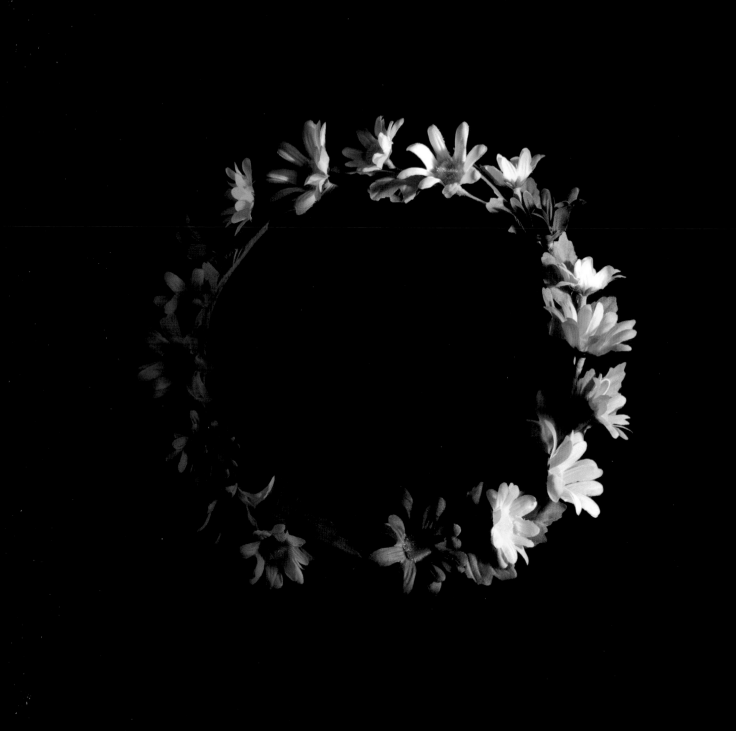

37. Snow White Witch

70 x 70 x 70 mm

A small plastic model made by Walt Disney Productions replicates the Evil Queen as the Wicked Witch from their first full-length animated film, *Snow White and the Seven Dwarfs* (1937). Unlike the original Brothers Grimm story (1812-14), where the Evil Queen disguises herself as an old woman, in the film she uses magic to transform herself into a stereotypical Wicked Witch or Old Hag. She then coaxes Snow White to take a bite from an apple laced with poison.

The Evil Queen was created by Art Babbitt, Joe Grant, Bob Stokes and Walt Disney, and voiced by Lucille La Verne. The inspiration for the design came from several film characters including Princess Kriemhild from *Die Nibelungen* (1924), and actresses such as Joan Crawford and Gale Sondergaard. Her transformed appearance as the Wicked Witch draws heavily on the stereotyped image established during the witch trials of an old woman, clothed in black – her ugliness seen as a measure of her long-term practice of evil.

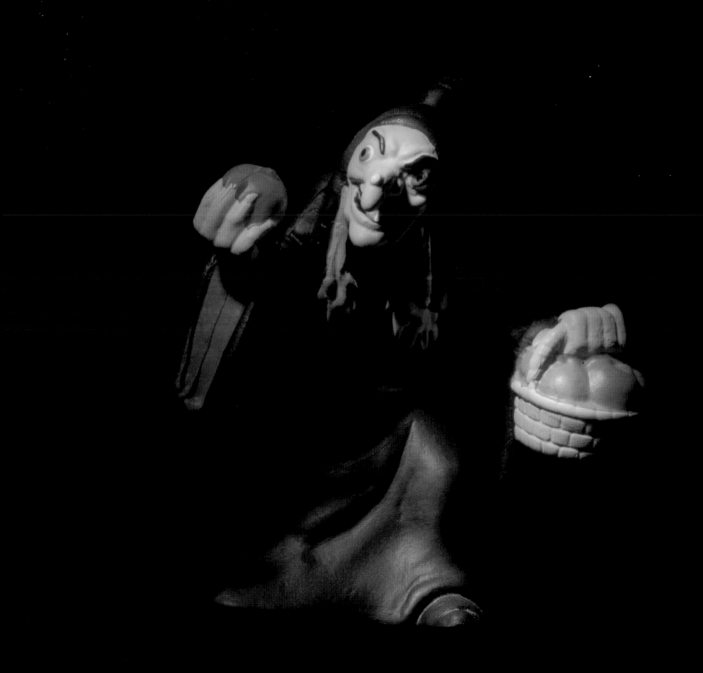

38. Ritual Skull

330 x 330 x 130 mm

This ram's skull of unknown provenance was found at Cecil Williamson's home after his death – it might have been with him at the Centre of Witchcraft and Superstition on the Isle of Man. Painted markings on the skull combine esoteric symbols – a pentagram and a downward pointing triangle – with colourful decorative embellishments.

Cecil believed in the spirit world and that objects retain a spirit presence:

'To the witch, the spirit world is a reality, a living thing. To her everything has a spirit, a soul, a personality, be it animal, mineral or vegetable. That is why to us in the Southwest, we believe in the little people. Oh, you may laugh, my fine up country folk, but beware for indeed you are in the land where ghoulies and ghosties and long-legged beasties still romp, stomp and go bump in the night. Come, let us show you what the witches and their spirits do...'

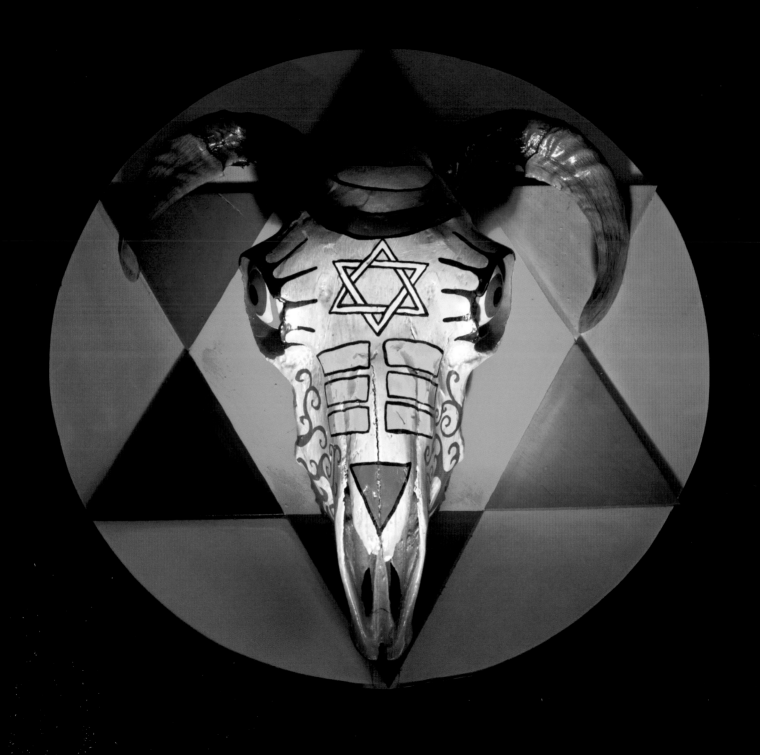

39. Golden Dawn Wands

1000 x 25 mm

In 1888 William Robert Woodman, Samuel Liddell MacGregor Mathers and William Wynn Westcott formed the Hermetic Order of the Golden Dawn in London. They developed a system of magical teachings and initiatory rites drawn from Freemasonry, medieval grimoires, astrology and Kabbalah. Modern magicians continue to build on the Golden Dawn's work to extend the basis of their system of magical correspondences, as described, for example, in Dion Fortune's *Mystical Qabalah* (1935).

It is thought that George Alexander made all or some of these ceremonial wands in Anglesey during the 1970s when he supplied tools and jewellery to magical practitioners such as Alex and Maxine Sanders. George has followed the original Golden Dawn design for the wands, which are used in initiation rituals and for the private magical workings of its members. The symbolism draws inspiration from Egyptian magic and medieval grimoires. Like the lamen (magical pendant, **see item 40**) and banners used by the Golden Dawn, the wands also embody an intricate system of colour symbolism employed as a mode of arriving at enhanced states of consciousness. Samuel Liddell MacGregor Mathers claims to have acquired this knowledge from Secret Chiefs, highly evolved invisible beings believed by some to be the secret government of the earth.

The first wand bears the distinctive mitre head ensign of the office of Hegemon known as the 'Sceptre of Wisdom', which is said to communicate religion. The Lotus Wand, the single most important tool used for general magical purposes by the adept in the Golden Dawn tradition, derives from a type of wand illustrated in *The Book of the Dead* and other Egyptian papyri. The hexagram that heads the wand of the Cancellarius symbolises perfection and the two great opposing forces – fire and water, or positive and negative – in balanced equilibrium. The Chief Adept's Wand (Ur-Uatchti) depicts the winged sun-disc and two serpents. The Hierophant's Wand known as the 'Sceptre of Power' is symbolically the most important wand in the Neophyte Hall and in all of the halls of the Outer Order. The Adept's Wand features a phoenix, revered by ancient Egyptians, and a stylised representation of the head of the god Set. On the uppermost part of the Praemonstrator's Wand there is a Maltese Cross or the 'Cross of Four Triangles' which represents the four elements in balanced control.

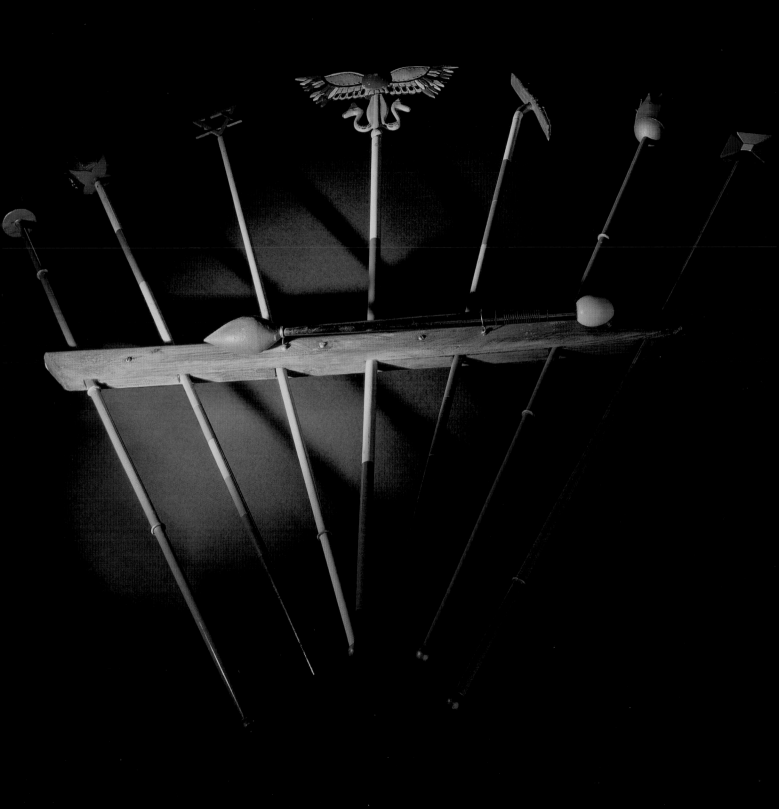

40. The Rose Cross

120 x 100 x 10 mm

A Rose Cross thought to have been made by George Alexander in the 1970s. It is a replica of those worn by Adepts in the Rosae Rubae et Aureae Crucis, the inner order of the Hermetic Order of the Golden Dawn. The Rose Cross is a lamen (magical pendant) worn over the heart by members during important operations. Its design is influenced by Rosicrucian legend, the Kabbalah and by Moina and Samuel Liddell MacGregor Mathers' symbolic application of colour.

The Red Rose and the Cross of Gold represents a reconciliation of divinity and humanity, which forms the basis of the glyph. As the occultist Israel Regardie describes in his book *The Golden Dawn: An Account of the Teachings, Rites and Ceremonies of the Order of the Golden Dawn* (1969): 'It is a complete synthesis of the masculine, positive or rainbow scale of colour attributions, which is also called the "Scale of the King"'.

The rose is centred on the Cross of Nature; each one of the arms represents a physical element: Earth, Water, Air and Fire, upon which pentagrams, fixed astrological signs, quintessence (spirit), the three alchemical principles of sulphur, salt and mercury are also represented. The hexagram below the rose shows the moon and the five planets centred on the sun. The white portion behind the rose represents divine light. Each rose petal is coloured differently and refers to the twenty-two letters of the Hebrew alphabet and the twenty-two Paths of the Tree of Life as explained in Kabbalah.

In the middle of the rose is the Calvary Cross, symbolic of death and spiritual rebirth. According to Regardie the Rosy Cross is '… a glyph, in one sense, of the higher Genius to whose knowledge and conversation the student is eternally aspiring. In the Rituals it is described as the Key of Sigils and Rituals.'

A visitor to the museum explained that traditionally the Rose Cross is to be made and consecrated by its owner unassisted, and must not be touched by another person after consecration.

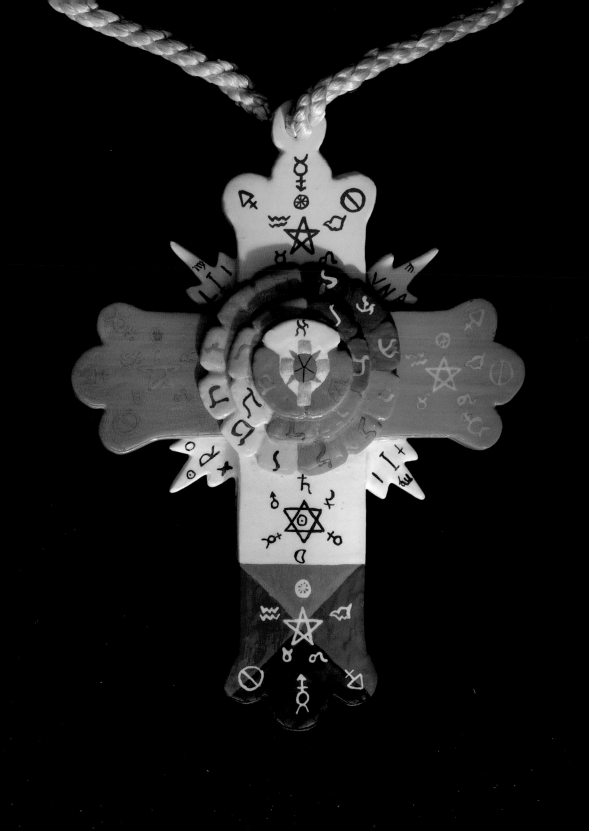

Sweeper made from the left wings of
three young ganders. The ends have been
dipped in mutton fat and beeswax and
secured with red wool. These sweepers
are used in the Isle of Man and Scotland
to sweep the luck away from a persons
house. They are also used to sweep up
the dust at four cross roads for use in
a Black Magic Rituals

41. Feather Sweepers

460 mm

Mrs Sheila Payne of Mousehole donated these two goose feather sweepers to the museum. Cecil Williamson explains that the particular direction of sweeping determines their magical force. The right-hand one sweeps good luck towards one while the left hand one sweeps bad luck away. Like the duck and swan, the goose is thought a beneficent animal associated with the Great Mother, often found in folktales such as 'Mother Goose'.

Birds pertain to the element of air and in symbolism they often represent thought, imagination, and swiftness.

In alchemy, birds stand for forces in the process of activation. Soaring skywards expresses volatilisation or sublimation, and swooping earthwards expresses precipitation and condensation. When the two movements join, they form a single feature expressive of distillation.

42. Bratzillaz Back to Magic — House of Witchez Doll

280 x 280 x 210 mm

Bratzillaz (House of Witchez Dolls) are an American line of fashion dolls, released by MGA Entertainment in 2012. There are twelve variations of the Witchez Doll, with names such as Cloetta Spelletta and Yasmina Clairvoya. Each doll is said to have particular powers and unique characteristics. This is Sashabella Paws with a magic wand which converts into a light-up fibre-optic broomstick.

Witches feature heavily in our culture and consciousness, and the links between women and witchcraft go back to antiquity. This playful range of dolls presents witches wearing clothes similar to Hallowe'en costumes, which perpetuate an outmoded image of the witch and her practices. Hallowe'en is rooted in Samhain, a Celtic festival marking the start of Winter, a Sabbat celebrated by modern witches as a liminal time when the veils between this world and the Otherworld are at their thinnest.

43. Cock Rock

170 x 110 x 60 mm

In 2003, a woman donated a wooden box containing a phallic-shaped flint stone and an explanatory letter. She wrote that 'cock rock' had been in her family for several generations and had helped many women to conceive. In order to promote fertility, the rock was to be placed under the woman's pillow on the night of a full moon and she would be 'with child' within nine months. The donor wanted the museum to have the stone because she lamented, 'No one in my village now believes in its powers'.

To find a natural stone with a recognisable form already apparent, rather than humanly created, is regarded by many modern witches as a gift from the earth. The museum also has a vagina-shaped 'fanny stone' to solve impotency.

44. Talisman

80 x 80 x 1 mm

This talisman was found inside Cecil Williamson's copy of Samuel Liddell MacGregor Mathers' translation of the medieval magical text *The Key of Solomon* (1888) (**see item 35**). A note on the back of the talisman reads:

'This Pentacle of Jupiter was compounded during the period of the full Moon Nov-Dec 1952 by Cecil H. Williamson within a properly constructed circle charged with power as is laid down in THE KEY.'

Cecil's drawing on parchment incorporates the names of the angels Adoniel and Bariel, and the words, 'Wealth and riches are in his house and his righteousness endureth for ever' (Psalm cxii.3). According to *The Key of Solomon* this talisman will bring riches, honour and wealth.

A talisman is normally prepared ritually by a magical practitioner to achieve a particular result such as self-protection, healing, for attracting love or wealth, or to cause harm, etc. After preparation a talisman can be used as an amulet, sometimes hung around the neck or carried in a charm bag. Frequently it is buried or destroyed in agreement with the ritual of which its preparation is a part.

45. Green Man

350 x 350 x 250 mm

The Devon based artist Shane Hahn carved this tree root into an autumnal representation of the Green Man. The term 'Green Man' stems from an article written in 1939 by Lady Raglan for *Folklore*, the journal of the Folklore Society. Having been shown a series of early church carvings of foliate heads she surmised that the drawings were from life, depicting the figure 'variously known as the Green Man, Jack-in-the-Green, Robin Hood, the King of May and the Garland King.'

Her argument follows theories outlined by Sir James Frazer in his book *The Golden Bough* (1890) that folk customs are survivals of pagan fertility cults. Despite historical inaccuracy, her article was hugely influential and the term Green Man has endured.

The Green Man has become an important icon in contemporary life with varied motifs including Green Women and Green Beasts. His name has been given to music festivals, clothes stores and numerous public houses. The Green man has also been adopted as a figurehead by many modern Pagans who consider his image a perfect representation of human kinship with nature. Many believe that this face is a representation of nature deities such as Cernunnous or Pan. The English historian Mercia MacDermott provides a detailed study on this theme in *Explore Green Men* (2003).

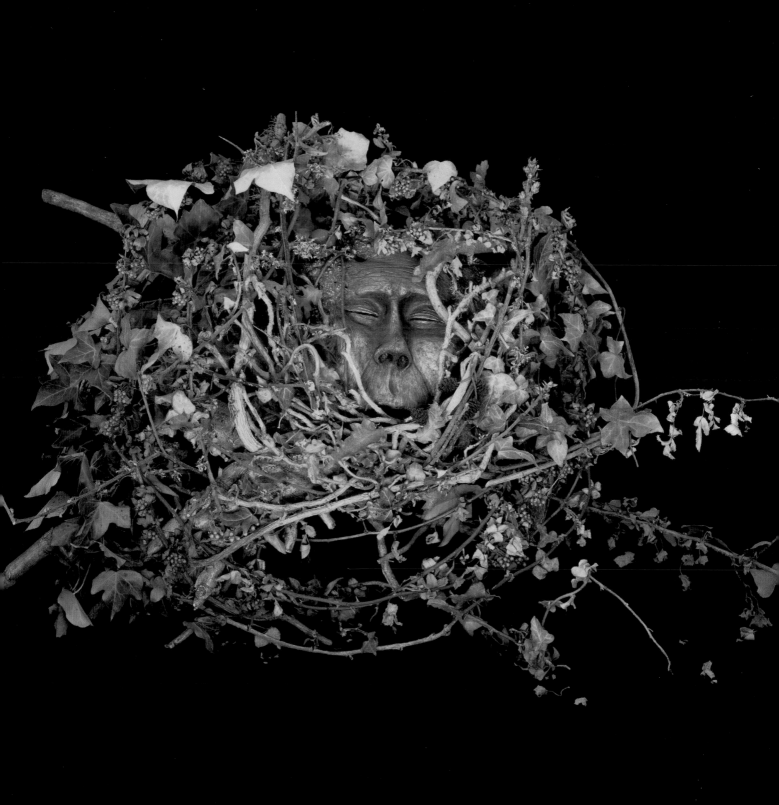

46. Old Nick

380 x 150 x 100 mm

'Gay with seven red candles, Old Nick the horned man-goat figure of the ancients, stomps the world with his load of mischief basket upon his back, one hand should hold a drinking cup the other a walking staff to help and defend himself on his way through the ranks of the sinners who populate this world. So much for the symbolism of this quaint little wooden carved figure, once the property of a Mrs Elise Monkton – a one-time housemaid who did rather well for herself and came up in the world. Indeed she drew into her purse many a crisp white five-pound note – a lot of money in those days, 1918, with the aid of this smiling little version of the man with a load of mischief, with it Elise made predictions and gave readings of both hand and cards. Picture the scene, Elise decked out in satin and lace, the seven candles blazing away, wax running all over the place and in the basket on Old Nick's back, some stupid request written on paper, folded and tucked tightly into the little container, waiting wide-eyed, some plump, simple minded member of the leisured class waiting for Elise's answer to her five-pound question.' Cecil Williamson.

Many nicknames for the Devil include the adjective Old, a possible reference to the Devil's primeval character. Examples include Old Billy, Auld Cloots (or Clootie), Old Gooseberry, Old Harry, Old Hob, Old Horny (or the Scottish spelling, Auld Hornie), Old Ned, Old One, Old Roger, Old Scratch and Old Serpent. 'Old Nick' is first recorded in the 17th century; its origin is uncertain but thought to relate to specific German and Scandinavian words beginning in *nik-*, used for dangerous or supernatural creatures.

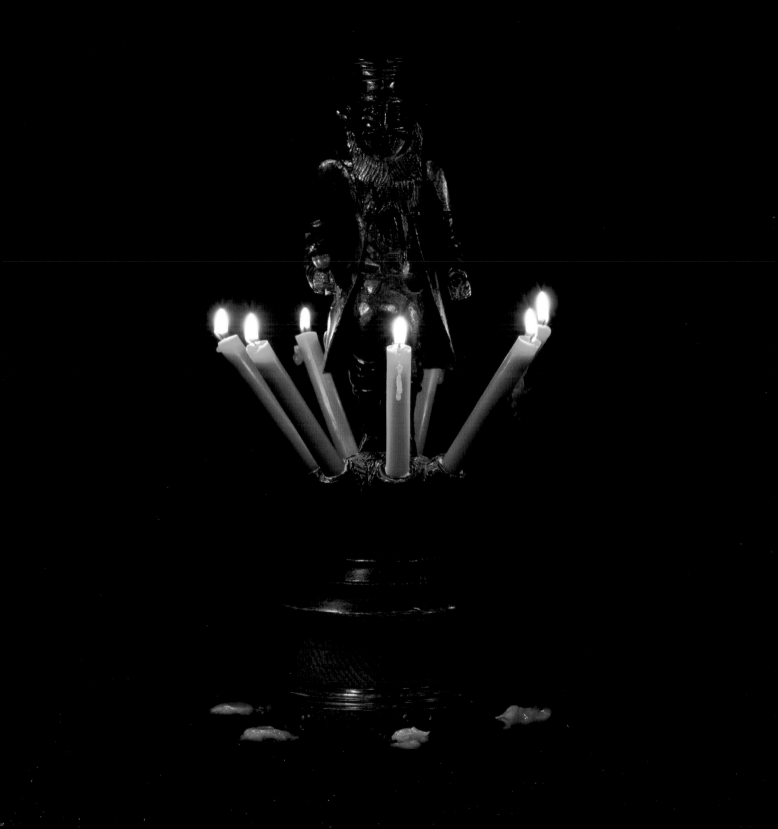

47. Chimney Doll

635 x 300 x 143 mm

This doll was found in the chimney of a cottage in Padstow, Cornwall in the 1990s. However, during the 1950s she was the 'guardian' of the Hole in the Wall public house in Bodmin, and known as Mother Shipton, after the Yorkshire prophetess. There is much speculation as to the identity of the original Mother Shipton, but according to a chapbook of her prophecies published in 1641, she was born Ursula Southeil in 1488 in Knaresborough, Yorkshire. Legend has it that her fifteen-year-old mother Agatha gave birth to Ursula in a cave during a terrible storm on the banks of the River Nidd.

From a young age, Ursula possessed a rare gift to tell the future. When she was twenty four years old, she fell in love with a young man by the name of Tobias Shipton. It is unknown whether they married but after only a few years Tobias died and Ursula took his name, Shipton. It wasn't until her later years that she became known as Mother Shipton.

Throughout her life she is alleged to have made a series of startling predictions, including the advent of cars, iron ships and even the end of the world.

A Carriage without a horse shall go;
Disaster fill the world with woe...
In water iron then shall float,
As easy as a wooden boat

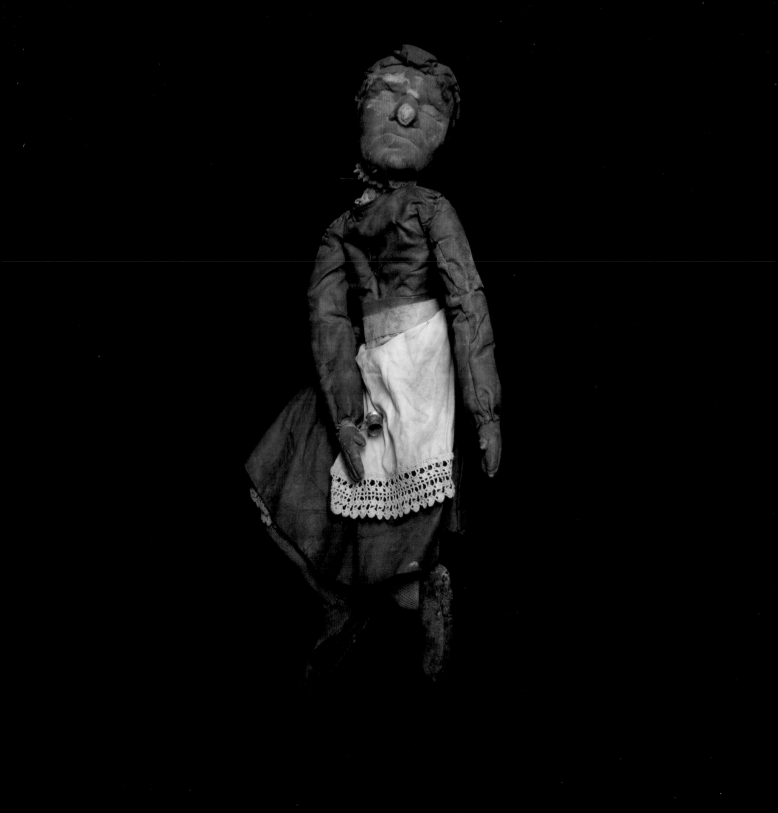

THE LOTUS WAND

THIS MUCH USED AND NOW SADLY BATTERED
RELIC OF ALEISTER CROWLEY'S SCHOOL OF
MAGIC CAME INTO MY POSSESSION AFTER ITS
OWNER AND MAKER HAD HAD A FRIGHTENING
MAGICAL ENCOUNTER OF OCCULT ANGER AND
PHYSICAL AGGRESSION AGAINST HIS PERSON
IN WHICH HE WAS FORCED TO USE THE WAND
AS A BATON WITH WHICH TO DEFEND HIMSELF.

48. Aleister Crowley's Wand

29 x 25 x 10 mm

Helen Richards and Pat Judson, High Priestess and Priest of the Coven of Ercall Yew Grove in Shropshire, donated this wand to the museum. It is thought to have come from Aleister Crowley. In most witchcraft traditions, wands are used to channel divine energy. A variety of natural and manmade materials are employed in their creation. This wand consists of a series of cylinders made of bone or ivory, decorated with black and red bands held together by an iron rod through its central core. It is probable that the components of the artefact had another, albeit unknown function before being used as a wand.

Aleister Crowley (1875-1947) is described variously as a genius, a madman, a philosopher, an expert mountaineer and the 'wickedest man in the world'. In 1898, he joined the Hermetic Order of the Golden Dawn and excelled as a ritual magician. When in Egypt, his wife Rose channelled a preternatural being, Aiwass, who dictated *The Book of the Law* (1904). The text includes the axiom 'Do what thou wilt shall be the whole of the Law'. The author of a great many magical books and texts, Crowley defined magic as causing a change to occur in conformity with the will. He was one of the first occultists to combine Western and Eastern mystical traditions into a coherent magical system and founded the magical order the A.:A.: (thought by some to stand for Argentium Astrum, or Silver Star) in 1907. In 1912, he was appointed the British head of the Ordo Templis Orientis.

49. Handfasting Cords

1430 x 15 x 5 mm

These cords belonged to Iain Steele and were used for his handfasting to Mary in 2003. Handfasting is widely practiced among the Pagan community and refers to a betrothal or engagement, where usually a couple declares a binding union for a year and a day or for 'as long as love shall last'.

Depending on the particular spiritual path there are different decrees regarding the symbolic use of colour, length of the cord, type and number of cords used. There are also variations in the joining of both pairs of hands, or only the left hands or each left and right. In most cases, a celebrant such as a High Priestess or High Priest conducts the ceremony according to the particular tradition practiced by the couple. The hands of the couple are clasped and fastened together with a cord or cords just before, just after, or during their vows. The wrapping of the cords can form an infinity symbol and the tying of the knot is regarded as a symbolic representation of their union as they become bound to each other.

Often the ceremony is closed by the couple 'jumping the broomstick', symbolising the sweeping away of the past and the start of a new life together.

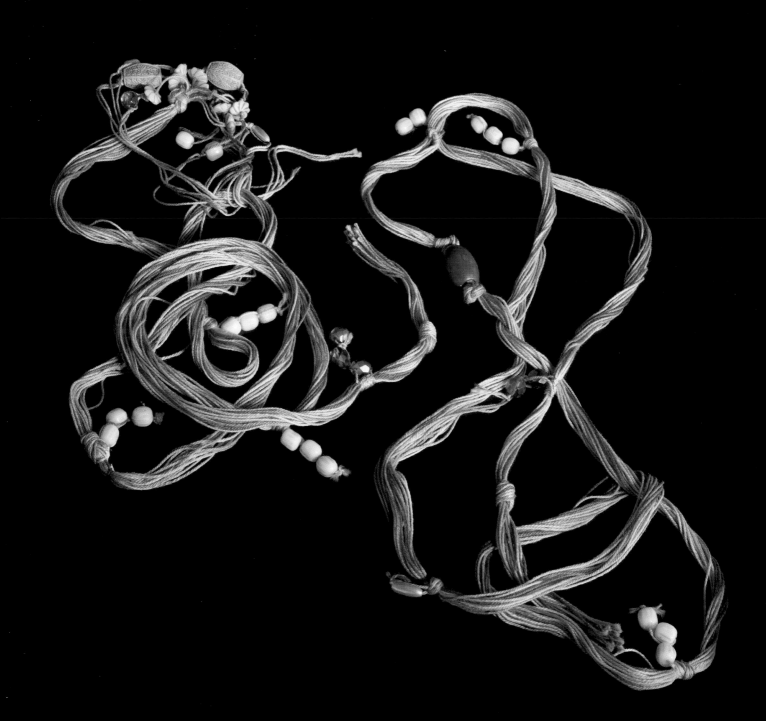

50. Replica of a Roman Bronze Hand

200 x 100 x 60 mm

A ceramic replica of the bronze 'Hand of Sabazius' from the 2nd century AD, donated to the museum by the magical practitioner Ralph Harvey. The hand is decorated with a serpent, a cymbal, a pinecone and a frog, which are symbols associated with worship of the god Sabazius. His cult originated in Phrygia or Thrace and later became popular in the Roman Empire. The Romans associated him with Dionysus, the god of wine. It is believed that Hands of Sabazius were placed in shrines or carried on poles in religious processions.

The bronze hand has also been used to ward off the evil eye. Hands are potent symbols and the two raised fingers are in the gesture of sacerdotal benediction known in Rome as the Mano Pantea.

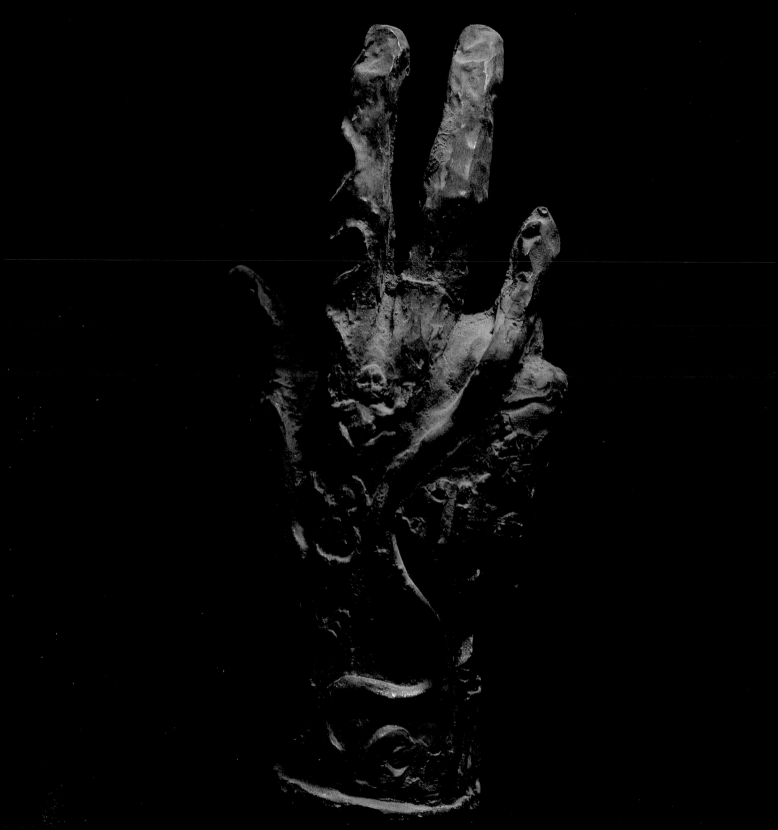

51. Devel Sasabonsam

430 x 200 x 140 mm

The Sasabonsam, depicted in this wooden carving, is believed to be a vampiric creature mainly associated with the Ashanti tribes of southern Ghana, the Ivory Coast and Togo. There are several descriptions of the Sasabonsam, this one taken from a report by Captain Robert Sutherland Rattray:

'The Sasabonsam of the Gold Coast and Ashanti is a monster which is said to inhabit parts of the dense virgin forests. It is covered with long hair, has large bloodshot eyes, long legs, and feet pointing both ways. It sits on high branches of an odum or onyina tree and dangles its legs, with which at times it hooks up the unwary hunter. It is hostile to man and is supposed to be especially at enmity with the real priestly class. Hunters who go to the forest and are never heard of again, as sometimes happens, are supposed to have been caught by Sasabonsam. All of them are in league with abayifo (witches), and with mmoatia, in other words, with workers of black magic.'

An article from *The West African Review* of 1939 examines a carving by renowned Ashanti craftsman Osei Bonsu. The writer J.B. Danquah wonders whether it could have been carved from life. There then follows a vivid description of the beast having been shot and brought to a village:

'Mr. A.W. Cardinall in *Tales Told from Togoland* (1931) states that: "One day a man called Agya Wuo, killed a Sasabonsam and brought it to the town. It is taller than myself, very, very tall ... It has fingers like a human being. The forehead is smooth …there is an abundance of hair on the head, long hair, like a woman's hair but hard and stiff. The claws are very hard and very long. It has wings like a bat and they can be stretched out into the 'lorry' road. (The speaker meant about 20 feet) ... There are scales, like those of a crocodile, over the eyes ... the lips are like those of a human being but wider ... it has a long beard. The nose is like that of a man but more prominent.

February 22nd, 1928"'

A photograph was apparently taken of the creature but when it was developed there was nothing visible to see.

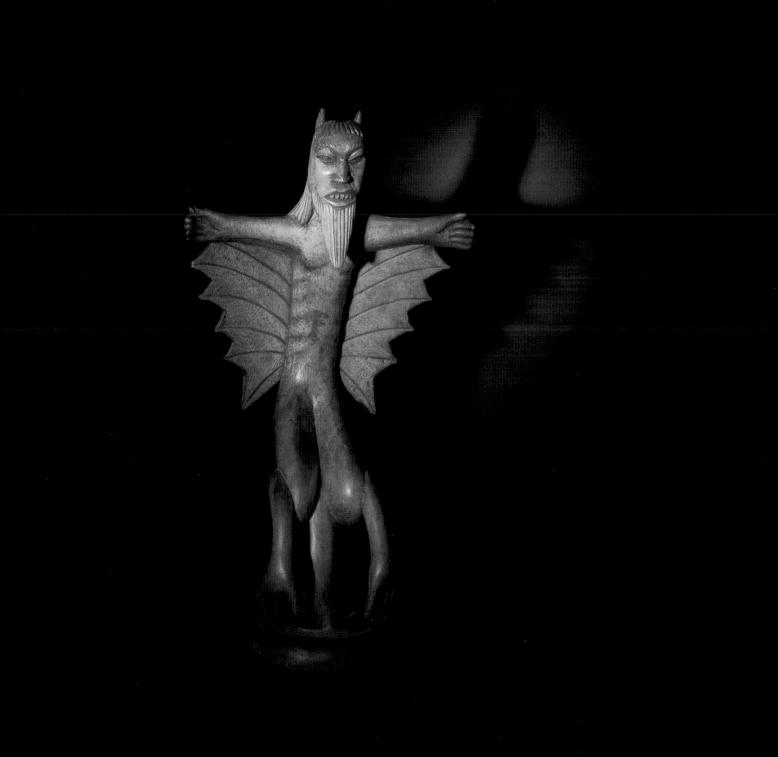

52. Chalice

170 x 75 x 75 mm

It is most probable that a witch named Isis engraved her name on this chalice. The inscriber has used the Theban alphabet and may have referred to Theban translations by the 15th-century German magician and occult writer Henry Cornelius Agrippa in his *Three Books of Occult Philosophy: Book III Ceremonial Magic* (1531).

In occult groups, particularly Wicca, the chalice is a vessel for libations and a ritual tool. It is also used within Christianity. For the Christian the chalice symbolises the cup used by Jesus Christ at the Last Supper. Within Wicca, the chalice represents the womb of the goddess and its element is water. It is one of the four main ritual tools, along with the pentacle (**see item 24**), athame (**see item 5**) and the wand (**see item 48**).

The chalice and the athame are frequently used together in rituals, for example, when charging the wine. As Janet and Stewart Farrar explain in *The Witches' Bible: The Complete Witches' Handbook* (2002): 'The High Priest kneels before the High Priestess, raising the filled chalice toward her. The High Priestess lowers the blade of the athame into the chalice, saying "As the athame is to the male, so the cup is to the female: and conjoined they bring blessedness". The chalice symbolises the feminine, the goddess, the vulva, the womb, the blade symbolises the masculine, the god, the phallus.'

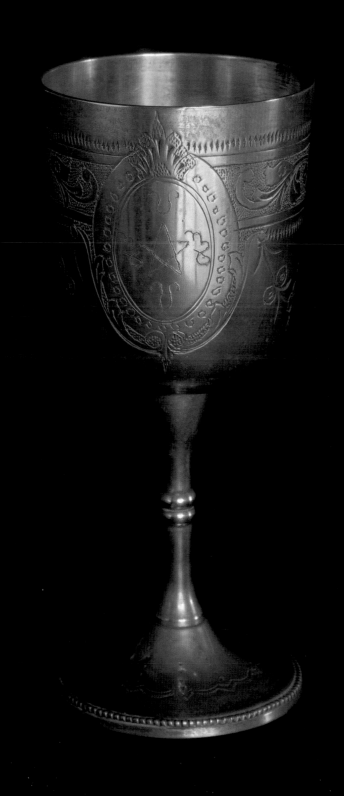

53. Hare

60 x 70 x 20 mm

This small pewter hare was discovered in 1998 set into the cob wall above a window at Trebrown Farmhouse, Liskeard. The date of its creation and installation is unknown, but the homeowners thought that finding the object at Easter was significant. The Christian observation of Easter is named after the Anglo-Saxon Goddess Eostre whose sacred animal many believe was the hare. The image of the hare is currently used as a symbol of femininity, linked with lunar cycles, rebirth and fertility.

The Three Hares Project formed in 2000 by art history researcher Sue Andrew and documentary photographer Chris Chapman has identified the ancient symbol of three hares or rabbits running in a circle joined by their ears in seventeen churches in Devon. The motif is thought to be an ancient archetype, found in diverse religious contexts in medieval Europe and Asia.

Hares were sometimes considered unlucky. Infants born with a harelip were thought to be the result of a hare crossing the path of the pregnant woman. A frequent belief about witches is that they could turn into hares. In the 19th century, many folklorists recorded a popular anecdote of a man hunting a hare that escapes into the house of an old woman reputed to be a witch. On entering the house the woman is found panting hard.

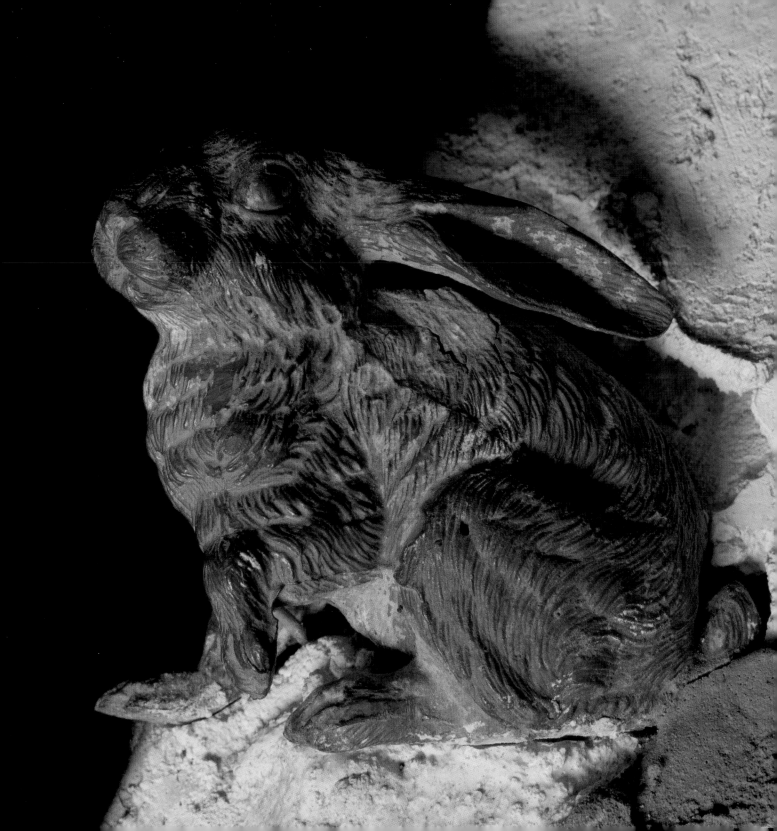

DRIED. HEDGEROW PLANTS AND. THEIR

IN THIS MORTAR **** ROOTS WERE POUNDED AND
GROUND WITH THE IRON PESTLE.

54. Gerald Gardner's Pestle and Mortar

Pestle 220 x 35 mm, Mortar 90 x 110 mm

Gerald Gardner, the founder of Wicca, gave this wooden and ceramic pestle and brass mortar to the Wiccan High Priestess Patricia Crowther. In 2010, Patricia donated it to the museum along with a photograph of herself before an altar with the object in view.

The pestle and mortar is an ancient medicinal, culinary and magical tool. The physical act allows for the grinding of intentions into the herbs. It is likely that Gerald used this implement for preparing herbal cures or incense.

Incense in ancient temples was used to carry the prayers and requests of the worshippers to the gods and goddesses above. Most incense is a mixture of gum, resins, flower petals, wood shavings, and oils. Sometimes modern witches make a special blend of incense for a festival or ritual by selecting ingredients that correspond to a particular magical or planetary force. Burning incense releases its magical power into the atmosphere.

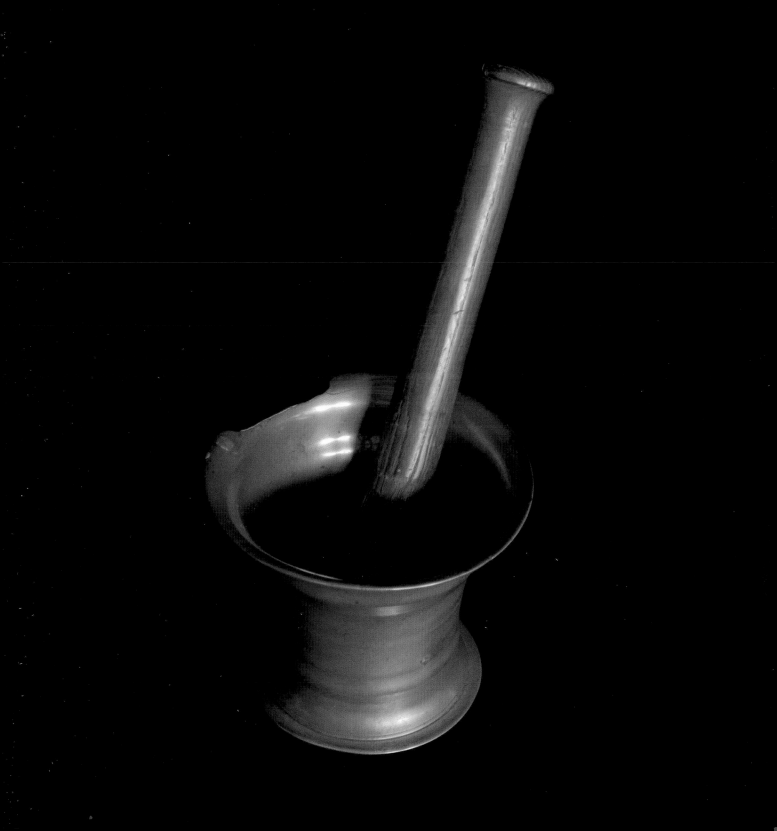

55. Joan

1040 x 500 x 620 mm

'A great many of us, when we be in trouble, or lose anything, we run hither and thither to witches and sorcerers, whom we call wise men… seeking aid and comfort at their hands.'
Bishop Latimer Sermons (1552)

This model, affectionately known as Joan, represents a 19th-century wise or cunning woman. She sits in a cottage room using a scrying ball. The full installation includes amulets, magical tools, and herbs. Adding to the atmosphere, a recording plays verbal charms collected by antiquarians in the late 19th and early 20th centuries, collated by the folklorist and author Steve Patterson.

Cunning folk were sometimes called wizards, conjurers, sorcerers, blessers, pellars, and charmers and were common in country areas until the 20th century. The people who sought their services did not consider cunning folk to be witches; in fact they were often called upon to detect witchcraft, identify witches and give protection against them through counter spells. Cunning folk would also locate lost objects, give information about people far away, make charms to attract love, predict the future, heal people and livestock and perform midwifery. Numerous herbs used by cunning folk have proven pharmacological benefits and many people went to cunning folk, as they were unable to afford a visit to a doctor.

Some cunning folk claimed that their gift was hereditary, while others consulted magical texts, herbal recipes, and magical formulas. Until 1951 cunning folk could be prosecuted under the Witchcraft Act of 1736, which imposed penalties for fraudulent behaviour on anyone who claimed to practice witchcraft.

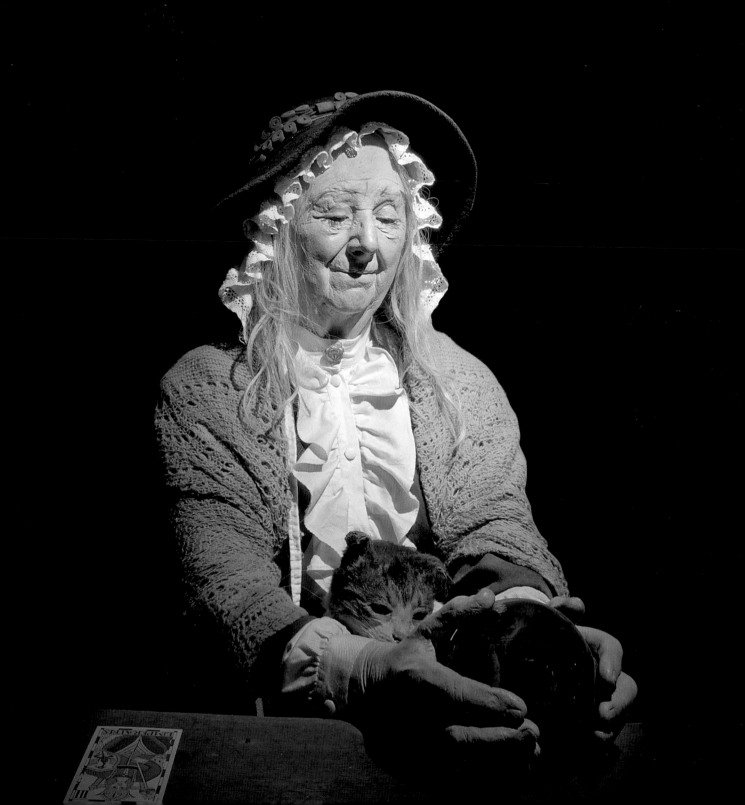

56. Mandrake Root

80 x 25 x 20 mm

The Dutch occultist Bob Richel donated this carved mandrake root with a bead phallus. The Mandrake (*Atropa mandragora*) is a poisonous plant related to nightshade. Its forked root often resembles the human form and was believed to possess many magical and curative powers. Legend has it that when sold or given away the mandrake will eventually find its way back to its original owner.

In the UK, sometimes white or black bryony were sold as 'English Mandrakes' or 'Womandrakes'. The folklorist Edward Lovett commented in the 1920s, '...I know several places in London where Mandrake can be bought, and I have two or three records of these little figures being fixed to the bedhead "for good luck"'. He bought one in Barking, carved into a mother and child, to aid fertility. The Romani, who sold it to him, said it had screamed when pulled from the ground.

In medieval Europe, the mandrake was thought to grow under gallows and gibbets. When dug up the root was said to shriek or produce noxious fumes that would kill the finder or cause them to go mad. Accordingly, to possess a mandrake a sorcerer must follow a complicated and perilous ritual, or trick a dog to pull the root from the ground so that it died instead of the sorcerer. Once the mandrake was dried, it was wrapped in a white silk cloth and kept in a box. The root represented a homunculus figure into which a sorcerer could consecrate and ensoul an elemental or spirit.

In 1953, records show Cecil Williamson purchased two mandrake roots from Heath & Heather Ltd, St Albans, Hertfordshire. He referred to the mandrake as:

'That most mysterious of plants full of the dream-inducing essences so vital to many a witchcraft spell.'

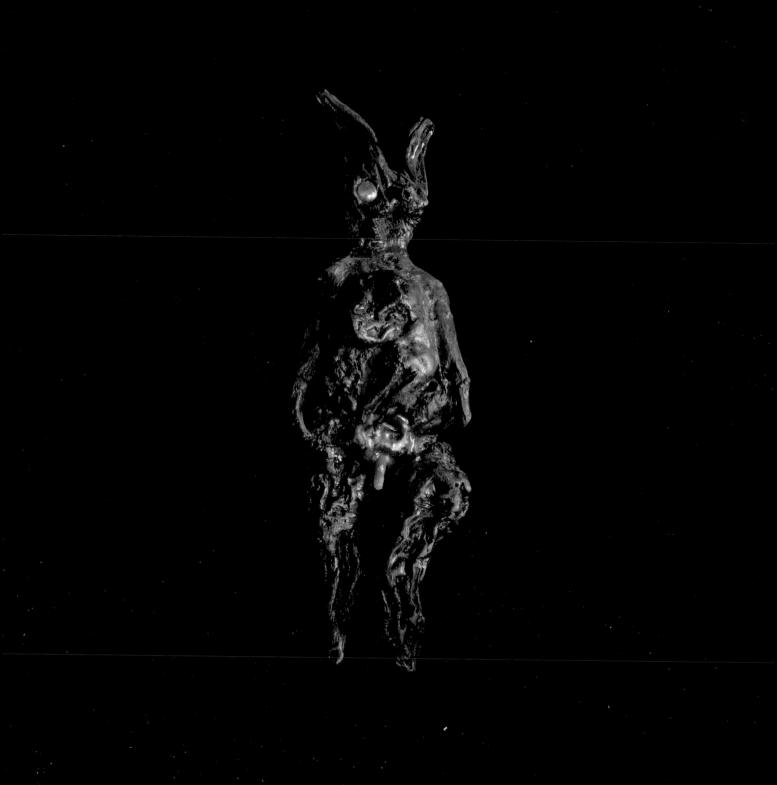

THE WHIP OF COMPULSION
WITCHES MADE USE OF TWO TYPES OF WHIP.
ONE, THE WHIP OF PERSUASION, IS A WHIP
MADE OF SOFT MATERIALS. THE OTHER, LIKE
THIS ONE OF COMPULSION, OF HARD HURTING
MATERIAL.

57. Scourge

730 x 30 x 25 mm

In 2009, Barry Vickers bequeathed to the museum this wooden ritual scourge with cord braids as part of his estate. The scourge is a magical tool and is not usually used to inflict pain. First Degree Wiccan initiates are lightly scourged during the initiation rite, an ordeal that symbolises their willingness to suffer in order to learn. As the Wiccan High Priestess and author Vivianne Crowley in her book *Wicca: The Old Religion in the New Millennium* (1996) explains, although physical endurance has played a key role in the initiation ceremonies of our ancestors and those of tribal peoples, scourging in Wicca is symbolic of the self-discipline necessary to follow an initiatory path.

'It is an effort of the mind, soul and spirit that is required to achieve the goal of initiation – higher consciousness.'

According to Gerald Gardner's Book of Shadows the scourge can also be applied gently with a monotonous action to assist with 'gaining the Sight'. By slowing down the circulation of the blood flow, a drowsy state can be induced which can make the person more receptive to visions.

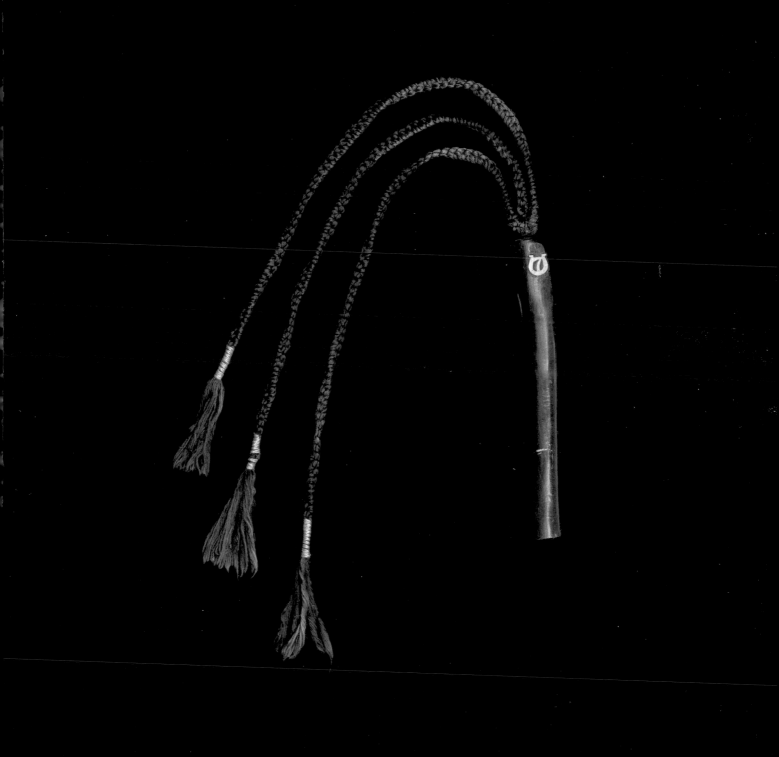

THIS STONE ~~WAS~~ IS USED BY THE TANITES A
CORNISH COVEN. THE MAZE LIKE PATTERN IS
~~THE KEY TO MANY OF THEIR MAGICAL SECRETS~~
~~AND IS~~ RELATED TO THE MAGICAL CULT OF THE
MIONIAN LABYRINTH. and is used for
DIVINATION and spell CASTING.

58. Labyrinth

500 x 300 x 50 mm

This stone came from a farm in Michaelstow, Cornwall. It is similar to one of the two maze carvings at Rocky Valley, situated to the northeast of Tintagel, Cornwall. When first discovered in 1948 the two circular labyrinths were thought to be early Bronze Age. However, some modern scholars believe that because the labyrinths were carved with a metal tool on a quarried wall they must be less than 300 years old. In 2005, it was claimed that another carving had been found, much fainter than the other two, suggesting an earlier origin.

The owner and curator of the museum from 1996-2013, Graham King, influenced by Paul Broadhurst, describes the labyrinth represented on this object thus:

'Entrance to the Other World? The labyrinth has always been associated with Mother Earth and the entrance to her underworld. Notice the shape of the entrance to a labyrinth and its womb-like centre. Slowly walking, or finger-walking, a labyrinth can induce a trance-like state (en-trance) suitable for the journey into the "Other World". With a unicursal (one way) labyrinth one can't get lost – start at the bottom and slowly follow the raised path, you will be moving deosil (sunwise) as often as you are moving widdershins (anti-sunwise). Eventually, you will arrive, well balanced, at the sacred centre of the symbol and maybe of another world.'

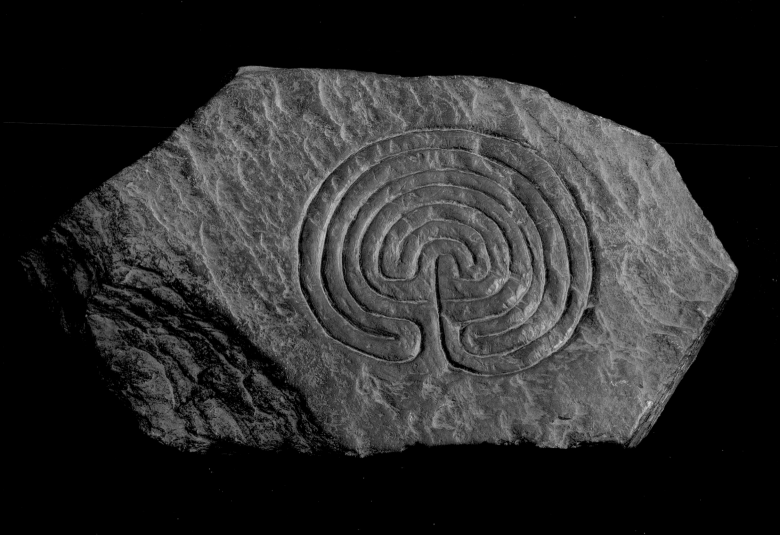

59. Skull used for Ritual Magic

200 mm

Cecil Williamson explains:

'This iron strapped human skull, secure on its star shaped stand, has been with me for over forty years. It came from a witch or wise woman living in the North Bovey area, and she kept "her friend" as she called this relic in a secret place upon Easdon Tor. Old Granny Mann always used to say when presented with a problem or a situation by her clients, "well me dear, I don't rightly knows what I 'a' do – till I have asked me friend. I'll let thee know later."'

Occultists sometimes use a skull as a device into which the spirit of the deceased can be called back from the Otherworld. Believed by some to contain surviving traces of the life force, many witches and magicians look upon the skull as a symbol of death and rebirth, which can aid magical workings and communication with the ancestors. In alchemy, the skull is represented as the receptacle used in the process of transmutation.

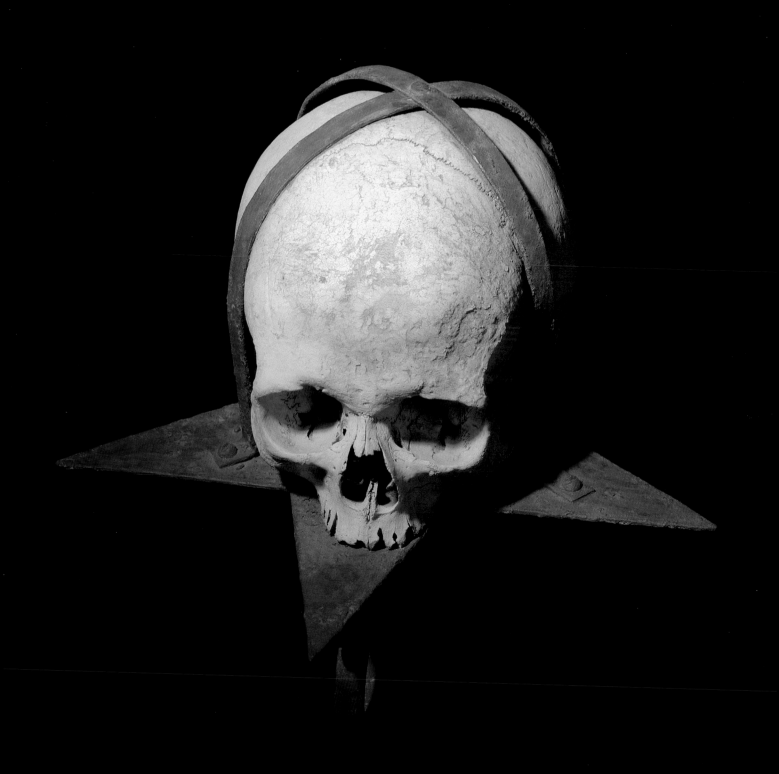

60. Mummified Cats

Black 360 x 290 mm, Red 460 x 230 mm

These mummified cats, one black and one red, were found by a builder in 2008, located together below the front door in a Victorian house in Bristol. Corpses of cats are often found concealed in cavities or bricked up in walls of old buildings. Sometimes they are arranged in lifelike poses, even holding a rat or mouse. Traditionally this was done to scare away vermin, just as dead vermin would be hung over the barn door to 'warn others'. This form of folk magic is defined as apotropaic, meaning to turn away evil. Wards such as these were also thought to repel witches and their familiars or to give protection against bogles and imps.

A 17th-century cat, prized by the Duke of Bedford as an excellent rat-catcher, was found in an airtight brick capsule in the foundations of Woburn Abbey in 1915. The cat had its internal organs removed to help to preserve it and is now on show at the Natural History Museum in London. Another cat found in Suffolk had its paws tied together, suggesting it may have been deposited alive, although the binding may have been symbolic, to restrain the cat's spirit. A visitor to the museum mentioned a Church of England school in Chelmsford, built in 1887, that has two 'cat's paw bricks' – each brick has the tiny imprint of a cat's paw on them – thought to offer protection against witches.

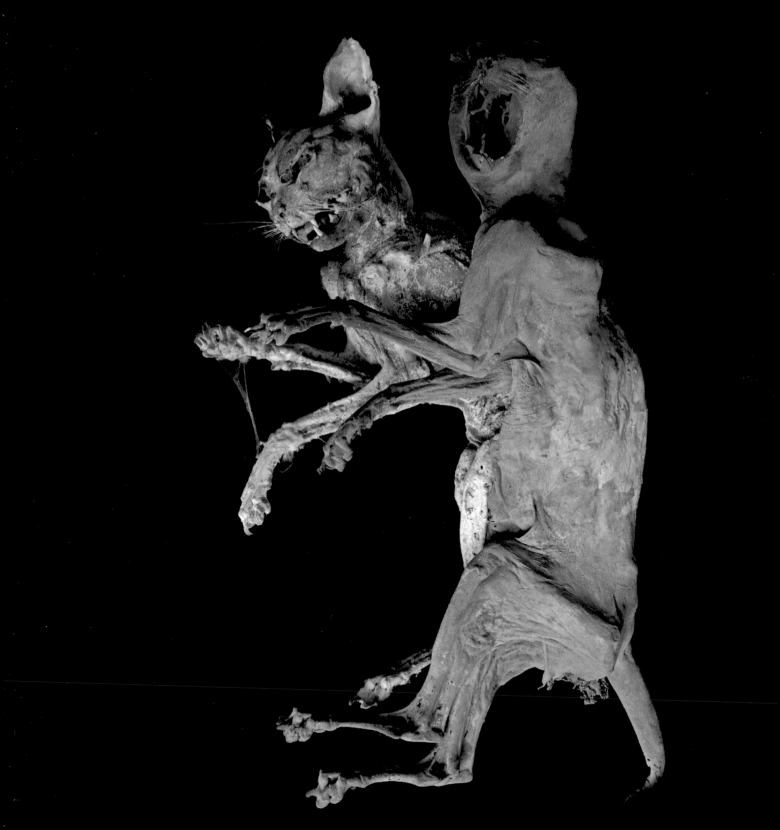

61. Forked Stick with Wax Effigy

405 x 205 x 120 mm

Discovered in an out-building in Cecil Williamson's Devon home after he died in 1999, this forked stick with a wax head was originally positioned in a tray of sand, surrounded by a structure of small bones strung together like a fence. It is presumed to be of Cecil's making, but the intention of the spell is unknown. The making of wax effigies is prevalent in the history of witchcraft to harm or to heal. Cecil had established his own repertoire of materials with which to pursue his goals, desires and to prevent misfortune. The properties of wax, wood, bone and sand are seen to retain and emanate their power and energy infinitely.

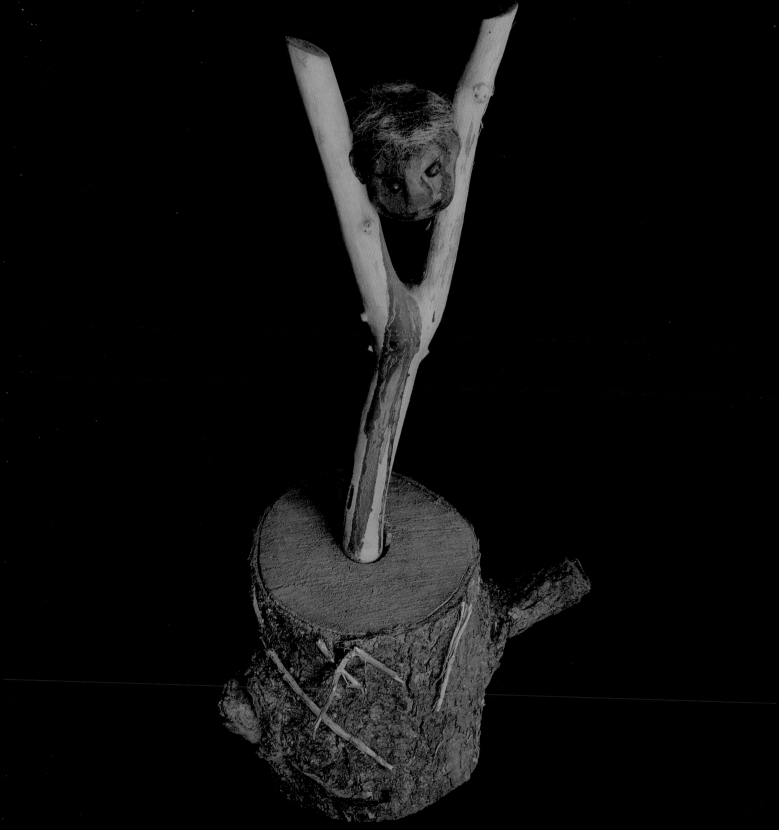

62. Defaced Ouija Board

295 x 445 x 4 mm

Ouija boards as they are currently known developed in the 19th century, when the vogue for spiritualism was at its height. Accounts of automatic writing on a board appear in China around 1100 AD, and similar methods of contacting the dead are recorded in ancient Greece, Rome, India and medieval Europe.

'Ouija, the Mystifying Oracle talking board' as it was marketed, was hugely popular in the 1960s-70s. The name 'Ouija' is a combination of the French oui and the German ja, both meaning 'yes'. Ouija boards are normally used by two or more people to elicit answers to questions, ostensibly in communication with spirits. Each participant would lightly place their right index finger on the planchette and ask a question, the planchette would slide across the board to 'yes' or 'no' or spelling out words with the alphabet provided.

In 2010, Tracey and Ed Ramsbottom were renovating their teenage daughter's bedroom and found this Ouija board plastered into the fireplace.

Interestingly, their daughter had previously sensed two spirits in the room, a young boy with blood on his face and an old woman who poked her and blew on her hair. Their house is close to the Westland Aircraft factory in Yeovil, which was heavily bombed during the Second World War, killing a five-year-old boy in the next street. The couple suspects that the boy's spirit may have been summoned and trapped in the house.

The media has often run stories of people using the Ouija board and conjuring unwanted spirits with frightening consequences. An urban legend circulated that Waddingtons, who manufactured this version of the 1940s William Fuld Ouija board, had recalled the boards and burnt them. Graham King, the then-museum-owner and curator thought this rumour might have contributed to the ritual deposition of the defaced Ouija board in the fireplace. An unwanted spirit may have been conjured or an attempt to banish an unwanted spirit may have failed. Perhaps by defacing the board the participants thought they could erase the activity.

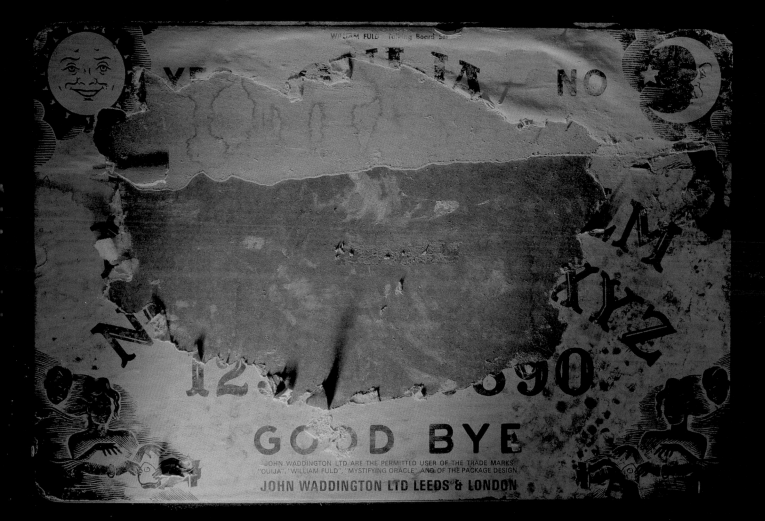

GOOD BYE

JOHN WADDINGTON LTD ARE THE PERMITTED USER OF THE TRADE MARKS
"OUIJA", "WILLIAM FULD", "MYSTIFYING ORACLE" AND OF THE PACKAGE DESIGN

JOHN WADDINGTON LTD LEEDS & LONDON

A SPARROW TRAPPED AND THEN EMBEDDED IN
MOLTEN WAX, ALL DONE TO THE ACCOMPANIMENT
OF A LONG INCANTATION. PURPOSE - TO BRING
VENGEANCE DOWN UPON THE HEAD OF A PERSON
WHO HAS CAUSED ANOTHER OFFENCE OR HARM.
PREPARED AND PRESENTED TO THE MUSEUM BY
LEN QUAYLE OF PEEL, ISLE OF MAN, THE LAST
OF THE MANX CHARMERS. 1949.

63. Jealousy Shoe Curse

270 x 12.5 x 130 mm

In folklore shoes are mostly associated with good luck, from miniature mantelpiece ornaments to tying a single old shoe to the back of a honeymoon couple's car. It has been suggested that these fortunate associations stem from shoes symbolising the female sexual organ. In 1987 the archaeologist Ralph Merrifield interpreted the common practice of hiding shoes within the walls, roofs and chimneys as defensive or protective magic. Unlike any other worn garment the shoe retains the unique shape of the owner and is therefore especially effective for spells directed towards the particular individual.

However, many modern witches are appalled by the use of animals or animal parts in magic spells; some even believe that without the good will of the presiding animal spirit the spell will backfire on the spell caster.

Indeed some witches emphasise the three-fold law: that whatever magical intention and energy you manifest will come back to you at least three times over. Power itself is neutral and depends on how it is used as to whether it is for good or bad. Appropriate uses of this power have long been debated. Spells created from inherently malevolent material indicate that the magic is intended as a curse, sometimes called 'hexing'. The Wiccan rede is 'Do what you will, an' harm none'.

64. Phallus and Yoni Carving

120 x 140 x 15 mm

This wooden carving is from the Richel-Eldermans Collection and represents a yoni and phallus. The Yoni is the symbol of Shakti or Devi, the Hindu Divine Mother and a representation of the creative force that permeates the universe. The Phallus is usually seen as a fertility symbol representing the regenerative force of nature.

In 2000, a Dutchman, Bob Richel, bequeathed to the museum a collection of occult artefacts and drawings that he had inherited from his father-in-law, Mr Eldermans. It is thought that Eldermans was a member of an occult group known as the M:. M:., based in The Hague and Leiden. He was also a Magister of the Ars Amatoria A.:A.:, a group using sex magic. Sex magic harnesses the use of sexual energy as a potent force within magical rituals to obtain certain goals or to reach a higher state of consciousness. This carving is typical of the collection's erotic nature, and has obvious links to love spells, curses and binding spells.

When Eldermans died, much of his collection was either destroyed or sold at auction in 1937. Richel managed to save a section of the artefacts and drawings, but the index for the drawings was burnt. Scholars are currently attempting to decipher the complex numbering system he employed. In 2010, Three Hands Press published a book of Elderman's drawings entitled *The Occult Reliquary*.

65. Bob Richel Carved Hand

250 x 120 x 10 mm

Numerous hands, carved from wood or drawn on paper, feature in the Richel-Eldermans Collection, which was bequeathed to the museum in 2000. The five fingers, like the five points of the pentagram, are analogous to the human figure (composed of four extremities plus a head). Five also corresponds to the golden section and the five senses representing the five forms of matter.

This hand resembles the Hand of Fatima, a powerful Islamic protective talisman and a symbol of loyalty, faith and patience. There are also visual similarities with a palm-shaped amulet believed to offer protection originating in Mesopotamia (modern day Iraq), called Hamsa, an Arabic word meaning 'five'. The Hamsa denotes love, health, and humanity, and is recognised as a sign of protection in many societies. It often appears on wall hangings and jewellery.

Due to the erotic nature of the Richel-Eldermans collection the downward pointing triangle most likely represents female genitalia and the hole in the centre of the circle underneath the pentagram could signify the path of transcendence.

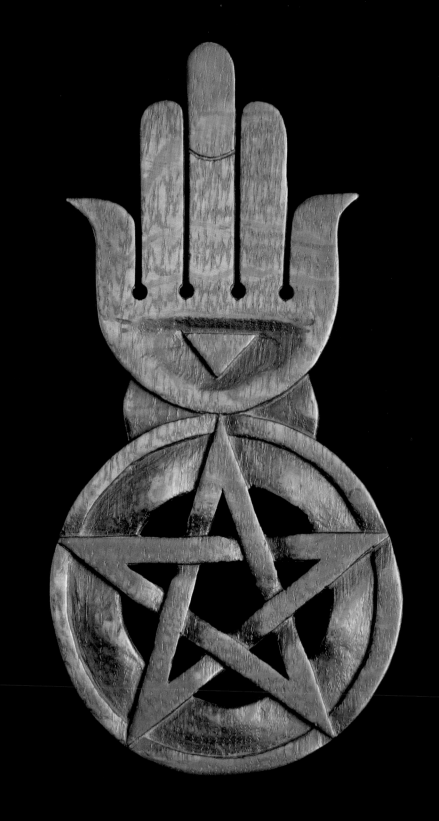

66. Metal Plate Mould of a Baby Wrapped in Swaddling

110 x 35 x 15 mm

Part of the Richel-Eldermans Collection donated to the museum in 2000, this small metal mould is most likely for use in fertility magic. It bears resemblance to the metal plates crafted to cast wax figurines used in votive offerings. Votive objects offered with a plea for fertility encompass diverse forms and are found in many different religious cultures. Objects known as ex-votos (**see item 4**) are also made to convey gratitude and operate as a type of payment for a fulfilled promise, for example the delivery of a healthy baby.

Fertility magic has a long history in imitative, sympathetic and ritual magic. Ancient forms of imitative magic function through mimicry: although similar to sympathetic magic the action is not merely symbolic but a close duplication of the desired reality. This mould can be filled with wax and manifest the creation of a baby. This identification between the baby made of wax, linked to physical and mimetic contact, may well have strengthened the perceived relationship between the wax baby and the body of the votary making of the offering. This connection between the votary's own body and the votive object could increase the talismanic properties of both the wax baby and the mould.

67. Witch-Hunting Pin

150 x 4 mm

During the witch hunts of early modern Britain, when a person was accused of witchcraft they were often stripped naked and their body examined for a 'devil's mark', 'witch's mark' or 'witches' teats', such as blemishes or birthmarks. When a mark was found the person was questioned as to its origin. During the questioning, a long brass witching-pin was driven deep into the mark. If the area was insensitive to pain or if on the pin's withdrawal no blood came forth, it was certain proof that the person was a witch. In England, the most common outcome of this 'test' was hanging. It is estimated that 400-500 people were executed for 'invoking evil spirits and using witchcraft, charms or sorcery'. In Scotland between 800-2,500 so-called witches were burnt at the stake.

68. Scold's Bridle

300 x 220 x 220 mm

These brutal devices were used to extract confessions from women accused of witchcraft. In 1591, Agnes Sampson of Berwick, Scotland was restrained to the wall with a cast iron witch's bridle which had four sharp prongs forced into her mouth against her tongue and cheeks. After being tortured in this manner and deprived of sleep, she confessed to witchcraft and a conspiracy between the Devil and the witches of North Berwick to assassinate King James VI. She was garrotted and burnt at the stake.

Cecil Williamson explains:

'Scolds' bridles such as this were used on witches when they were paraded, stripped naked to the waist and whipped through the town. The purpose of the bridle was to prevent the witch shouting and cursing the town or persons in authority.'

The persecution of witches was often a form of scapegoating; blaming marginalised individuals for the misfortunes of individuals or communities. Witch hunting occurred in Britain between 1450-1750 during a time of Reformation and religious wars, social upheaval, and economic crisis.

The Malleus Maleficarum (Hammer of Witches) (1487) became hugely influential throughout Europe in identifying witches and the practices of witchcraft. The author, Heinrich Krämer, a Dominican and inquisitor, saw witchcraft as a Christian heresy and thought that the practice of magic implied a pact with the Devil. He outlined elaborate rules and methods for establishing guilt synonymous with an accusation. The English legal system placed an onus on the accuser, who had to testify in court, whereas in other European countries the system was inquisitorial.

69. Cecil Williamson's Dark Mirror

600 x 450 x 70 mm

This dark mirror was found set up on an easel in Cecil Williamson's private study after his death in 1999. Divination with a mirror, or other reflective surface, is mentioned in classical times and has been recorded in Britain since the 14th century. Traditionally, dark mirrors were made from polished obsidian (volcanic glass), protected from strong light and charged by the light of the moon. Cecil's mirror is standard glass and has black paint applied to the reverse side.

A dark mirror is used for summoning spirits or scrying, a form of divination or fortune telling that conjures up visions. In magic, a mirror has the capacity to absorb. Everything, once reflected, is stored, providing information that is then accessible for future use. In quiet contemplation, staring deeply just beyond the mirror's surface, images can sometimes appear, or an answer may be whispered.

In the British Museum in London, there is a highly polished obsidian 'shew stone' described as 'Dr Dee's mirror', used by the Elizabethan mathematician, astrologer, magician and hermetic philosopher, John Dee (1527-1608/9), in his occult research.

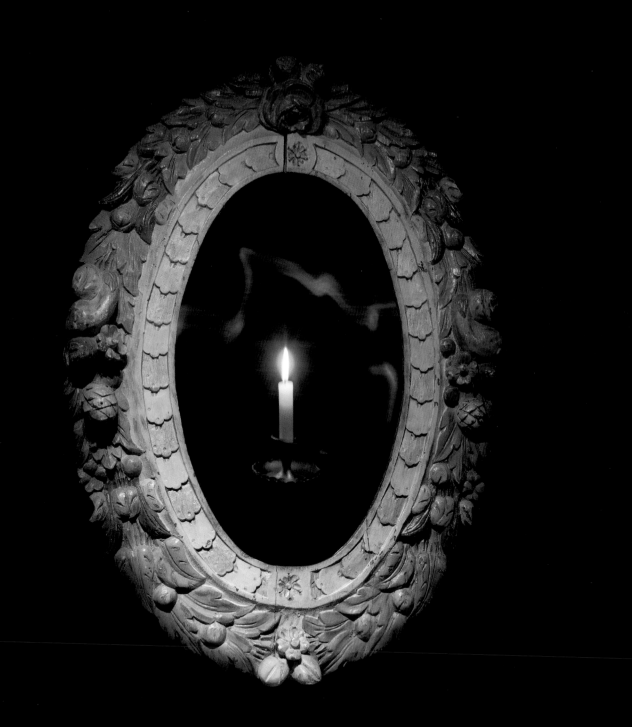

70. Baphomet

1350 x 750 x 750 mm

In 1960, when Cecil Williamson first opened the museum in Boscastle, he arranged this life-size goat-headed figure on a throne, with a mannequin of a young witch at his feet offering up a baby. A postcard of the tableau sold at the time reads:

'"To give is to receive" A young witch offers the Horned God the foetus, proof of her conception with the Spirit Force from the World Beyond the Grave. In return, the Horned God will assign to the witch a familiar Spirit Guardian Angel to serve her and to be the catalyst for her magical power.'

Graham King, museum owner and curator from 1996-2013, removed the tableaux and changed the Horned God figure to represent Baphomet, the alleged deity of the Knights Templar. The best-known image of Baphomet comes from an illustration created by the French occult author and ceremonial magician Eliphas Levi and shows a cross-legged, Sabbatic Goat with both male and female attributes, representing the 'sum total of the universe'.

The velvet robe, edged with fake fur, belonged to the late magical practitioner Chris Gosselin. As High Priest, Chris would sometimes assume the role of the Horned God during rituals wearing this robe and a horned mask. In 1921 the Egyptologist Margaret Murray argued that during the witch trials the Horned God was perceived as the Devil. This notion is embedded within popular culture, most famously illustrated in the 1968 Hammer Films production of Dennis Wheatley's novel *The Devil Rides Out*. In fact Dennis Wheatley used a photograph of Horny (as he is affectionately known) in his book *The Devil and all his Works* (1971).

In 2014, The Satanic Temple in America commissioned an enormous statue of Baphomet to be placed alongside the monument of the Ten Commandments at Oklahoma State Capitol. Permission was denied and the statue was instead unveiled, just before midnight on 25 July 2015, in an industrial building in Detroit.

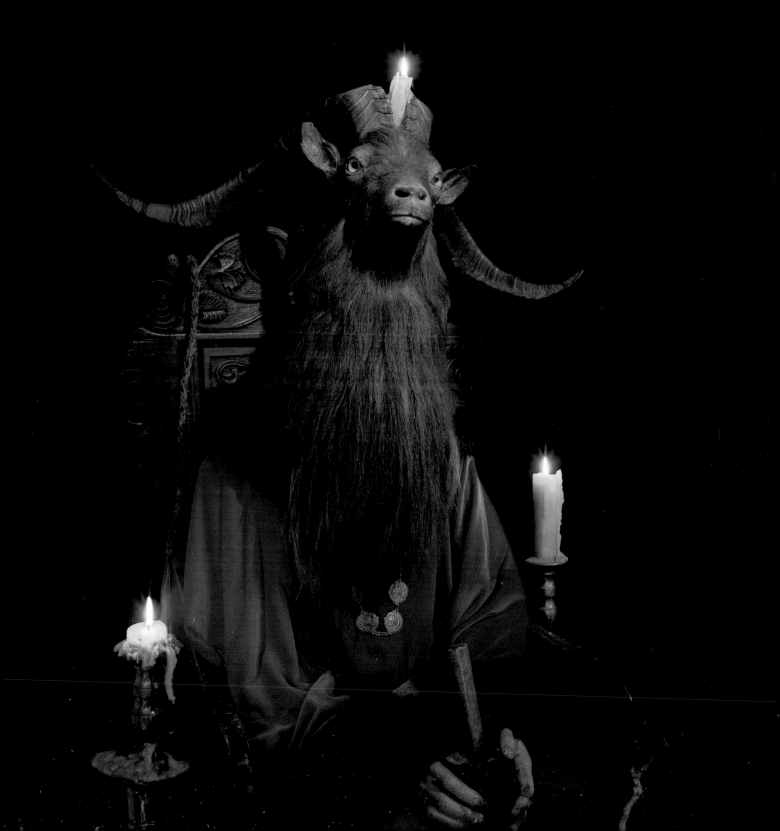

71. Horse Brass

97 x 77 x 2 mm

Horse brasses are thought to be an ancient form of magical protection. This 1950s crescent moon design embodies the horned moon – the symbol of the moon goddesses such as Isis, Hathor or Hera – which was thought to be the most powerful protection against the evil eye and witches. The traditional crescent moon design has various associations ranging from horses' hooves to the tusks of wild boars. The efficacy of ornamental horse plaques was thought to reside in two factors; the protective symbols that they displayed and the fact that they possess a shiny, polished surface, which would reflect back any harmful gaze.

While many brasses are modern trade symbols, the design can often be traced to motifs representing ancient gods and goddesses linked to the horse, sport or agriculture. Reginald A. Brown supports this argument in his book *Horse Brasses: Their History and Origin* (1949). He cites a 2000-year-old grave in the Siberian Altai Mountains in which a Sumerian chief together with seven mummified horses were preserved by frost. The bronze trappings on the mummified horses were similar to those found on a modern carthorse.

There are also records from medieval England mentioning decorative horse brasses, which were used as status symbols and often had talismanic qualities. The range of decorative symbols developed hugely during the 1800s. The traditional sunburst and crescent moon were complimented by anchors and ships, pixies, wheatsheafs, place names, coats of arms, famous people of the times and royalty.

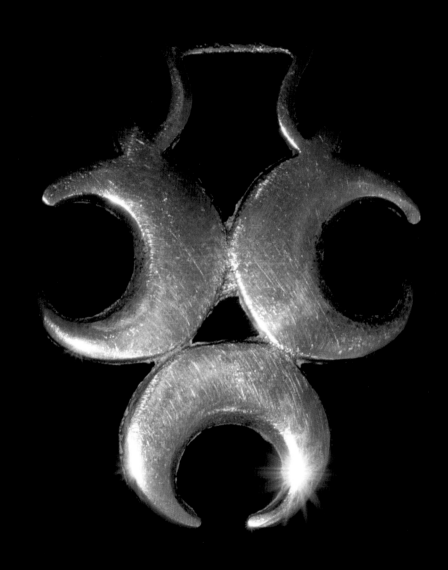

TO IMPRESS THEIR CLIENTS WITH THEIR
POWERS SORCERERS DELIGHT IN SHOWING
EXAMPLES OF THEIR SKILLS. A TYPICAL
EXAMPLE BEING THIS GAY BOTTLE DECKED
OUT WITH ITS GLITTER BEADS AND BOBBLES.
HOW DID HE DO IT? THE SORCERER
GENERALLY CLAIMED THAT HE SENT HIS
SPIRIT DEMON INSIDE THE BOTTLE TO
GIVE HIM A HAND AS HE PASSED THE
THINGS INTO HIM TO ARRANGE AS INSTRUCTED.
WELL, IF HE DID NOT, THEN HOW ON EARTH
DID HE DO IT!

72. Spirit House

300 x 120 x 120 mm

Cecil Williamson explains:

'This Spirit Bottle contains paper and wood flowers, a spiral staircase construction, frames wrapped with coloured thread and with hanging rods, bells and beads etc. If you have an unwanted spirit in your home a glass spirit house such as this will keep it amused indefinitely. The more going on inside the bottle the better.'

Another traditional form of witch bottle is packed with short pieces of thread. Occultist Levanah Morgan, who has donated several other similar spirit bottles to the museum, describes her approach thus:

'The idea is that the threads form a dense maze, which will confuse the spirits so they won't be able to get past the bottle. I have adapted the tradition a little. I do a lot of sewing, embroidery and knitting; mostly I make magickal artefacts. Every time I make something, I snip off the odd ends of thread or wool and put them into a bottle.'

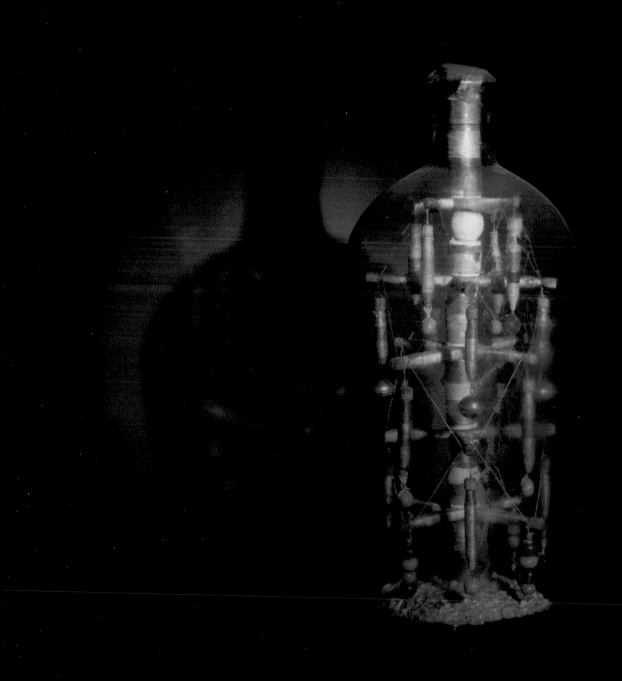

A PURE WHITE ROPE WITH THREE KNOTS
THIS IS A WITCH'S CHARM OF ANCIENT
ORIGIN. IN BYGONE TIMES THE WITCHES
"SOLD THE WIND" TO THE MARINERS, CONTROL
OF THE WIND BEING OBTAINED BY THE
CEREMONIAL UNTIEING OF EACH KNOT.
BOSCASTLE, IN NORMAN TIMES, WAS
RENOWNED FOR ITS THREE WITCHES, THE
BEACON LIGHT AND ITS FINE PIGS.
AMONG OTHER THINGS, SUCH AS THE EXPORT
TO NORMANDY OF PREPARED MEDICINAL HERBS,
THE BOSCASTLE WITCHES WERE RENOWNED FOR
THEIR MAGICAL WHITE ROPES WITH WHICH
ONE COULD CONJURE UP THE WIND.
TODAY THE TRADITION OF THESE ROPES IS
KEPT ALIVE BY THEIR SYMBOLIC USE AT
LOCAL WITCH GATHERINGS.

73. Selling the Wind

360 x 15 x 5 mm

Knots have long featured in magic. In Devon and Cornwall witches living along the North-facing coasts did a good trade in selling the wind to seafaring men. In exchange for money, the witch would present a white rope in which three knots had been tied. (This white rope was discoloured in the 2004 flood.)

As explained in *The Polychronicon* by Ranulph Higden c.1350:

'...for women there be wont to sell wind to the shipmen coming to that country, as included under three knots of thread, so that they will unloose the knots like as they will have the wind to blow.'

Untying the first knot would bring a fine breeze, the second a high wind, the third would unleash a storm.

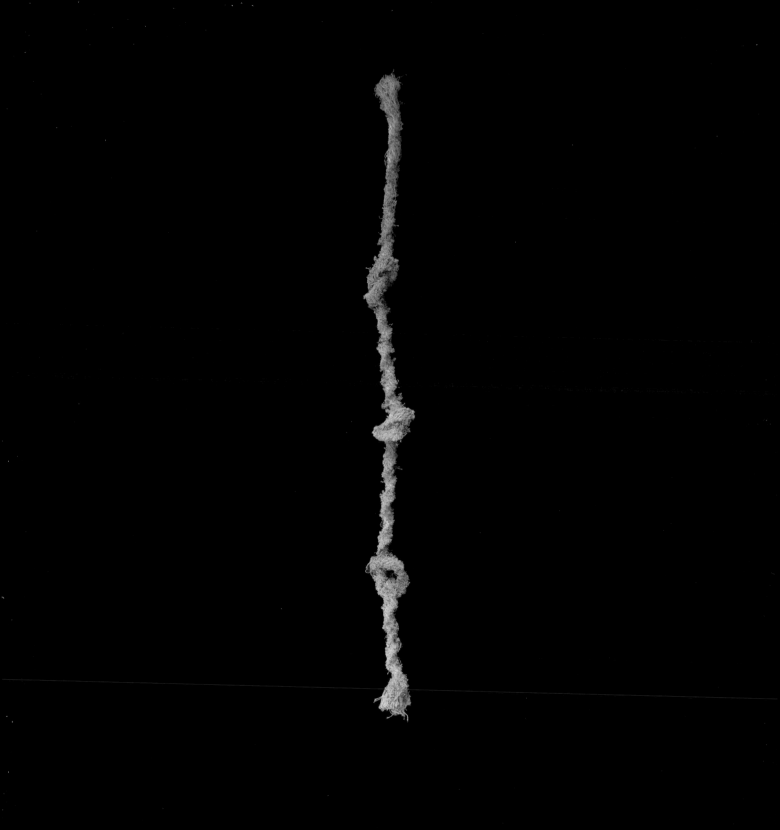

LOVE MAGIC

TO WIN THE HEART AND HAND OF THE MAN DESIRED THE YOUNG WOMAN WOULD BE GIVEN THIS BOWL FILLED WITH SALT AND BE INSTRUCTED AT THE NEXT FULL MOON TO GO TO A CERTAIN LANDMARK SUCH AS THE TOP OF A HILL OR A PARTICULAR FIELD.
THERE SHE IS TO REMOVE ALL HER CLOTHING AND, NAKED, TO WALK SLOWLY AROUND THE PRESCRIBED AREA.
AT EVERY STEP SHE IS TO DROP A PINCH OF SALT BEHIND HER.
SALT IS SACRED TO THE INFERNAL DEITIES AND IS A SYMBOL OF THE SOUL AND OF LIFE.

74. Salt Dish

75 x 75 x 15 mm

Magical practitioners Iain and Mary Steele donated this cut-glass dish to the museum. They used the dish on their altar as a container for salt. Salt was once regarded as a precious commodity extracted deep from the earth and sea at human expense. It is thought to provide intense magical and spiritual protection against evil spirits. In ritual, the element of Earth is often represented by bread and salt.

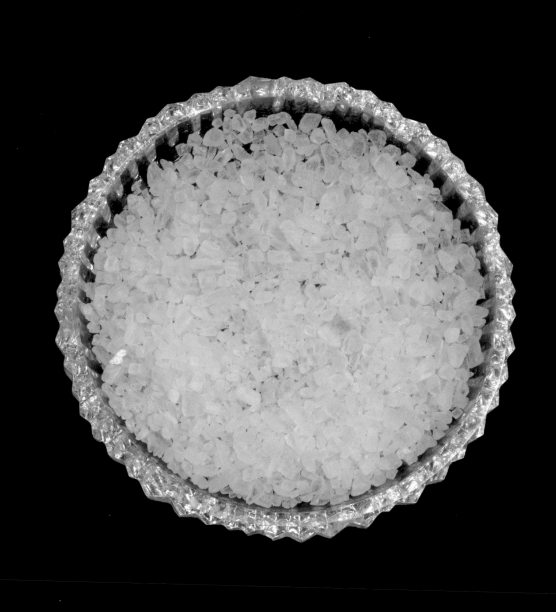

75. Knitted Poppet

360 x 165 x 350 mm

Poppets (**see item 10**) are recorded in the witchcraft trials and also featured in literature and film. Materials used to create the figures range from wax, clay, paper, carved roots, and twigs to cloth stuffed with herbs and knitted wool. The circumstances surrounding the creation of the poppet may vary, but the desired outcome is the same – to affect some form of change within the individual depicted. Poppets can be made to procure love when bound to another figure, heal disease or promote fertility, although in most instances their purpose is to cause harm.

This knitted poppet is made to represent a particular woman; her likeness reinforced by the incorporation of a black and white photograph. The pin that pierces her face in the photograph suggests a desire to cause her harm. Possibly this intention is also invested in the knitted body. It is thought that knitting is like ancient knot magic where magical force can be willed into each stitch.

'To make a spell stick it should be repeated a countless number of times. An easy way to do that is to knit a doll of your victim and with each stitch recite your particular hate wish. This pink lady had been doing a bit of what you fancy with another lady's old man. Oh yes, the doll did put an end to his seven-year itch.'

Cecil Williamson.

76. Alex Sanders' Ceremonial Mask

600 x 160 x 160 mm

This helmet mask belonged to Alex Sanders (1926-1988). Together with his partner Maxine he founded Alexandrian Wicca and became known as the 'King of the Witches'. Several press images show this helmet mask variously accessorised – Alex appears in Stewart Farrar's book *What Witches Do* (1971) wearing the mask with straight horns.

The transformation from human to beast is a central aspect of many traditional Pagan rituals that celebrate the seasonal cycle, fertility, life and death. The origins of animal symbolism can be linked to totemism and animal worship. A masked ceremony can stimulate the life force in nature by symbolic means. Distinguishing features, stylised dance imitating movements and actions, shapes and colours of animals are all emphasised, and sometimes in a relationship with humans. Ritual masks adorned with shells, feathers, skin, bone and horns from a totem animal can provide a ceremonial guise to mediate with spirits. Shamans often use masks to commune with the spirit world and share the spirit condition.

Biographies of Alex and Maxine Sanders include *King of the Witches* (1969) by June Johns and *Fire Child: The Life and Magic of Maxine Sanders 'Witch Queen'* by Maxine Sanders (2008).

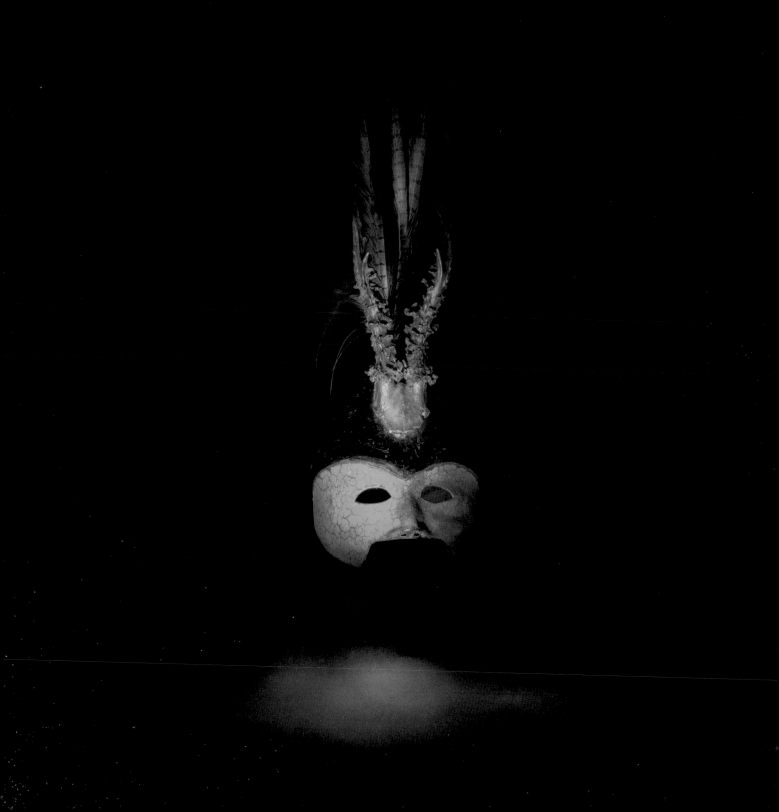

77. Charm to Prevent Further Miscarriage

Counterpane 2000 x 2000 mm

In 1976, a builder working on an old cottage in Falmouth, Cornwall found this crocheted white counterpane, sheet and dead swift sealed into a cavity beneath a bedroom floor. The builder wrote to Cecil Williamson explaining what he had found. Cecil concluded that this was a charm to prevent a further miscarriage, presumably because he had come across similar examples. He suggested that the bedding from the first miscarriage was used in the spell and the bird was killed as a sacrifice for the life to come.

In his book *The British Book of Spells and Charms* (2016) Graham King, museum owner and curator from 1996-2013, cites a related spell 'Ingredients to Cause Love or Hatred' found in the *The Book Of Witches* (1908):

'Take all the young swallows from one nest; put them into a pot and bury them until they die from hunger. Those that have died with their beaks open will excite love, and those with their beaks closed will bring hatred.'

He says 'It is thought that the dead swallows were placed under the bed or pillow of the person into whom love would "be excited".'

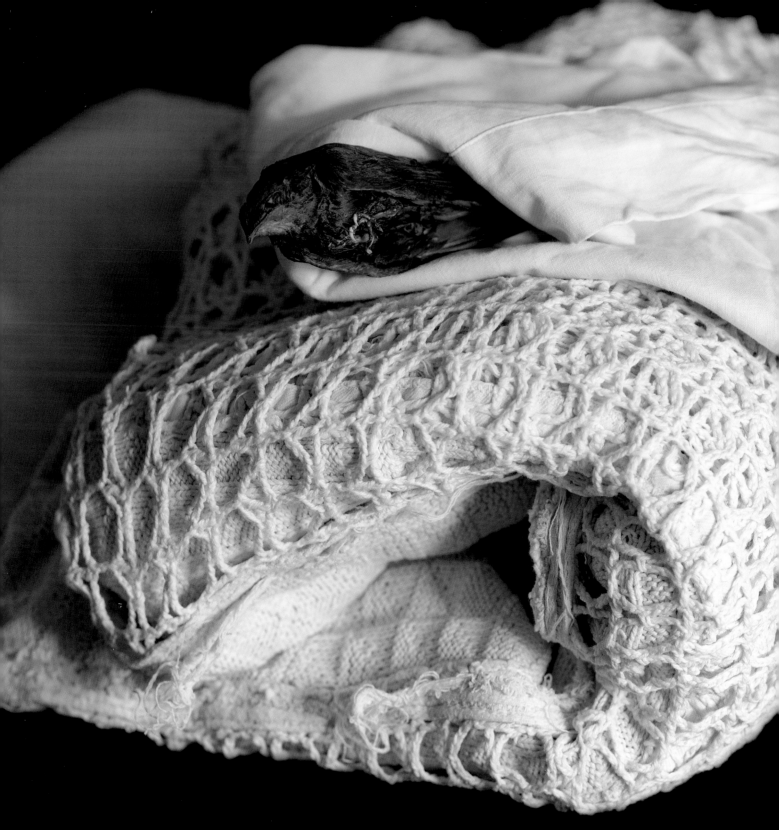

78. Corn Neck

540 x 80 x 80 mm

Gillian Nott, the Straw-work historian and archivist for the Guild of Straw Craftsmen, made this complex representation of a 'Corn Neck'. The 'neck' marks the end of harvesting and is traditionally kept until the following year. It is plaited from the last ears of standing corn, which are solemnly cut off in the field. A ceremony and celebration to mark an end of the harvesting was once common in Cornwall and Devon but declined with mechanisation. In 1928, St Ives Old Cornwall Society revived the ceremony of 'Crying the Neck':

When the last sheaf is held aloft, the person holding it would cry:

"I 'ave 'un! I 'ave 'un! I 'ave 'un!"
The rest would then shout,
"What 'ave 'ee? What 'ave 'ee? What 'ave 'ee?"
And the reply would be,
"A neck! A neck! A neck!"
Everyone then joined in shouting:
"Hurrah! Hurrah for the neck!
Hurrah for Mr (farmer's name)"

The ceremony is now held at various locations and often the local clergy is invited to conduct a short service in the field before the 'neck of corn' is cut. The sheaf is then carried in procession to the church where a service is held.

79. Lucky Grouse Foot Brooch

75 x 30 x 20 mm

Grouse or ptarmigan brooches originated in Scotland during the Victorian era. Scottish men and women would pin them to their kilts, shawls and cloaks for good luck, particularly when hunting. This brooch has the traditional grouse's foot bearing a ring on the central claw and an amethyst in a stag's head setting. The talismanic value of wearing an animal part is used variously to give its bearer particular magical powers associated with the animal, to provide protection from, or to attract and gain power over, the animal for the specific purpose of hunting.

This brooch, made in the 1950s by Mizpah, is in the style of Victorian examples. On the back of the pin the Mizpah range bears the trademark of two joined hearts with an arrow through them. These were popular in the mid-1800s. Mizpah is a Hebrew word for 'watchtower' and came to be known to mean an emotional bond between parted lovers.

80. Lucky Black Cat

150 x 45 x 60 mm

There are numerous and contradictory beliefs related to black cats. In parts of the UK and Japan a black cat crossing your path will bring good luck, but the opposite is true in the US. However, in Finland, cats are thought to carry the souls of the dead over into the other world whereas in Russia, if a black cat crosses your path you need to clasp hold of a button on your coat to avoid bad luck. In Scotland, if you come home to find a black cat sitting on your doorstep, it is regarded as good fortune. On the whole, black cats are considered lucky in Cornwall.

A good luck charm such as this, mass-produced in the 1930s, is sometimes known as a 'fairing', so called because cheaply made china or plaster ornaments were often sold or given as prizes at fairs. Fairings were a common feature on windowsills and mantelpieces.

In the popular imagination, the black cat, more than any other animal, is closely linked to the traditional image of the witch. The idea that cats could be witches' familiars was encouraged by the witch trial reports during the 16th century. A familiar is a specific, individual creature with whom a person has a psychic bond or, as described in the witch trials, minor demons who at Satan's command have become servants of the witch. When tortured some witches claimed to have received them directly from the Devil, others from a relative or friend.

81. Austin Osman Spare's Scrying Crystal

230 x 100 mm

This large quartz crystal is said to have belonged to Austin Osman Spare (1886-1956) the visionary artist and occultist. Quartz crystals are believed to enhance extrasensory perception and are often used for scrying; a method of divination or spirit-summoning that involves gazing at the surface of a translucent material. Concentration of the gaze can produce a state of self-induced hypnotic trance, which can increase the sensory powers of the scryer. In the 1920s, Austin developed his own form of magical practice, which came to be known, posthumously, as the Zoa-Kia Cultus. He experimented with trance-induced automatic drawing and writing, which later attracted comparison with the Surrealist movement. Austin Spare's magic and art have been extremely influential on many strands of occultists and esoteric artists.

This crystal, or one very similar, is thought to feature in several of his paintings depicting ritual magic including 'Rite and Ceremony', seen in *Zos Speaks!: Encounters with Austin Osman Spare* by Kenneth and Steffi Grant (1998).

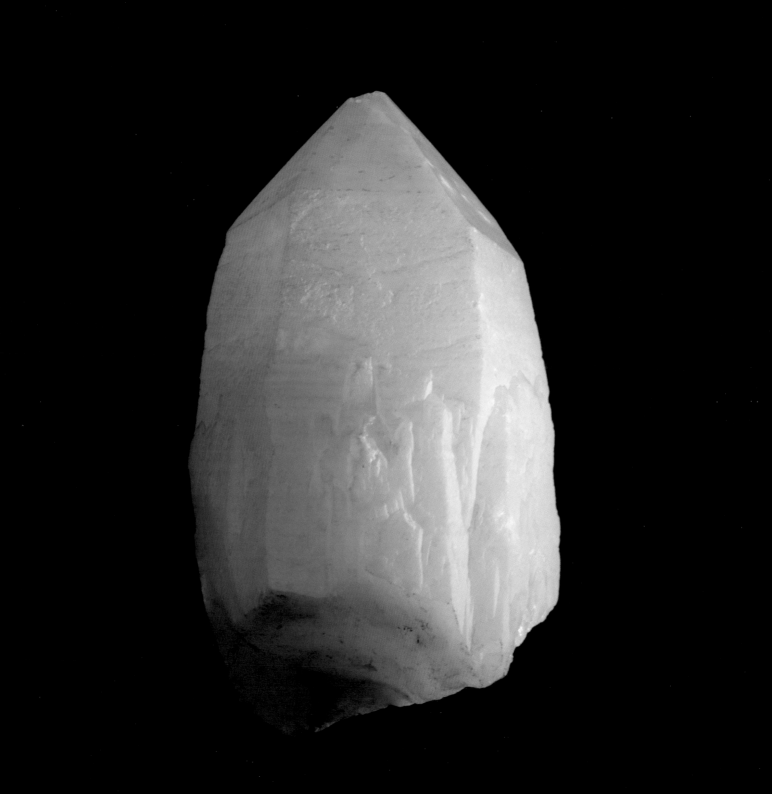

82. Meg Merrilies

830 x 260 x 230 mm

Old Meg she was a Gipsy,
And liv'd upon the Moors: Her bed it was the
brown heath turf,
And her house was out of doors. Her apples
were swart blackberries,
Her currants, pods o' broom; Her wine was dew
of the wild white rose,
Her book a church-yard tomb.

John Keats (1795-1821) wrote his poem while on a walking tour of Scotland as a trifle to send to his sister Fanny. He had heard the stories of the fictitious character, Meg Merrilies, from Sir Walter Scott's best-selling novel, *Guy Mannering* (1815). The poem is alleged to be based on a woman called Jean Gordon, a gypsy, who lived in the Scottish village of Kirk Yetholm in the Cheviot Hills. There's very little written of her cunning woman skills, but they seem to have been elaborated on in Scott's novel and then later by Keats. Jean was killed for her Jacobite sympathies in 1745.

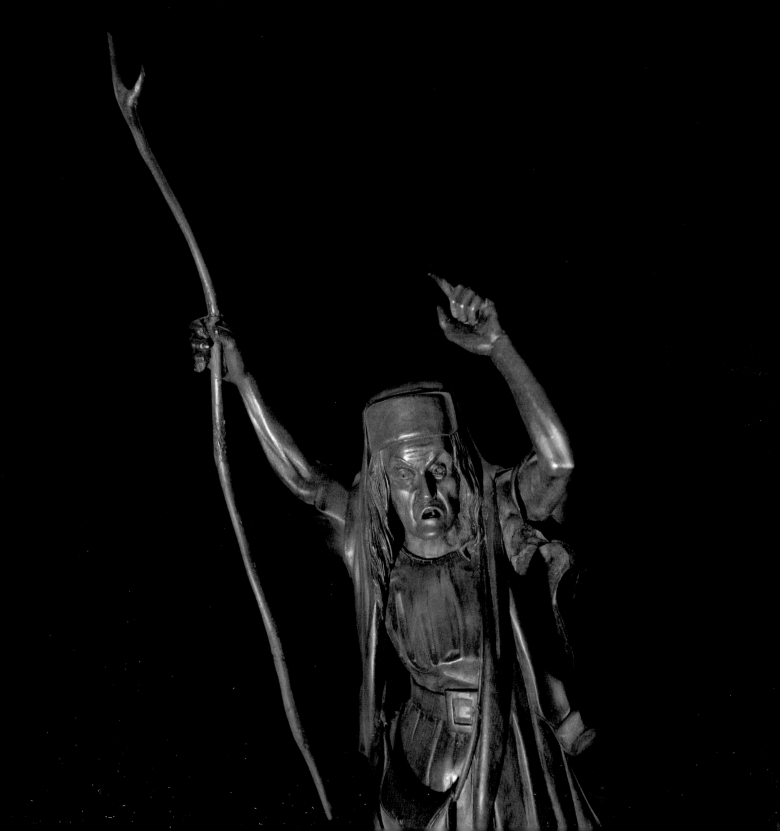

83. Coffin Puzzle with Beeswax Poppet Dolls

200 x 100 x 75 mm

'Everyone should take a little interest in coffins. We will all make use of one [some] day. Certainly witches know about them in all of their aspects and usage. This is a puzzle coffin of sarcophagus form and made of various woods. When closed, the trick is to find how to re-open it. With it are seen a stock of three beeswax poppet dolls. Note that these dolls have a slot provided in their back into which can be inserted written spells, nail parings, hair etc. and then sealed before enclosing within the coffin, this is straight up and down ill-wishing black magic. This rather elaborate toy for an average West Country witch belonged, as its sophistication indicates, to a well-to-do lady who once lived in the Mount Pleasant area of Exeter. She was a clairvoyant and medium who worked in her maiden name of Madam de la Cour, known to her friends as Flora.' Cecil Williamson.

The flesh-like appearance and malleable properties of beeswax lend themselves to the making of human effigies for religious and magical purposes. The practice of modelling or moulding wax can be traced back to the production of ritual death masks in ancient Rome. During the Middle Ages, it was common for votive offerings of wax figurines to be offered to the church (**see item 4**). Effigies of notable individuals and scenes depicting monarchs were also made from wax. Similarly, likenesses were produced of hated persons, into which pins were thrust, believing this would inflict fatal injury (**see items 10, 19 and 75**). The inclusion of the victim's hair or nail clippings into the effigy would further strengthen the connection with the individual.

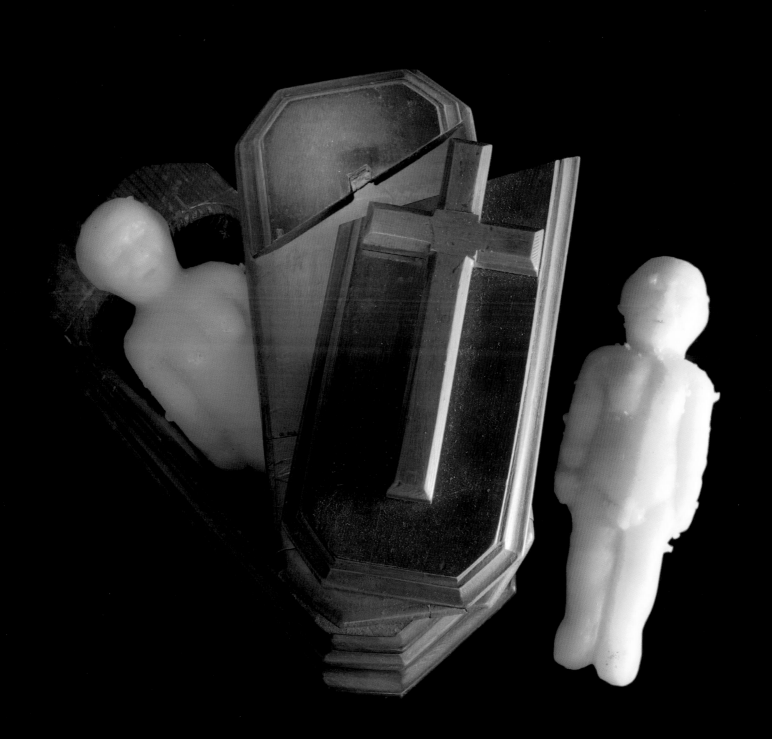

84. Dance of the Witches

400 x 265 x 70 mm

Dance of the Witches is a memory and strategy board game designed by Bjorn Holle and produced in 1999 by FX Schmid, a German company based in the UK. The game involves trying to remember which of the witches' hats is yours: they all look the same but have a witch hidden beneath them. This game demonstrates the complex identity of the witch who can be both hidden and present.

The imagery portrays a light-hearted image of the Witches' Sabbat and includes some distinctive elements described by Reginald Scot in *The Discoverie of Witchcraft* (1584). Reginald quoted from a French source Bodin who says:

'At these magicall assemblies, the witches neuer fail to danse; and in their danse they sing these words, Har bar, divell, divell, danse here danse here, plaie here plaie here, Sabbath sabbath. And whiles they danse, euerie one hath a broome in hir hand, and holdeth it vp aloft.'

The stereotyped representation of a witch wearing a pointed hat was common by the 1700s. Suggestions as to the origins of this motif range from the desire to show witches as old-fashioned by portraying them in clothes worn in the Middle Ages, to notions that the conical shape of the hat is a powerful conduit for energies, therefore implying magical power.

85. Witch Doll

300 x 150 x 70 mm

The provenance of this witch doll is unknown. She has a reinforced wax head with fixed glass eyes, a cloth body and ceramic hands. Like many of the wax dolls produced in England and Germany, she is without a maker's mark. Her clothes are in poor condition and her broomstick has been missing since the flood of 2004.

There is a long European tradition of placing witch dolls in the home. In Germany, many homes have a 'house witch' – a fabric model of a witch often with a small coin sewn into the witch's pocket – to bring them good luck. Some homes even have both a large 'house witch' and a small 'kitchen witch'. The doll or puppet, often represented as an old crone, is regarded as a good witch who protects the home. According to some sources the Kitchen Witch was also known in England during Tudor times. The will of one John Crudgington, of Newton, Worfield, Shropshire, dated 1599, divides his belongings between his wife and three children, 'except the cubbard in the halle the witche in the kytchyn which I gyve and bequeathe to Roger my sonne.'

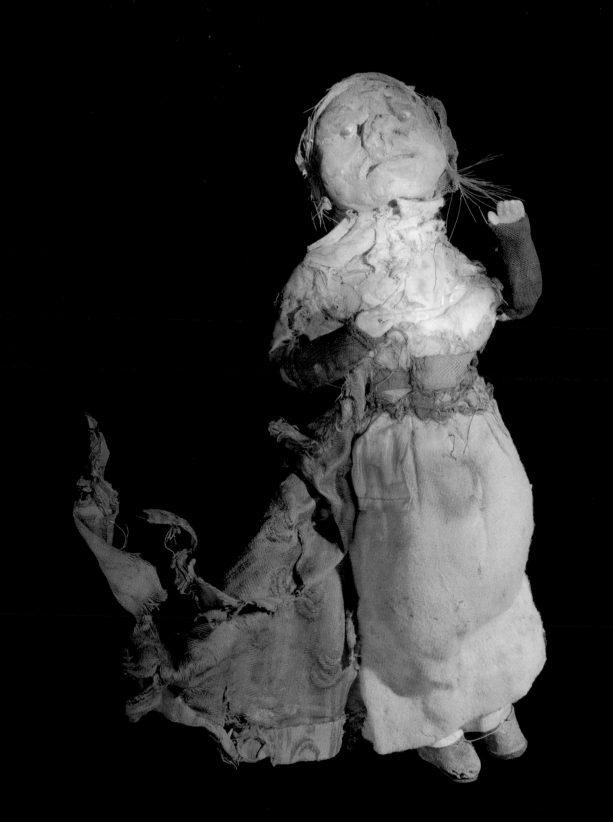

86. Ram-Headed Rhyton

300 x 100 mm

Rhytons such as this possibly originated from ancient drinking horns widespread throughout Eurasia since prehistoric times. These vessels were used as containers from which fluids were intended to be drunk or to be poured ceremoniously as a libation (a liquid offering to a deity or spirit). Ritual sprinklers or libation vessels were frequently made in the shape of animal heads with small holes in the mouth to allow the liquid to issue forth. Rhytons terminating in animal heads were designed to resemble, when being filled, an animal drinking. The maker of this object is unknown but its shape and decorative motifs bear strong resemblance to a ceramic ram-headed rhyton from Southern Italy circa 4th century BC.

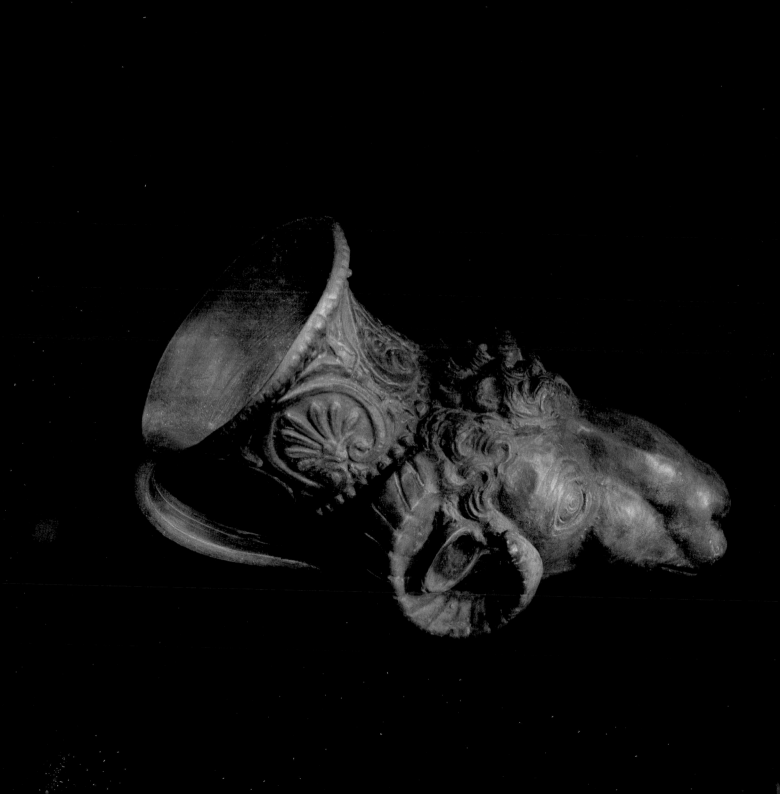

87. Plait of White Hair

300 x 80 x 50 mm

Cecil Williamson describes this object as:

'A hank of plaited white hair removed from the head of a beloved one before burial.' He concedes that 'the folklore of human hair and the preservation of snippets of locks of hair is a large subject. To a witch, the hair of any person contains a part of the spirit of that person and so on, anyway to have, to hold and to preserve a hank of hair is as good as having a front door key to a house. Hence with the hair the witch can conjure up the late owner, surprisingly séance mediums do not make any use of this method of jumping the fence of death which separates our worlds.'

A single strand of hair can be worked into a waxen poppet or woven into a witch's ladder. In Italy, these ladders are known as 'witch's garlands'. The hair is knotted or braided with a length of rope or strong thread. Knots are tied to bind the spell and often feathers are introduced to make it take flight. The number of knots and the specific incantations repeated during its creation vary with the particular magical intention.

One of the most important factors concerning hair is its disposal. Traditionally, cut hair should be buried. *The Vendidad* – a 5th-century Zoroastrian sacred text – advocates:

'Thou shalt take them away ten paces from the faithful, twenty paces from the fire, thirty paces from the water, fifty paces from the bundles of baresma [holy twigs]. Then thou shalt dig a hole, ten fingers deep if the earth is hard, twelve fingers deep if it is soft; thou shalt take thy hair down there and thou shalt say aloud these fiendsmiting words, "Out of His pity Mazda made plants grow". Thereupon thou shalt draw three furrows with a knife of metal around the hole, or six or nine and thou shalt chant the Ahuna Vairya three times, or six, or nine.'

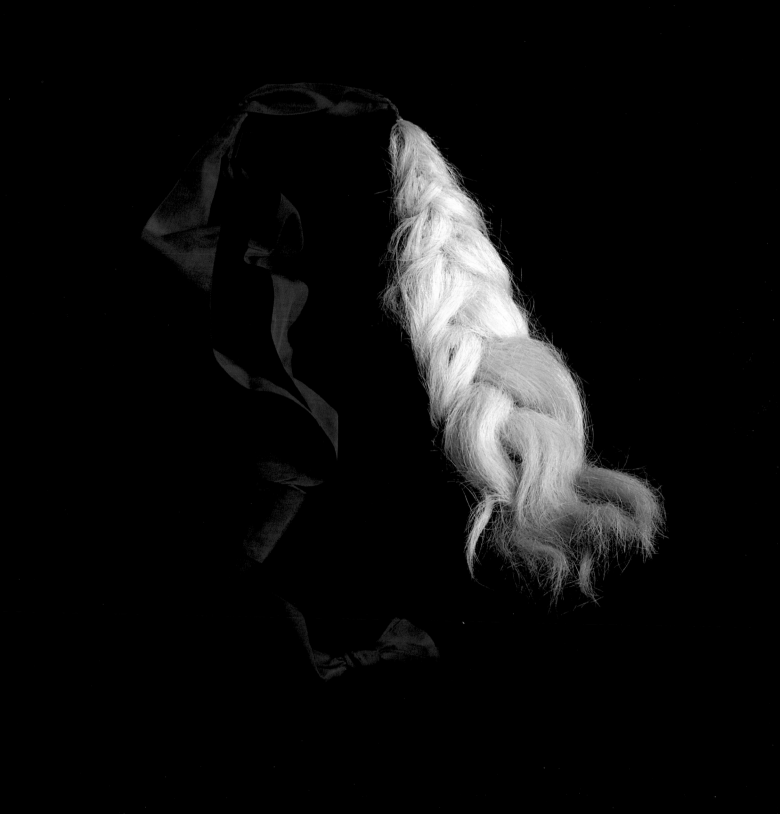

PLEASE DO NOT DISLIKE THIS SKULL. LIKE YOU IT ONCE COULD LAUGH AND MAYBE CRY, BUT THOSE IN AUTHORITY DECIDED IN THEIR SELF-ASSUMED WISDOM TO CHOP HIS HEAD OFF AND DUMP IT INTO A CAULDRON OF HOT TAR. AND THE HEAD WAS EXPOSED AS A PUBLIC WARNING. AT SOME LATER DATE A KIND SOUL, ALMOST CERTAINLY A PRIEST, RETRIEVED THE MUCH ABUSED HEAD AND PLACED IT IN THIS BIBLE-BOX. HITLER'S BOMBS BLASTED THE LONDON CHURCH WHERE THE BOX WAS FOUND IN THE RUBBLE OF WHAT HAD BEEN THE EAST WALL DIRECTLY BEHIND THE ALTAR. REJECTED BY THE CHURCH AS AN UNWANTED RELIC - NOT SURPRISING - THE HEAD PASSED THROUGH NUMEROUS HANDS AND IN PASSING STRANGE TALES STARTED TO GROW UP AROUND IT.

AS JESUS CHRIST URGED US - "LOVE ONE ANOTHER". WELL, THIS EXAMPLE OF MAN'S INHUMANITY TO MAN RESPONDS TO KINDNESS AND AFFECTION. ACCEPT MY WORD FOR THAT. SO AS YOU GO ON YOUR WAY, SPARE THE POOR SOUL A KIND THOUGHT, MAYBE A SMILE AND JUST A LITTLE WAVE OF YOUR HAND. YOU MAY WELL BE SURPRISED AT WHAT A LITTLE WARMTH AND AFFECTION CAN DO FOR YOU.

88. Skull of an Egyptian Mummy

330 x 230 x 380 mm

Research conducted by Dr Martin Smith at the University of Bournemouth has enabled him to conclude that: 'This human cranium belonging to a female probably aged in her thirties has a quantity of skin and other soft tissues preserved beneath a layer of a dark resinous substance.'

The skull was acquired by Cecil Williamson several decades ago and was claimed to have been recovered from a London church that was bombed during the Second World War. It was placed inside a carved oak box similar to that of a Bible box. Known affectionately as 'Harry' the original museum record described it as the head of a medieval execution victim, assumed to have been dipped in tar to preserve it for display. Modern analysis of the head using CT scanning, radiocarbon dating and chemical analysis, amongst other methods, has in fact revealed it to be from an Egyptian mummy, dating from between 361-112 BC. Further information can be found in the *Archaeological and Anthropological Sciences* article 'Multidisciplinary analysis of a mummified cranium claimed to be that of a medieval execution victim' (2011).

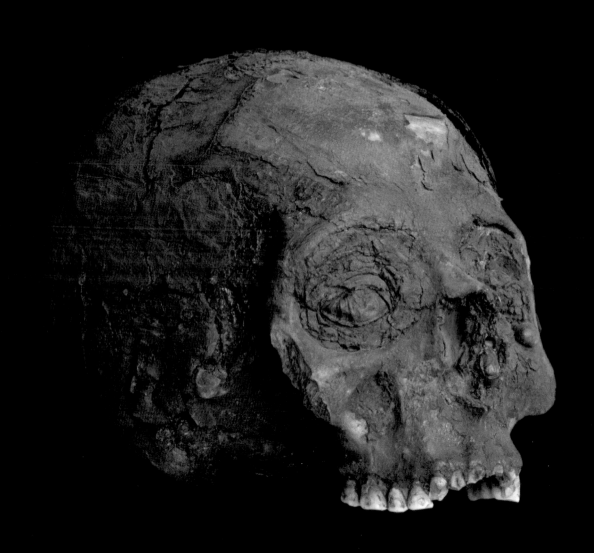

"CROSS MY PALM WITH SILVER AND I WILL READ YOUR HAND" – AND WHO OF US IS THERE THAT, AT ONE TIME OR ANOTHER, HAS NOT HAD THEIR HAND READ.

89. Palmistry Hand

260 x 170 x 80 mm

Palmistry is an ancient art, believed to have originated in the earliest civilisations. According to a text by Bavarian physician Johannes Hartlieb in 1456, palmistry was prohibited by canon law. It was considered one of the forbidden arts along with nigromancy, geomancy, hydromancy, aeromancy, pyromancy and scapulimancy.

This ceramic palmistry hand shows the significant lines and mounts on the palm, the study of which is known as cheiromancy. The symbolic meanings attached to the various lines, mounts and markings on the surface of the palms and wrist indicate the past, present and future. The second aspect in palmistry is chirognomy, which ascertains one's personality from the physical characteristics of seven different types of hand.

Palmistry hands were first manufactured in the UK in the 1880s, partly due to the popularity of Count Louis Hamon (1866-1936), an Irish palmist, numerologist, and astrologer, better known as 'Cheiro'. He is said to have predicted the dates and deaths of Queen Victoria, Edward VII, the assassination of King Humbert of Italy, and even his own death, to the hour. Some Romani Gypsies in the UK recall past generations placing palmistry hands in their caravan windows to advertise their fortune telling skills, a strategy seen today by many commercial palmists wherever they practice.

IDEAL

IDEAL

IDEAL

MENTAL

MENTAL

MENTAL

1ST PHALANGE

MATERIAL

MATERIAL

Saturn

2ND PHALANGE

MENTAL

3RD PHALANGE

MATERIA

MERCURY the Sun Ring of Saturn Solomon's Ring

ne of marriage Girdle of Venus JUPITER

Line of HEART

The Quadrangle Line of Head

Line of Sun

Line of Life

ARS Line of Destiny

Line of Health

VENUS

NA Line of Intuition

Line of Lascivia

BRACELETS of LIFE

Palmistry

90. Besom

110 x 1800 x 600 mm

A broom or besom traditionally constructed by Sue Nash using silver birch for the brush head and hazel for the handle. Sue's late husband Arthur made besoms all his working life, and his family before him, for three hundred years. Their company, A. Nash Besom Brooms, was awarded the Queen's Royal Warrant in 1999. Sue also makes brooms for witches, Romani Gypsies and Travellers, and the cast of Harry Potter films.

There can be no other implement more closely associated with the traditional image of a witch than the broom. In fact, this household implement has become an emblem of witchcraft. Countless images show the witch flying through the night skies on a broom, especially to the Sabbat. Witches were thought to fly by smearing themselves and the broom with a 'flying salve' made from various plant extracts such as hemlock, belladonna and wolfsbane. Mind-altering drugs enabled them to go on 'night rides': the visions depicted are often sexualised.

In modern witchcraft, the besom is used in ritual to cleanse a sacred space before a circle is cast. At many Wiccan and modern Pagan handfasting ceremonies, often a besom is laid on the floor for the newly wed couple to jump over, denoting the sweeping away of the past and a clean start for their future. 'Jumping the broomstick' to signify marriage has long been practiced by Romani Gypsies and Travellers in Britain.

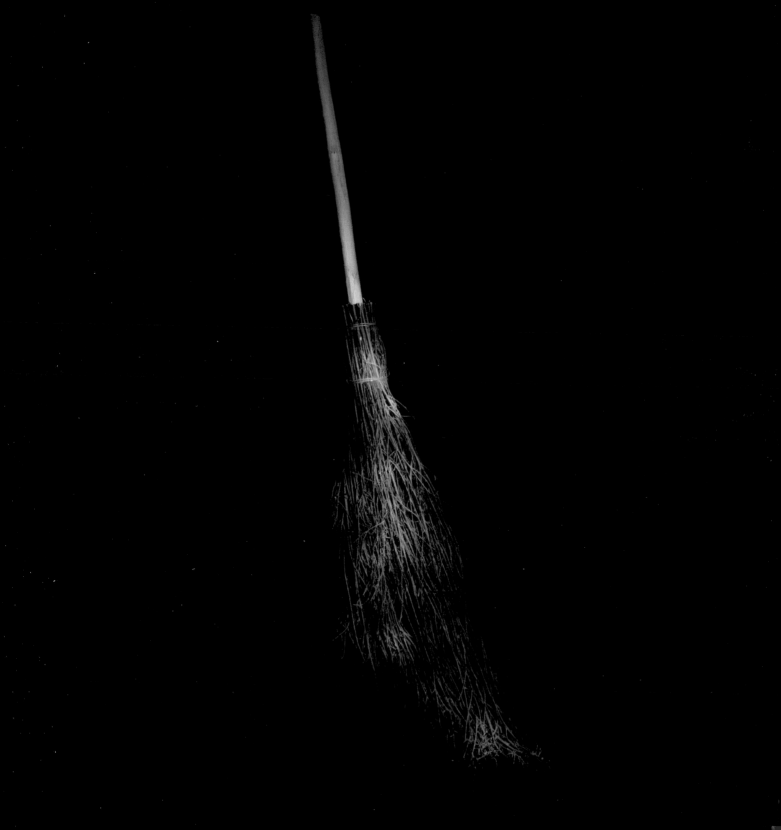

91. Healing Herbs

90 x 300 mm

In 2000, fifty-six jars of herbs were donated to the museum from the Monica Britton Medical History Collection (1800-2000) in Bristol. Medicines were usually extracted from plants and other raw materials by soaking or dissolving herbs in liquids, most commonly water or alcohol. However, distillation produces a purer and stronger result: an alembic – a vessel with a tube – captures steam or the 'essence' of the materials and the liquid obtained is known as an essential oil.

Plants are ubiquitous in magic and herbal lore remains the root of all traditional healing systems. *The Lacnunga* (Remedies) a collection of miscellaneous Anglo-Saxon medical texts from the late 10th/early 11th century, gives instructions on the medical uses of herbs, sometimes with accompanying spoken or sung charms, prayers and ritual action. The most efficacious time for a plant to be picked is also outlined. Mulberry, for example, should be picked, 'when to all men the moon is seventeen nights old, after the meeting of the sun, 'ere the rising of the moon.'

In *The Physical Directory* (1649) and *The English Physician* (1652) the British herbalist Nicholas Culpeper provides many herbal remedies still in use today. Practical knowledge of the effects of herbs and plants was often the domain of 'cunning folk' – wise women or men. Herbal lore was also passed on orally, and in homemade 'recipe' books listing ointments, poultices, infusions, distillations, fumigations, and oils.

The herbs pictured here include dandelion, the juice of which is a well-known cure for warts, and an infusion, which is recommended for gallstones, jaundice and other liver problems. Golden Seal is a multi-purpose remedy and effective aid for digestion. The bulbs of Meadow Saffron contain colchicine, which is used medically for gout and arthritis.

DANDILION

" With this homely
salad, Hecate
entertained
Theseus . "

JOHN EVELYN

" Acetaria "

Golden Seal
Root

Meadow Saffron
Corms

SEMEN PAP...
Papaver somni...
...bien, Deut...
E. Merck.

...TUS JUNIPERI
...communis
Conifrege...

92. Poppy Seed Heads

250 x 40 mm

Like all of the herbs and plants donated from the Monica Britton Collection in 2000, these dried poppy heads can be used for medicinal and magical purposes. Because of the multiplicity of its seeds, the poppy is considered a symbol of abundance and fertility. The bulging seedpods can be hung on red thread and suspended over the bed as a fertility enhancer. This is a form of contagious magic that enchants transference of fullness and fecundity.

The hypnotic qualities of the poppy were well known in ancient Greece where it was regarded as a magic or poisonous plant and used in religious ceremonies. The divinities of the underworld were portrayed wreathed with poppies or carrying poppies in their hands. Poppies adorned statues of Kybele, Isis, Apollo, Asklepios, Pluto, Demeter and Aphrodite among other deities. Poppy seed heads are also found in the headdresses of Minoan goddesses, and on figurines, bas-reliefs, vases, tombstones, coins and jewellery. Later the plant was used medicinally. The ancient Sumerians in Mesopotamia referred to the poppy as *hul gil* (the plant of joy).

More than 900 years ago Arabic physicians identified opium. The alkaloid morphine was purified from crude opium in 1803 and reacted with acetic anhydride to yield heroin in 1874. Derivatives of opium alkaloids continue to play a major role in analgesics.

93. The Rider-Waite-Smith Tarot Deck

12 x 7 x 1 mm

Tarot cards are thought to have originated in the mid-15th century in Italy and France as playing cards with four suits – swords, batons, polo sticks and cups or coins – later evolving into swords, wands, pentacles and cups. By the 18th century tarot had developed into a pack of archetypal images, each with a divinatory meaning ascribed, almost exclusively used by occultists for cartomancy.

Arthur Waite (1857-1942) commissioned Pamela 'Pixie' Colman-Smith (1878-1951) to illustrate a tarot deck, which was published in 1910 by William Rider & Son. Waite and Colman-Smith were both members of the Hermetic Order of the Golden Dawn. They developed the deck to further the order's teachings, incorporating astrological, alchemical and magical symbolism in relation to Hebrew Kabbalah. It consists of the Major Arcana of twenty-two cards and the Minor Arcana of fifty-six cards, and was accompanied by a guidebook, *The Key to the Tarot* written by Arthur Waite.

The imagery is inspired by the Italian Sola-Busca tarot deck, which was exhibited at the British Museum in 1907. However, Pamela has adopted the style of Japanese colour prints, employing a flat perspective with black outlines. The symbolism builds upon the influential ideas of the philosopher Eliphas Levi (1810-1875), who formalised the link between the Kabbalah and the tarot. The stages of development on the Tree of Life are represented by ten sephiroth in four worlds of creation. The ten numbered cards in each suit of the Minor Arcana reflect the subject's progress through the human condition via the four elements, Fire, Earth, Air and Water. There are twenty-two pathways passing through all the stages in the Tree of Life and twenty-two cards of the Major Arcana.

The High Priestess depicted on this tarot card sits on a throne between darkness and light, represented by the pillars of Soloman's Temple and The Tree of Life in the background. She holds the half revealed Torah on her lap, symbolising exoteric and esoteric teachings and higher knowledge. The moon under her left foot indicates her dominion over intuition. Her arms are crossed equally, showing a balance between the material and spiritual, 'as above so below'. She embodies spiritual enlightenment, intuition, higher powers, wisdom, serenity, mystery and the subconscious mind. The High Priestess card represents mothers, psychics and intuitive women teachers.

94. Gerald Gardner's Hat

100 x 230 x 330 mm

This trilby was made by Frank's Hats in the 1920s and belonged to Gerald Gardner (1884-1964). He may well have worn this hat while working as a customs officer in Malaysia, where he became interested in the occult and anthropology.

According to Gardner, in 1939 he was initiated into a New Forest coven that claimed a continuity dating back to medieval times. After the war he started a coven at Bricket Wood, St Albans, and co-authored the standard texts and liturgy of Wicca, along with High Priestess Doreen Valiente. He was influenced by Freemasonry, The Hermetic Order of The Golden Dawn, and Aleister Crowley's ceremonial magic. Publications inspirational to his magical practice were *Aradia, or the Gospel of the Witches* (1899) written by the American folklorist Charles Godfrey Leland and *The Witch-Cult in Western Europe* (1921) by the Egyptologist Margaret Murray. In 1954 Gardner's book, *Witchcraft Today,* was published, outlining his beliefs and setting the foundations for Wicca with a preface by Margaret Murray.

Patricia Crowther donated Gerald's hat to the museum. Patricia was initiated into Wicca by Gerald in 1960 and was later to become High Priestess of the Sheffield coven. She is a celebrated occultist and author of many books including *High Priestess: The Life and Times of Patricia Crowther* (2001).

95. Mother Goddess

170 x 70 x 25 mm

Museum records indicated that this goddess figure was inspired by the 6,000-year-old statue thought to be of the Nile Goddess Nathor, in the Cairo Museum. She has a prominent belly and wide hips, the characteristics of an archetypal divine mother. In addition the elongated, abstracted form, unarticulated legs and slender upstretched arms resemble female forms that occur throughout most of the Predynastic Period as figurines and on vessels.

In 1989 the Lithuanian-American archaeologist Marija Gimbutas analysed the symbols identified with the snake goddess, bee goddess and bird goddess etc. and recognised these as manifestations of a Great Goddess. She postulated the existence of an ancient matriarchal goddess religion that had been suppressed by patriarchal powers. Taking an American radical feminist perspective on the early modern witch trials, she asserted that the eight million women murdered were those who had venerated the goddess. She described the victims as the 'wise women, prophetesses and healers who were the best and bravest minds of their time'.

In response to the feminist spirituality movement in America and the UK in the 1980-90s many artists made figurines based on the Palaeolithic and Neolithic sculptures, which were placed on altars or in shrines. Variations on this form of the Goddess figure are commercially available today.

96. The Romany Fortune Telling Cup and Saucer

Cup 60 x 110 x 100 mm, Saucer 20 x 145

The Romany Fortune Telling Cup and Saucer was designed by the English ceramic artist Clarice Cliff (1899-1972) and produced by A.J. Wilkinson, Royal Staffordshire c.1936-7. 'Reading' leaves for fortune-telling was commonly practiced by Romani Gypsies, hence the design. First reports of this method of divination appear in the 17th century, coinciding with the introduction of tea into Europe from China.

These printed cups are a 19th-century development of tasseography. The word derives from the French, tasse, meaning cup and the Greek, graph, meaning writing. By noting which symbol the tea leaves land on, the diviner would consult an explanatory booklet to reveal its meaning and interpretation. The original method of divination involved the diviner's ability to recognise, in the dregs of tealeaves, shapes and patterns that suggest and resemble emblems or letters. The symbolic meaning is also determined by its position in the cup.

Traditionally, after the enquirer has drunk tea made with loose leaves, the dregs are swirled around inside the cup, inverted on the saucer and sometimes turned clockwise three times. The diviner examines any leaves on the inside of the cup and sometimes those deposited in the saucer.

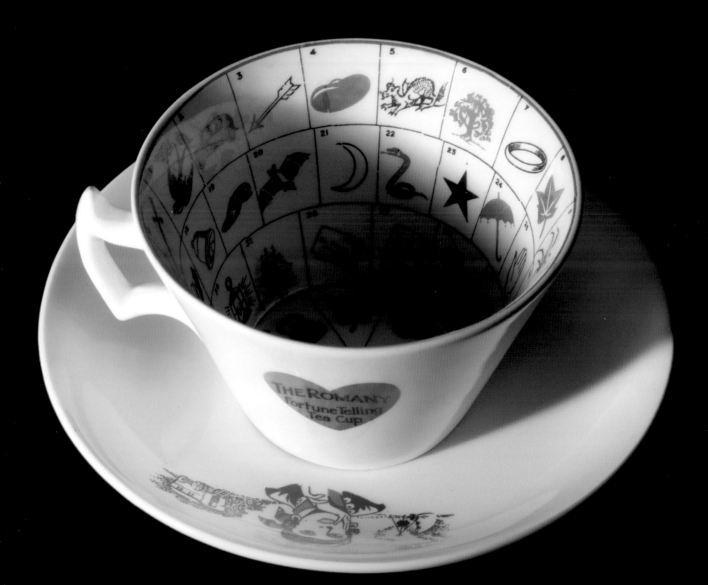

97. Wish Box

100 x 65 x 65 mm

Wish boxes come in all shapes, sizes and materials. Magic boxes are thought particularly auspicious for spells, and the desire to protect a written wish within a box is a widespread practice. This hardwood casket with lions' heads on each of the sides originated from the Honiton area in Devon.

Many beliefs are associated with the charging and the placement of wish boxes. Some people keep a magic number of seven items in the box. Occasionally the boxes are bound in red thread while the wish is repeated, or a mirror is placed inside to increase the potency of the wish.

The museum also has an example of a 'Get Lost Box' concealed within a silk stocking. To banish someone or something, a representation would be placed inside the box and then left at a crossroads. Another belief concerning magic boxes was that illness could be transferred via contagion. By placing diseased skin scrapings inside the box, it was thought that whoever picked it up would contract the illness.

98. Crystal Ball

190 x 130 x 130 mm

The crystal ball is one of the most ubiquitous aids to clairvoyance and spirit summoning. It has featured in numerous films and books including the *Wizard of Oz* (1939), *The Crystal Ball* (1943), *Harry Potter and the Prisoner of Azkaban* (2004), *Grimm's Fairy Tales* (1812-14) and the novels of J.R.R. Tolkien.

Scrying with translucent material is an ancient practice. The scryer assumes a mild self-induced trance, fixing his or her gaze upon the ball, on which images can appear. These images may refer to the past, present or future in chronological order or in disconnected scenes.

In 1820 a rock crystal was found in a grave dating to 300 BC in Aarslev Kirkebakke on the island of Funen, Denmark. The crystal has a palindromic inscription, ABLANAQANALBA, which relates to the Mediterranean God Abraxas, meaning 'You are our Father'. Abraxas was the ruler of the cycle of birth, death and resurrection. The Greek letters of his name correspond to the numerical equivalent of 365, the number of days in the solar year. Beneath the inscription on the ball is a small anchor, an early symbol of hope which may refer to the soul of the deceased.

Classical authors thought that rock crystal possessed healing properties – it could assuage thirst, and cool and cure fever. Another property of the crystal ball is that if one looks through it, it is possible to see the world upside down, which contributes to its magical significance.

This crystal ball belonged to Cecil Williamson who asserted: 'If you really must understand this world, first you must stand upon your head.'

Thus turning your vision upside down.

99. Ceremonial Robe from the Order of Artemis

1350 x 420 x 30 mm

The use of ceremonial clothing, during ritual or magical practise, is an ancient one. Robes and vestments serve to make a clear distinction between the everyday and the magical or spiritual. The magical practitioner Ralph Harvey donated this ceremonial robe to the museum in 1999. It was worn by 'Herne', the High Priest of The Order of Artemis, in Shoreham-by-Sea in Sussex.

Made around 1953, the robe has a sigil of power marked in silver ink on the right sleeve. One of the tests for witches in the group being elevated to the third degree was to name the sigils and to identify the mark of power. The first robes that many of the members wore were primitive and subsequently discarded as most of the coven chose to work skyclad (a term for ritual nudity). Clothing is seen by some as an impairment to the natural flow of energy emanating from the body during a rite.

100. Carved Wooden Witch Mask

320 x 200 x 160 mm

The heavy features of this mask depict a traditional image of a hag or Old Witch-woman. It bears a resemblance to the masks worn during The Swabian Alemannic Fasnetin (Carnival) in Furtwangen, Black Forest, Germany. The mask shares common features with the Offenburger Hexe (Offenberger Witch) and the Gengenbacher Hexe (Gengenbacher Witch). These local witch characters were introduced into the carnival during the 1930s. It also looks similar to the carnival disguises adopted by men who formed a 'witch group' in the 1950s, resulting in the 'Town Witch', Stradhexe.

The Furtwangen carnival, like others in Southwestern Germany, culminates with a parade on Shrove Monday before ending on Shrove Tuesday. This is followed by Ash Wednesday, the first day of the 40-day Lenten fast. The folklorist Dietz-Rüdiger Moser, in his book *Fastnacht – Fasching – Karneval* (1986), explains that Fastnacht was equated with the kingdom of the Devil, '*civitas diaboli*', and Lent was seen as part of the kingdom of God, or '*civitas Dei*'. The conflict between the enjoyment of Fastnacht and the deprivation of Lent may have led to the creation of characters such as demons, devils and witches in the carnival.

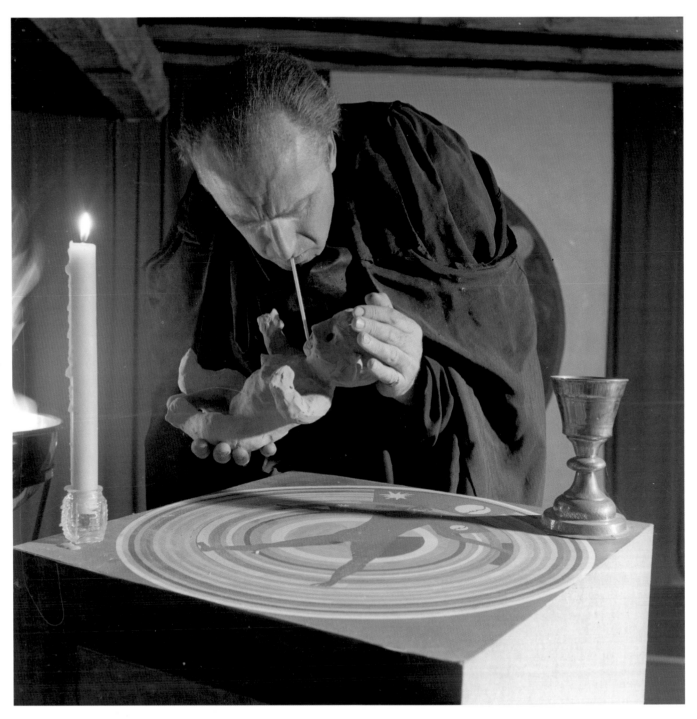

Cecil Williamson breathes life into a poppet.

Sara Hannant is a photographer and author whose work over the last ten years has explored magical belief, seasonal cycles and folklore. Her first book *Mummers, Maypoles and Milkmaids: A Journey through the English Ritual Year* (2011) received the runner-up Katharine Briggs Folklore Award 2012. Sara has exhibited widely including at The Royal Society of Arts, The Horniman Museum, The South Bank Centre and Towner Art Gallery. Her photographs have been featured on the BBC, and in *The Guardian* and *The Sunday Times* among others. Since 2010 she has lectured in photography at City University in London.

Simon Costin is the director of the Museum of Witchcraft and Magic in Cornwall. He studied Theatre Design at Wimbledon School of Art in the mid '80s and has since become an internationally respected art director, set designer and curator. Costin's artwork has been displayed in many exhibitions, at venues as diverse as a forest in Argyll, the ICA in London and the Metropolitan Museum of Art in New York, which now owns several of his pieces. His lifelong passion for folklore has resulted in the launch of the Museum of British Folklore, a long-term project which aims to establish the first ever centre devoted to celebrating and researching the UK's rich folkloric cultural heritage.

Bibliography

Agrippa, Henry Cornelius. (1993) *Three Books of Occult Philosophy*. trans. Freake, James., ed. Tyson, Donald. St. Paul, MN: Llewellyn. 1st ed.1531

Ansell, Robert. (2005) *Borough Satyr: The Life and Art of Austin Osman Spare*. London: Fulgar

Aubrey, John. (1696) *Miscellanies*. London: Edward Castle

Beskin, G. & Bonner, J. eds. (1999) *Austin Osman Spare: Artist - Occultist - Sensualist*. Bury St Edmunds: Beskin Press

Blagrave, Joseph. (1671) *Astrological Practice of Physic, Discovering the True Way to Cure All Kinds of Diseases and Infirmities Which are Naturally Incident to the Body of Man*. London: S.G & B.G.

Booth, Martin. (2000) *A Magick Life: The Life of Aleister Crowley*. London: Coronet

Bottrell, William. (1870) *Traditions and Hearthside Stories of West Cornwall*. Burnham-on-Sea: Llanerch Press (reprinted 1997)

Bray, Mrs A. E. (1879) *The Borders of the Tamar and the Tavy. Their Natural History, Manners, Customs, Superstitions, etc., new edition, 2 vols.,* London: John Murray

Bridges, R.S. (1919) *The Spirit of Man; An Anthology in English & French from the Philosophers & Poets.* (inc. Keats. J. 'Meg Merrilies') London: Longmans Green and Co.

Briggs, Katharine. (1977) *A Dictionary of Fairies.* London: Penguin. 1st ed. 1976

Briggs, Katharine. (1967) *The Fairies in Tradition and Literature*. Chicago: University of Chicago Press

Brown, Reginald A. (1949) *Horse Brasses: Their History and Origin*. Lewes: Baxter Ltd. 1st ed. 1949

Budge, Wallis E.A. (1895) *The Egyptian Book of the Dead: (The Papyrus of Ani) Egyptian Text Transliteration and Translation*. New York: Dover Publications Inc.

Cadbury, Tabitha. (2010) *The Clarke Collection of Charms and Amulets in Scarborough Museum. Museum of Witchcraft and Magic Library,* Book no. 5841

Cardinall, A.W. (1931) *Tales Told in Togoland*. Oxford: Oxford University Press

Carr-Gomm, Philip & Heygate, Richard. (2009) *The Book of English Magic*. London: John Murray

Chope, Richard Pearse, ed. Hill, Vernon, illus. (1912) *Ballads Weird and Wonderful*. London: John Lane

Cirlot, J.E. (1962) *A Dictionary of Symbols*. London and Henley: Routledge & Keegan Paul Ltd.

Colquhoun, Ithell. (1975) *The Sword of Wisdom: MacGregor Mathers and The Golden Dawn*. New York: Putnam Books

Culpeper, Nicholas. (1652) *Culpeper's English Physician and Complete Herbal*. London: Ebenezer Sibly

Culpeper, Nicholas. (1649) *The Physical Directory: or a Translation of the Dispensatory made by the Colledge of Physitians of London*. London: Peter Cole

Crowley, Aleister. (2004) *The Book of the Law: Liber AL vel Legis: with a facsimile of the manuscript received by Aleister and Rose Edith Crowley on April 8, 9, 10, 1904*. York Beach, ME.: Weiser; Enfield: Airlift

Crowley, Vivianne. (1996) *Wicca: The Old Religion in the New Millennium*. London: Thorsons

Crowther, Patricia. (2001) *High Priestess: The Life of Patricia Crowther*. US: Phoenix Publishing Inc.

Crudgington Family Organisation [Websfor.me.uk.] Retrieved 2015-10-23.

Danquah, J.B. 'Living Monster or Fabulous Animal? Sasabonsam of the Gold Coast'. *The West African Review*, September 1939. New York: African Resource Centre

Davidson, Thomas. (1949) *Rowan Tree and Red Thread: A Scottish Witchcraft Miscellany of Tales, Legends and Ballads*. Edinburgh: Oliver and Boyd

Davies, Owen. (2010) *Grimoires: A History of Magic Books*. USA: Oxford University Press

Davies, Owen. (2007) *Popular Magic: Cunning Folk in English History*. London: Hambledon Continuum. New edition

Delderfield, R.F. (1954) *The pixies' revenge; or, the threat to the bells of St. Mary's Church, Ottery*. Ottery St Mary: E.J. Manley

Ehrenreich, E. & English, D. (1976) *Witches, Midwives and Nurses*. London: Writers and Readers Publishing Coop.

Eliade, Mircea. Trans. Trask, Willard R. (1995) *Rites and Symbols of Initiation: The Mystery of Birth and Rebirth*. Woodstock: Spring Publications Printing

Estes, Eleanor. (1960) *The Witch Family*. Middlesex: Kestrel Books (Penguin)

Farrar, Janet & Farrar, Stewart. (1990) *Spells and How They Work*. London: Robert Hale Ltd.

Farrar, Janet & Farrar, Stewart. (2002) *The Witches' Bible: The Complete Witches' Handbook*. London: Robert Hale Ltd

Farrar, Stewart. (1971) *What Witches Do: A Modern Coven Revealed*. London: Peter Davies

Fortune, Dion. (1935) *The Mystical Qabalah*. London: Llewyllyn

Frazer, James. (1929) *The Golden Bough: A Study in Magic and Religion*. (Abridged Edition). London: MacMillan Publishers Ltd. 1st ed. 1906

Gardner, Gerald Brosseau. (1949) *High Magic's Aid*. London: Michael Houghton

Gardner, Gerald Brosseau. (1954) *Witchcraft Today*. London: Rider & Co.

Gimbutas, Marija. (1989) *The Language of the Goddess: Unearthing the Hidden Symbols of Western Civilization*. San Francisco: Harper & Row

Grant, Kenneth & Grant, Steffi. (1998) *Zos speaks!: Encounters with Austin Osman Spare*. London: Fulgar

Green, Marian. (2003) *Practical Magic: A Book of Transformations, Spells and Mind Magic* London: Anness publishing Ltd.

Grimm, Jacob & Grimm Wilhelm. (1910) *Kinder und Hausmärchen (Grimms' Fairy Tales 1812-14)*. Berlin: Globus Verlag

Hannant, Sara. (2011) *Mummers, Maypoles and Milkmaids: A Journey through the English Ritual Year*. London: Merrell

Harte, Jeremy. (2004) *Explore Fairy Traditions*. Marlborough: Heart of Albion Press

Hartlieb, Johannes. (1456) *Das puch aller verpoten kunst, ungelaubens und der zaubrey (Book on all forbidden arts, superstition and sorcery)*. University of Heidelberg

Heselton, Philip. (2000) *Wiccan Roots: Gerald Gardner and the Modern Witchcraft Revival*. Taunton: Capall Bann

Herrick, Robert, ed. Clarke H.G. (1859) *Hesperides or Works Human and Divine*. vol. 2. London

Higden, Ranulf. (1375) *The Polychronicon*. trans. Trevisa, John. ed. Waldron, Ronald

Horne, Charles F., ed. (2010) *The Vendidad: The Zoroastrian Book of the Law*. Whitefish: Kessinger Publishing

Howard, Michael. (2011) *Children of Cain: A Study of Modern Traditional Witches*. USA: Three Hands Press

Hutton, Ronald, ed. (2015) *Physical Evidence for Ritual Acts, Sorcery and Witchcraft in Christian Britain: A Feeling for Magic* Basingstoke: Palgrave Macmillan

Hutton, Ronald. (1996) *The Stations of the Sun: A History of the Ritual Year in Britain*. Oxford and New York: Oxford University Press

Hutton, Ronald. (1999) *The Triumph of the Moon: A History of Modern Pagan Witchcraft*. New York: Oxford University Press

Hueffer, Oliver Madox. (1908) *The Book of Witches*. London: Eveleigh Nash

Johns, June. (1971) *King of the Witches: The World of Alex Sanders*. London: Pan Books

Kirk, Reverend Robert. (1692 I-H-O Books) *The Secret Commonwealth of Elves, Faunes and Fairies*. (Reprint 2003)

King, Graham. (2016) *The British Book of Spells and Charms*. London: Troy Books

Krämer, Heinrich. (1487) *The Malleus Maleficarum (Hammer of Witches)*. Speyer

Latimer, Bishop Hugh. (1555) *Sermons by Hugh Latimer, sometime Bishop of Worcester, Martyr, 1555*. Cambridge: University Press

Leek, Sybil. (1968) *Diary of a Witch*. Upper Saddle River: Prentice Hall

Leland, Charles Godfrey. (1899) *Aradia or Gospel of the Witches*. London: C.W. Daniel Co Ltd.

Levi, Eliphas & Waite, Arthur Edward. (1923) *Transcendental Magic: Its Doctrine and Ritual*. London: Rider. (First ed. 1854)

Lovett, Edward. (2014) *Magic of Modern London: Magic In Modern London 1925 with Folk-Lore & Legends of the Surrey Hills and of the Sussex Downs and Forests 1928*. Boscastle: Red Thread Books (First Ed. 1925)

MacDermott, Mercia (2003) *Explore Green Men* Loughborough: Heart of Albion Press

Mather, Cotton. (1693) *The Wonders of the Invisible World: Observations as Well Historical as Theological, upon the Nature, the Number, and the Operations of the Devils*. Boston

Mathers, Samuel Liddell M. (1888) *The Key of Solomon The King: Clavicula Salomis*. London: George Redway

Merrifield, Ralph. (1987) *The Archaeology of Ritual and Magic*. London: Batsford

Moser, Dietz-Rüdiger. (1986) *Fastnacht – Fasching – Karneval. Das Fest der, Verkehrten Welt*. Graz u. a. Ed. Kaleidoskop

Murray, Margaret. (1921) *The Witch-Cult in Western Europe*. Oxford: Oxford University Press

Opie, Iona & Tatem, Moira. (1993) *A Dictionary of Superstitions*. Oxford: Oxford University Press

Patterson, Steve. (2015) *Cecil Williamson's Book of Witchcraft: A Grimoire of the Museum of Witchcraft*. London: Troy Books

Pennick, Nigel. (1989) *Practical Magic in the Northern Tradition*. Loughborough: Thoth

Pettit, E. (2001) *Anglo-Saxon Remedies, Charms, and Prayers from British Library MS Harley 585: The 'Lacnunga', 2 vols*. Lewiston and Lampeter: Edwin Mellen Press

Raglan, J. (1939) 'The Green Man in Church Architecture'. *Folk-Lore vol. 50*. London: The Folklore Society

Regardie, Israel. (1969) *The Golden Dawn: An Account on the Teachings, Rites and Ceremonies of the Order of the Golden Dawn*. St. Paul MN: Llewellyn Worldwide Ltd.

Richel, Eldermans, Bob, J. H. W., King, G. & Schulke D.A. (2010) *The Occult Reliquary*. Richmond Vista: Three Hands Press

Sanders, Maxine. (2008) *Fire Child: The Life and Magic of Maxine Sanders 'Witch Queen'*. Oxford: Mandrake

Scot, Reginald & Weyer, Johann. (1584) *The Discoverie of Witchcraft*. Arundel: Centaur Press

Scott, Walter (1816) *Guy Mannering. The Astrologer, or The prophecy of Meg Merrilies, the Gypsy*. London: W. Hone

Svensson, Horik. (1995) *The Runes Book*. London: Carlton Books Ltd.

Simpson, Jacqueline & Roud, Steve. (2000) *A Dictionary of English Folklore*. New York: Oxford University Press

Sinclair, John. (1797) *The Statistical Account of Scotland 1797*. Edinburgh: W. Creech

Smith, M.J., Kneller P., Elliot D., Young C., Manley H. & Osselton D. 'Multidisciplinary analysis of a mummified cranium claimed to be that of a medieval execution victim'. *Archaeological and Anthropological Sciences*: New York: Springer

Sontag, Susan (1977) *On Photography*. New York: Farrar, Straus and Giroux

Spare, Austin Osman. (1905) *Earth Inferno*. London: Self-published

Spare, Austin Osman. (1913) *The Book of Pleasure (Self Love): The Psychology of Ecstasy*. London: Self-published

Spence, Lewis. (1948) *The Fairy Tradition in Britain*. London: Rider & Co.

The Federation of Old Cornwall Societies. (1992) *Crying the Neck: A Harvest Celebration*. St Columb: Old Cornwall Societies

Waite, Edward Arthur. (1910) *The Key to the Tarot*. London: William Rider & Son

Wheatley, Dennis. (1935) *The Devil Rides Out*. London: Hutchinson

Wheatley, Dennis. (1971) *The Devil and all his Works*. London: Hutchinson

Zipes, Jack ed. & trans. Deszö, Andrea illus. (2015) *The Original Folk and Fairytales of the Brothers Grimm*. Princeton and Oxford: Princeton University Press

Archive

The Museum of Witchcraft and Magic Archives, The Harbour, Boscastle, Cornwall PL35 0HD

'Hexing Hitler!' March 1941 *The Reader's Digest*

Films

Die Nibelungen (1924) Directed by Fritz Lang. Germany: UFA

*Harry Potter and the Prisoner of Azkaban (*2004) Directed by Alfonso Cuaron. UK: Warner Bros. Pictures

Snow White and the Seven Dwarfs (1934) Directed by Walt Disney. USA: Disney

The Crystal Ball (1943) Directed by Elliott Nugent. USA: Paramount Pictures

The Wizard of Oz (1939) Directed by Victor Fleming, George Cukor. USA: Metro-Goldwyn-Mayer

Acknowledgements

The idea of Sara Hannant as artist-in-residence at the museum was first discussed with Simon Costin in 2012. Work began in 2013 in the months before Simon was appointed director of the Museum of Witchcraft and Magic.

We would both therefore very much like to thank Graham King for having entrusted us with the museum's collection, archive and library and for allowing the project to take place. Graham has been a constant source of inspiration over the years and his deep knowledge of the museum and its collection has been invaluable.

Our thanks also go to Peter Hewitt and Judith Kelly, the museum's managers, and to Hannah Fox and Joyce Froome, both long-serving members of staff at the museum, for all their help and support.

Another long-time supporter and patron to the museum is Professor Ronald Hutton, whom we thank greatly for writing the preface to this book.

We are extremely grateful to Mark Pilkington, Jamie Sutcliffe and Tihana Šare of Strange Attractor Press for their enthusiasm and dedication in producing *Of Shadows*, and to Eric Wright for his layout and design.

Thanks also to Clive Harper for his observations regarding some of the ritual objects.

Finally, we would like to thank the benign presence of Cecil Williamson, without whom none of our lives would have been woven together with a small village in North Cornwall, and a most remarkable collection.

ONLY THE WITCH KNEW WHAT TO DO.